WITHDRAWN

Children Are Artists

Children

AN INTRODUCTION TO CHILDREN'S AR

DANIEL M. MENDELOWITZ

ire Artists

FOR TEACHERS AND PARENTS · *SECOND EDITION*

STANFORD UNIVERSITY PRESS

STANFORD, CALIFORNIA

Stanford University Press
Stanford, California

© 1953, 1963 by the Board of Trustees of the
Leland Stanford Junior University

Library of Congress Catalog Card Number: 63-10734

Printed in the United States of America

First published, 1953
Reprinted five times
Second edition, 1963
Second printing, 1965

To Mildred and Louis

PREFACE TO
THE SECOND EDITION

Children Are Artists was originally conceived for parents. So many of my friends and acquaintances had asked me to pass judgment on art work, to assure them that their children had or had not special talents, that I decided to write a book that would summarize current thinking about children's artistic expression. My aim was to keep the book short, to avoid any involvement with problems of technique, and to keep the terminology simple and nontechnical.

My publishers, however, were convinced that the work would be useful not only to parents, but to teachers, especially teachers in training. So the original manuscript was modified with elementary school teachers in particular in mind. Time has corroborated the publishers' judgment, for since its appearance ten years ago *Children Are Artists* has been adopted as a text in a large number of teacher-training institutions.

The present second edition has been revised to increase the scope of the book without changing its essential nature. Its previous success now makes it possible to include a collection of colored illustrations, thereby adding both information and delight. I have also attempted to summarize recent findings in the field of creativity. In the past ten years American educators have become increasingly concerned about what appears to be an overemphasis on learning facts and acquiring skills in our schools, frequently at the cost of developing creative patterns of behavior, resourcefulness, and an inquisitive attitude toward knowledge. The role of the arts as a stimulus to creative activity in all fields has been explored, and there has been considerable research of a psychological nature in the field of art education. I have purposely avoided any detailed reporting on the rather extensive studies that form an important part of current graduate research in art education, since the separate

studies tend to be fragmentary and relate more to psychological theory than to educational practice. This in no sense denies the value of what is being accomplished, for as the theory of art education is strengthened by psychological and sociological disciplines, the practice of art education will be enriched. However, since my aim is to keep this volume concise and of practical value, I have attempted to summarize and generalize on current findings to the degree that they apply to general teaching practice rather than to explore the various separate studies.

I have also purposely avoided pronouncing upon the many problems related to schoolroom practice or the administration of art education programs in the public schools. A number of art educators, drawing upon a wealth of personal experience, have published excellent books summarizing their thinking and experience. It would be presumptuous for me with my limited experience in public schools to advise about classroom practice. I have also kept recipes and advice on processes to a minimum, since many good books on the craft and how-to-do-it level already exist. Instead, my hope is to strike directly at the heart of the role of the visual arts in education, to present a guiding philosophic and psychological framework based on the chronological stages through which a child's artistic expression evolves, and to relate this framework to the parent-teacher-child relationship. Given this broad orientation I trust the intelligence of parents and teachers to solve specific practical problems as they occur.

I would like to express my appreciation of the help that the following people and institutions have given me. For illustrations I am indebted to Mrs. Maxwell Arnold for Fig. 24; to Mrs. Elizabeth Aronstein for Plate VI; to Mrs. Felix Bloch for Fig. 33; to Mr. William Bowman for Fig. 25; to Mrs. William Carter for Figs. 9, 10, and 11; to Mrs. William Crosten for Figs. 15, 16, 17, and 41; to Mrs. Sidney Davis for Fig. 28; to Mrs. Edward Farmer of the Palo Alto Senior High School for Figs. 44, 48, 57, and 58; to Dr. Ray Faulkner for Figs. 1, 19, and 20, and Plate I; to Mr. Mike Fromhold for Figs 51 and 52; to Mr. Paul Glenn for Plates II, III, VII, and VIII; to Mrs. Jack Granoff for Fig. 22; to Mr. Alvin Hansen for Figs. 2, 14, 18, and 29; to Mr. Douglas Hofstadter for Fig. 56; to Mrs. Susan Irwin of the San Francisco City Schools for Figs. 26 and 33; to Mr. Matt Kahn for Figs. 43 and 59; to the Leupp Boarding School, Winslow, Arizona, for Fig. 42; to Mrs. Charles Lindstrom of the De Young Museum, San Francisco, for Fig. 45; to Mrs. Francis Marshall for Fig. 7; to Mr. Leon Mead of the Florida State University, Tallahassee, Florida, for Fig. 38; to the National Art Education Association for permission to reproduce Figs. 27, 37, and 47 from the Association's year-

book, *This Is Art Education*, 1952; to Mr. Richard Rankin for Figs. 21, 30, 31, and 32; to Mr. Robert Sterling of the Palace of the Legion of Honor, San Francisco, for Figs. 5, 35, and 49; and to Mr. Wesley Williams of the Terman Junior High School, Palo Alto, for Figs. 34 and 53; to Mr. Alvin Zelver for Plates IV and V.

The photographing of Figs. 2–12, 14–18, 21, 23, 29–33, 39, 45, 52, 55, and 56 was done by Mrs. Rose Mandel. Mr. Burton W. Crandall photographed Figs. 4, 13, 35, 36, 40, 41, 44, 48, 51, and 57; Mr. Richard Keeble Fig. 42; and the Stanford Photography Department Figs. 22, 24, 25, 28, 33, 43, 55, 56, and 59. For their patience and interest I am very grateful.

Most of the illustrations have been used without the artists' knowledge. Often the artist forgot to sign his name. I owe a special debt to the many children and adolescents whose works inspired this book and now serve as illustrations for it; similarly I feel much indebted to the parents and teachers who encouraged the children to express themselves and who collected and saved their works.

I could well have dedicated the book to all these people, but I have reserved that notice for two who have helped throughout its preparation and before. The book is thus dedicated to my wife, Mildred, and my son, Louis, who helped in many ways, in particular by producing illustrations Figs. 4, 8, 12, 13, 23, 36, 39, 40, 46, 50, 54, and 55.

D. M. M.

Stanford University
July 1963

CONTENTS

Children Are Artists

1 THE ARTS AND EDUCATION

W H A T do the words "the arts" suggest to you? Do you think of pleasant leisure-time interests—an occasional afternoon at an exhibition, an evening concert or play, agreeable, even stimulating, but not essential, adjuncts to daily living? Or do the words describe a fundamental means of communication between men? The aura of fashionable sophistication that surrounds the world of the arts today tends to obscure their fundamental role in society: to provide basic vehicles for speculative inquiry into the nature of human experience. As soon as communication goes beyond practical day-to-day needs it is cast in some art form, be it literature, music, painting, or sculpture, just as shelter, when carried beyond the purely utilitarian level, becomes architecture. From paleolithic times until today, man's beliefs, speculations, and perceptions have been made concrete and tangible through the arts, and as such the arts constitute the most eloquent artifacts of civilization. They have retained their expressive force throughout history, and their power to excite and inform makes them primary educative instruments that can stimulate adults and children to realize their full potential for enjoying and understanding themselves and the world of man and society.

The Arts as Communication

The premise on which this book is written is a belief in the educative value of the arts—a conviction that most of life tends to remain only partially experienced except to the degree that the arts give it form and meaning. This is a plea, then, for the full use of the arts in education, rather than for education in the arts, using the term "the arts" to refer to the full range of artistic expression—literature, music, drama, painting, sculpture, architecture, and the decorative arts, as well as contemporary forms such as photography and the motion picture.

The basic function of education is to help children "grow up"—to prepare them for adult life. Preparation for adult life necessitates discovering oneself as well as the world about one. This process involves the creation of what the psychologists call a "self-image," and an important component of this self-image is an ideal of life, or a pattern for living that reconciles the self-image with the external world.

Very few of us realize how many of our most fundamental ideas about life are drawn from artistic experiences—from literature, the drama, movies, music, painting, and the allied arts. Our most personal ideals—that is, our ideas of what we expect from life, from love, about how society works, what human nature is like—are seldom distilled primarily from our personal social experiences. Life is too vast and complex, its patterns too tenuous and changing, and the average person too inarticulate and too lacking in analytical powers for the development of a coherent philosophy and set of values out of confused personal experiences. Instead, to a large degree we compose our concept of life from the myriads of stories, pieces of music, pictures, and plays that we know. With these are blended fragments of our own direct experience and that of our family and friends, and the resulting mosaic constitutes our picture or philosophy of life and serves as a guide for our actions and beliefs.

The mosaic is inevitably a fantastic potpourri of images: some are the prejudices of our family and environment, some are drawn from the great literary minds of the ages, some come from movies or paintings we saw in our sensitive and receptive teen-age years, some are from the funny papers we read as children. All through our lives, but particularly during our growing and formative years, certain experiences answer the needs of certain moments and shape our picture of life: Shakespeare and a cosmetic ad, Rembrandt and Dennis the Menace, all work together. Every person in our culture is continuously assailed by a wide variety of artistic images: books, plays, paintings, and music, as well as advertisements, illustrations, movies, television programs, radio broadcasts, comic books, and similar sources, are constantly shaping a picture of life. Many of these influences are cheap, superficial, and cynical, and if more profound and penetrating experiences are not encountered by our children, their philosophy of life will be shaped by these shoddy images.

Years ago I saw drawn upon a blackboard a striking visualization of this concept of personality development that had the virtue of describing pictorially a very abstract and subtle process. The individual was drawn as a small circle. Around this circle a configuration of dots was placed upon the blackboard, each dot representing a great artist from

the past or present. As the individual reached out from his limited central sphere to absorb the thoughts and feelings of the great men who formed the encircling constellation—Phidias, Rembrandt, Shakespeare, Beethoven, Picasso, Wright, to suggest a possible few—a line was drawn that encircled the appropriate dot. Each encircling line created a shape resembling the petal of a flower. The drawing, when completed, described the flowering of a personality, for a personality only achieves full bloom by exploring all the varying dimensions of experience.

My thesis, then, is that we come to know the nature of man, of society, of life and love, through seeing plays, movies, and pictures, reading novels and poems, and hearing music, and of course, through family, school, and church experience. This does not deny that science and philosophy provide important guiding concepts to society, but such guiding concepts influence living patterns only after they have been popularized and dramatized. The arts provide a means for transcribing abstract concepts into flesh and blood realities. The role of aesthetic formulation in giving coherence to living experience, and reality to scientific abstractions, can be perceived when one is asked to perform such a simple task as describing the appearance and character of a new acquaintance. Though modern psychologists have discovered much about human personality and have put this knowledge into formal systems, faced with the problem of describing someone, one is apt to end up by saying, "Oh, he reminded me of that egocentric but charming lawyer in the movie we saw last week," thereby using the movie characterization rather than the appropriate scientific term—narcissistic—to describe a real person.

Although most people can readily perceive that many of their ideas about life come from literary and dramatic sources, they feel that their eyes tell them how the physical world looks without the aid of the artist. But do they? If a primitive savage, unacquainted with the pictorial conventions, were shown a photograph of himself, he would look at the piece of paper, taste it, smell it, and then probably stick it in his hair as a piece of decoration. Since he had not learned to read photographs, it would not occur to him that the little blotches of black and white on the piece of paper were a duplication of his own appearance. It took the impressionists to show us the cool color of shadows and the warm color of sunlight. Through the eyes of artists we have come to know the nature of physical reality and also to form ideals of beauty. We see life through works of art, and "realistic" most frequently means aesthetically familiar. The human body as rendered by the Greek sculptor appears to be a realistic ideal to us because we have learned to see the human body through the conventions of Greek sculpture.

Aesthetic experiences that mold vision constantly surround us, but unfortunately, in our contemporary world, they are not always of an admirable character. Educators and parents can do much to determine whether the child's picture of life is shaped primarily by television programs, comic books, advertisements, and all the images that pour from the commercialized mass media, or from the complexities and subtleties of ageless works of art. Thirty years from now the living rooms in which today's children will live will reflect either an adventure into man's greatest experiences or only the nearest department store.

The Visual Arts

Before proceeding, we might do well to define our subject. By the visual arts I mean those arts that are meant primarily to be seen. All the arts are directed toward the senses—the visual arts are designed for the eyes, music is dependent upon hearing, while taste, smell, and the sense of touch are most directly involved in such applied arts as the culinary and fashion arts. Literature is the least direct of all the arts in its sensory impact, for though it appeals to all of the senses, it does so indirectly, through the medium of words. Certain hybrid arts, such as opera, are equally dependent on words, sounds, and visual impressions.

The visual arts, our particular concern, serve two main functions. First, as has just been indicated, they provide a means for communication, for commenting on visual experience. Painting, sculpture, and the print media and photography have this essentially philosophic role, and though they may be used for such practical purposes as to illustrate and decorate, in essence they remain contemplative activities. Second, the visual arts, particularly those formerly described as the "applied arts" and now frequently called the "space arts," provide the means whereby man controls and shapes his environment to create the setting for effective living. Architecture, city planning, interior design, industrial design, and the household arts, though rich in philosophic implications, derive from practical needs.

We live in an English-speaking world, and the English seem to be verbally oriented, achieving their major creations through literary forms such as poetry, the novel, and the drama rather than in the visual arts. As a consequence American children tend to be most sensitive to the literary arts and to know names like Dickens and Shakespeare rather than Rembrandt, Phidias, or Beethoven.

Until recent years, many American cities have had no museums, and thousands of American children have grown up without ever having seen the original of a great work of art, be it painting, sculpture, or architecture. The tradition of museum-going is still remote from Amer-

ican daily experience, and even when cities do have museums, many Americans attend from a sense of duty rather than with a feeling of delight. How frequently one hears a visitor to New York say, "I suppose I ought to see the Metropolitan," or hear the homecoming tourist boast that he "made the Louvre in two hours"! How different is the attitude of most educated Europeans who have grown up amid marvelous museum collections and have formed the habit early in life of spending delightful hours amidst treasured objects! I remember years ago seeing a Frenchman in the Louvre with a child on a Sunday morning. They were examining a Flemish primitive painting through an enlarging glass, and the child was beaming with pleasure as the father pointed out how fantastically tiny and yet how perfect the forms were, how wonderful that someone could paint so small! This was enjoying a work of art as it should be enjoyed, through a spontaneous surrender to experience, not as a dry obligatory involvement in a cultural duty. But such a full surrender demands familiarity, and familiarity demands opportunities to see as well as the habit of making the most of these opportunities. For these and other reasons that will be discussed later the graphic and plastic arts are among the less favored subjects in American schools, which despite assertions to the contrary already veer toward a pragmatic three R's philosophy of education and therefore look with some skepticism on a liberal arts education.

The growth of museums in this country and the continuous increase of what Malraux has termed "the museum without walls," that is, of reproductions of works of art, photographic or otherwise, make increased familiarity with the visual arts possible. If, along with increased availability, the school and home establish the habits of seeing and enjoying works of art, the foundation will be laid for appreciation and growth. Many Americans feel that they lack some particular sensitivity that makes them capable of enjoying the visual arts. Such an attitude fails to take into account the importance of familiarity in appreciation. Most Americans, even when their musical interests are not deep, are sufficiently familiar with jazz to be able to distinguish among orchestral styles and to appreciate refinements of execution or virtuosity. Literary conventions are even more familiar. When students read "Her eyes were as big as saucers," they do not throw down the book in disgust and exclaim "How ridiculous, no one's eyes are that big!" Instead they translate the figure of speech in terms of the author's intent to mean either "She was surprised" or "She had enormous eyes." Familiarity with literary conventions makes it possible unconsciously to translate the expression in terms of the author's meaning, just as familiarity with jazz permits a discriminating response.

Few of these same people could respond to strong distortions in

painting with the same sensitive spontaneity. This is not because Americans are by temperament less sensitive to visual arts than to literature or music, but because they are less familiar with the visual arts; to those popular forms of visual art with which they are familiar, they respond instinctively. Almost all American students "read" fashion drawings or cartoons without any difficulty. The high school girl is undisturbed by the unnatural proportions of the long, thin figures in fashion magazines, as she studies the lines of a dress. In the same way the junior high school boy translates the conventions of comic book illustration without even thinking about them. A large-chested, large-jawed male is a hero, a shallow-chested dark male with sideburns is a villain, a galaxy of stars surrounding a figure means unconsciousness, etc. Even the most sensitive child from an alien culture would be perplexed by these strange symbols, just as the intelligent adult in America, when confronted with an abstract painting, if unfamiliar with the conventions involved, finds himself looking for representational elements, symbolic meanings, or other elements that are outside the abstract artist's intent.

But one then asks what is the fundamental educative value of this increased familiarity with and sensitivity to the arts, in particular the visual arts.

To assess the educational potential of artistic activity one must examine three aspects of this distinctively human function, viewing it (1) as communication, (2) as self-expression, and (3) as the orderly arrangement of the environment. The first of these, communication, relates to externalization, the way man makes his thoughts and feelings known to other men. This has already been touched on. Self-expression is concerned with the individual's awareness of the meaning of his own experience and the way he satisfies psychological drives by projecting his perceptions into artistic form. The third aspect of the visual arts, the orderly arrangement of the environment, is the particular province of architecture, city planning, interior design, industrial design, and the other related fields of design. Every object used by man is shaped by two factors, functional considerations and the tastes of the people who make and use it. In certain periods of history there appears to be a particularly fortuitous relationship between man's activities and his environment, and at such times the cities and buildings that man creates, as well as the objects that he uses in daily life, are beautiful and serve their practical purposes admirably. At other times man has been thwarted by his environment with consequent conflict and loss of happiness. One glance at the endless wasteland of ugly, inefficient, unplanned highway strips that lead to and from the cities of today, and we realize how drastic is the need to educate for the orderly and beautiful arrangement of our environment.

Self-Expression and Creative Activity

While the arts provide a bridge by which we come to know the re-actions of others to the world about us, they also provide the means whereby man crystallizes his own tenuous perceptions. Since human thought and feeling are ever changing and fragmentary, and since the fluid kaleidoscope of images that assault the senses is infinitely complex, existence frequently appears chaotic. Chaos is inevitably threatening; there must be the illusion of order for man to function. One of man's needs is to avoid the threat of chaos by creating a sense of order. All of man's endeavors in religion, science, philosophy, and art represent at-tempts to perceive ordered relationships behind existence.

For man to arrange his experience in orderly and meaningful pat-terns he must first seize upon and define the nature of his experience. This can only be accomplished by a slow and arduous process of con-tinuous observation, analysis, and expression. Through this process the individual finally becomes aware of the nature of his own experience and the degree to which it is unique and different from that of all other men. Equally important is the discovery that there are large areas of experience which all men share. This process of discovery, of defining both one's unique and one's common perceptions, characterizes the act of self-expression for the child as well as the creative artist, and here we touch on one particular role of the arts in education—to provide avenues for self-expression that will make the child more conscious of the full range and nature of his experiences. Redness is inevitably sensed more fully after a child has deliberately painted something red; the many-fingered flexibility of the hand becomes more consciously realized after a child has carefully drawn or painted this familiar part of the body finger by finger (Fig. 1).

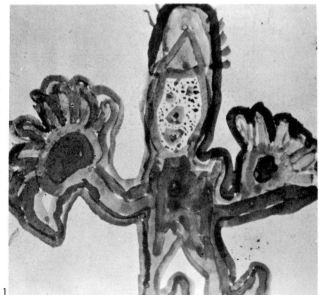

1. Watercolor. Age estimat-ed at six years.

This appears to be a de-lighted discovery of the fin-gered character of hands. The spotted face, however, suggests that an itchy ailment might have precipitated the discovery, and that frustra-tion rather than delight was the motivating emotion. Whatever the stimulus, the fingered character of hands has ceased to be merely ex-perienced and has become symbolized.

Much has been written in the past ten years about creativity and the need to foster it in our schools. A recent study, *Creativity and Intelligence,* by Jacob W. Getzels and Philip W. Jackson explored the relationship of creativity to conventional measures of intelligence among a group of gifted children. A number of the conclusions reached by Getzels and Jackson are relevant here. First, it seems clear that certain aspects of intelligence, particularly those relating to inventing, exploring, and questioning, are not adequately measured by most types of intelligence tests. Second, though creativity goes hand in hand with a high level of intelligence, it appears that the children who measured highest on the standard intelligence tests employed by Getzels and Jackson did not measure highest in the tests for creativity devised for this study. This led to the conclusion that many important aspects of intelligence go unmeasured and that these unmeasured features have become of secondary importance in our scale of educational values. Third, and this is most important inasmuch as adult expectations influence children's goals, neither parents nor teachers valued those characteristics that typified the creative children as highly as they valued the general characteristics of the more conforming, highest IQ children. Last, there was a general recognition, all through the study, of the unique contribution of the arts to furthering the exploratory, playful, and imaginative attitudes so characteristic of the creative personality. All these conclusions provide evidence that contemporary American education stresses conforming, passive types of learning rather than creativity.

Creativity has been described and analyzed in varying degrees of elaboration. Very simply, creative behavior might be described as the ability to invent or innovate. The following list of characteristics represents a more elaborate description of creativity, whether in the arts, in science, or in other fields of endeavor. (1) Originality, or the ability to react to stimuli in an unusual way. (2) The ability to develop and amplify original responses to some degree of fruition. (3) Productivity, or the ability to produce ideas, symbols, and objects easily and frequently. (4) The ability to evaluate and think critically, and approach the solution of a problem from a number of viewpoints. (5) Flexibility in meeting new situations has also been described as an attribute of the creative person, but it might be pointed out that although creative people tend to be flexible and inventive in their own fields of endeavor, they frequently seem inflexible and unable to adjust easily to the demands of daily life. The lives of a host of great creative personalities in a wide variety of fields attest to the difficulties that these men experienced in coping with the routine problems of living, partly because of their com-

plete involvement in their creative work. Here it may be necessary to differentiate between the creative person and the genius, and to recognize that the genius often appears to be a creative personality operating on an almost compulsive level. (6) Playfulness, a sense of humor, and moral purpose also appear frequently as components of the creative personality.

While these responses to external situations may well characterize the behavior of creative people, the inner drives that motivate creative behavior are not so easy to define. One of the most apparent drives is a strong sense of personal destiny, as can be witnessed in the lives of Van Gogh, Madame Curie, and many others. Paradoxically enough this intense commitment to a goal of rare achievement is frequently accompanied by acute self-doubts, so that the individual follows an almost manic-depressive cycle of elation and achievement alternating with periods of depression and inactivity. The sense of personal destiny, like other aspects of the creative personality, may be a remnant of infantilism, the child's illusion of magical omnipotence being retained in the adult personality, and sustaining and carrying the adult through the torments of self-doubt.

Another deep psychic drive, mentioned before, is the need to alleviate the threat implicit in the chaos of disorderly sensation in "raw life" (i.e., life unstructured by art). This is achieved by creating order, or at least by establishing orderly relationships between the swarming sensations that continuously assault the senses and through them the mind. Certain psychoanalytically oriented philosophers have developed a fascinating hypothesis to explain the desire for an orderly and harmonious relationship of parts, a harmony that characterizes all works of art and that we term aesthetic form. They feel that the creative artist is unconsciously motivated by the need to liquidate a sense of guilt over destructive impulses. This is done by atonement through the symbolic act of creation. Atonement establishes within the mind a harmonious mood suffused with love, and this mood dominates the creative act. This emotional harmony is translated into the formal properties of the work of art as conspicuously fine orderliness.

In his own writings Freud established many of the premises on which modern psychoanalytical theories concerning creativity are based. Greatly simplified, one might summarize Freud's theorizing as follows: (1) Creativity has its genesis in psychic conflict. (2) The psychic function and effect of creativity is the discharge of pent-up emotion resulting from conflict. (3) Creative thought derives from the elaboration of "freely rising" fantasies and ideas, an activity that is related to daydreaming and childhood play. (4) Creative behavior can be seen as a

continuation of and substitute for the play of childhood. As summarized here Freud's theorizing points to the appropriateness of free art activities as a means of establishing creative patterns of behavior that can sublimate internal tensions and conflicts, and direct them into socially constructive exploratory drives.

The various theories about the drives that lie behind specific creative acts are fascinating but not subject to proof or autobiographical verification. With regard to the genesis of the creative process, however, ample testimony exists in the form of statements made by creative people in a wide field of endeavor. An extensive collection of such statements has been compiled by Brewster Ghiselin in *The Creative Process* and leads to the conclusion that "production by a process of purely conscious calculation seems never to occur. More often it defines itself as no more than a sense of self-surrender to an inward necessity inherent in something larger than the ego and taking precedence over the established order."

Four steps have frequently been identified in the creative process; these might be described as impulse, gestation, outpouring, and refining. However, in a paper entitled "Dimensions of the Creative Process," Louis A. Fliegler wisely points out that creativity "is not a single intuitive reaction to the environment but a consistent and sustained accretion of knowledge." Initially man must absorb the symbols of his culture and build up a habit of creative responses to stimuli. To use an obvious illustration, no one from a culture in which painting does not exist expresses his creativity through painting; moreover, only by painting does one establish the habit of expressing oneself creatively through painting.

Thus, after this culturally induced preparation for the act of creation has been established, the four previously mentioned steps can occur. First, there is the conscious impulse to initiate an action. According to Ghiselin, "Creation begins typically with a vague, even confused excitement, some sort of yearning, hunch, or other preverbal intimation of approaching potential resolution." Second, there follows a period of gestation during which there is usually a conscious struggle to give form to the "preverbal intimation," to lay out the essential structure of the work of art, scientific experiment, mathematical hypothesis, or whatever it may be. Third, and of particular significance in characterizing the creative act, is a period of automatism, of spontaneous outpouring, a welling up from subconscious depths. Workers in all creative fields have given testimony to the nature of this automatism, but no one has described the process better than Henri Poincaré: "Ideas rose in clouds; I felt them collide until pairs interlocked, so to speak, making a stable

combination. By the next morning I had established the existence of a class of Fuchsian functions . . . I had only to write out the results, which took but a few hours." Frequently the automatic outpouring, though it establishes the main form of the work, demands further refinement. This constitutes the fourth step in creative activity—the conscious reshaping, pruning, and refining of the final work.

⁄ Ways of encouraging creative activity in the school will be taken up in subsequent chapters, but certain aspects of creativity should be recognized here. First, creative activities draw on some very valuable aspects of intelligence that tend to be neglected and even stifled by the more routine learning tasks normally stressed in school. Furthermore, patterns of creativity can only be established by habits of doing. And, finally, just as a differentiation can be made between talent and genius, so can a distinction be drawn between a healthy and normal level of inventiveness, with its flexible response to new situations, and the almost compulsive intensity that characterizes the creative activity of genius. One might say that the role of the home and school is to stimulate the first level without excluding the possibility of the second, although this represents almost too pat an attitude to be realistic. The point should be made, however, that although the well-adjusted personality represents an ideal toward which home and school should strive, the concept of the well-adjusted personality must not be oversimplified, nor can it be assumed that conforming to standardized patterns of behavior (e.g., mixing with groups, being popular, doing assignments willingly, etc.) always represents a desirable goal. Certain levels of neuroticism remain well within the range of normal behavior, and internal tensions always remain with people. The ideal atmosphere in the home and classroom is one that channels tensions and neurotic drives into socially constructive behavior and provides a creative outlet for potentially destructive impulses.

⁄ The arts play a particularly constructive role in education by providing outlets through creative behavior for many types of personalities, including those with strong potentially destructive drives. When the arts are an intrinsic part of the school curriculum, they are particularly valuable because their therapeutic role is enacted within the framework of established social institutions. [The arts have the further virtue of providing important avenues for achievement in our word-minded schools for those children whose intelligence is least evident in verbal activities. That our schools place too high a premium on verbal skills has long been recognized, but there is still a tendency to be patronizing about nonverbal activities and to regard them essentially as voca-

tional possibilities for those who will not be going in for higher educa-
tion. The visual arts provide areas for distinguished nonverbal achieve-
ment on a nonvocational level. More than any other type of activity,
the arts provide for the creative integration of sensory and social exper-
ience, of thought, feeling, and action.

The Visual Arts and Our Environment

The distinction has already been made between the philosophically
oriented visual arts and those that are primarily utilitarian in origin,
namely, the space arts. Each person is to some degree a working artist
in the space arts. Each time a room is arranged, a garment purchased,
one pen selected rather than another, or one color preferred to another,
a decision is being made about design (whether about material, color,
form, or texture). Cumulatively these decisions create the environment
with which one surrounds oneself, and the shaping of this environment
is the creative act that makes every person a designer for better or for
worse. Cumulatively our tastes shape our cities and our culture. When
a house is purchased, the type selected influences the type of design
employed by subsequent builders, for the builders follow public pref-
erence. When new subdivisions are laid out and new highways planned,
the degree to which thoughtful planning in terms of community needs
prevails depends largely on community concern over such matters and
community participation in planning.

One of the problems that faces modern designers is to reconcile
modern industrial practices and high aesthetic standards. Our day must
forge a style that is compatible with democratic ideals and machine
production to replace traditional styles of earlier days, particularly in
the household arts. The elegance and splendor of the furniture, fabrics,
and china and silver of former ages were made possible by an aristo-
cratic mode of life that emphasized lavish consumption by a limited
few, thus permitting a large number of highly trained craftsmen to pro-
duce a limited amount of splendid wares. These older handicraft prac-
tices can no longer face the competition of the machine, and machine-
made imitations of the richly embellished objects of earlier ages now
result in vulgarity, pretentiousness, and aesthetic dishonesty. Modern
design at its best represents an attempt to forge for the machine age an
aesthetic style suited to democratic beliefs and standards of living. Our
modern designers work to make the thousands of objects we use func-
tion effectively. They strive to use materials with sensitivity and beauty,
and tools with efficiency and logic. Every well-designed object repre-
sents an imaginative solution of a problem by means of logic, ingenuity,

and taste. In the hands of our best modern designers this directness of approach, combined with an honest use of materials, results in a simplicity and dignity of form of an almost anonymous elegance. However, unless public taste finds such objects acceptable, designers are forced into dishonest and pretentious practices. Since every child grows up to arrange certain aspects of his environment and to consume goods, it is important that the sense of design be developed in children, both in terms of arranging and making things and in terms of appreciation and discrimination.

After sixteen or more years of education many a college graduate remains with no formal knowledge to assist him in the relatively easy task of choosing colors and furniture for a home, and thus finds himself completely at the mercy of the salesman. Nor have the habits of participating in group decisions concerning community planning been established during childhood in the neighborhood and school community. As a consequence adults, unless they are professionally involved as architects or city planners, tend to be ineffectual in influencing the physical form of the community. Despite the general recognition of the disastrous effects that have resulted from not having planned our cities and controlled their growth, most new suburban areas reveal the same faults of congestion, destruction of natural beauties, and ugly monotony that grew from nineteenth-century laissez-faire attitudes. Public apathy is usually blamed for this lack of progress, but even when the public is indignant and concerned, it does not have the habits of group participation that would enable it to make its concern felt. Therefore a broad training in design as it applies to the buying of the things we live with, and to the shaping of our towns and cities, is necessary if people are to live in a benign and beautiful environment.

This entire concern is sometimes called consumer education, but frequently consumer education places its chief stress upon matters of price and durability, and neglects the design and aesthetic factors that are so essential to subsequent satisfaction and pleasure. Also, consumer education is hardly ever directed toward forming the habit of making group decisions, a practice that is vital in city and community planning. Our goal as art educators is to refine and personalize taste, and to make the shaping of both the personal and the community environment major concerns of education at all levels.

Summary

The arts have three main functions in society, and hence in the classroom and home. (1) They provide fundamental avenues for communi-

cation between men on a philosophic level. Through works of art we share the experiences and perceptions of others and come to know the world of other men. Works of art help shape our "self-image" and help determine our goals and expectations in life. (2) The arts provide discipline for both self-discovery and self-expression. Through the arts men define both the unique aspects of their perceptions and those that they share with all men. The visual arts provide important areas for self-expression that do not require elaborate disciplines. This makes them particularly valuable in establishing habits of creative behavior. Creative attitudes established in childhood appear to influence all subsequent behavior, tend to become personality factors, and should be valued as such rather than as professional attributes. The arts encourage high levels of achievement for many different types of personality. These high levels of achievement contribute to emotional stability and encourage easy participation in a wide variety of social situations. (3) Certain visual arts, the space arts, are concerned with the arrangement of the total environment for effective social living. School programs and home activities should emphasize both aesthetic and social values in visual design, and recognize that a design problem exists wherever objects, materials, forms, colors, or textures are combined. Such attitudes form the habits of arranging the environment for greater beauty, group comfort, and efficiency, and thereby integrate art and daily life.

II ART AND THE CHILD

WHAT do you think about the childlike art work children create? When a child proudly presents you with a painting, do you enjoy the painting with the child, observe it, and discuss it together? Do you put the painting where other children, family, and visitors can see it? Many of my friends have the charming habit of hanging children's drawings and paintings in their homes, and rooms so decorated offer a pleasant and lively contrast to those where the walls are solemnly dedicated to adult masterpieces.

Equally impressive are the classrooms decorated with the work of the children as contrasted to those garlanded with the cute banalities that are supposed to please children but in truth delight adults with undeveloped tastes.

Understanding Children's Art

A love of children's art does not automatically develop from loving children, for it takes a certain amount of knowledge to enjoy and comprehend the drawings and paintings of children. All art is a language learned through interest, information, and familiarity, and the artistic expression of children is no exception. Being a connoisseur of adult art does not ensure an understanding of children's work—in fact, the application of adult standards to children's work may contribute to a misunderstanding of it. Even people with deep and genuine artistic interests do not always fully grasp the role of the arts in education and daily living.

Too often people ask to be reassured that a painting they like is "good" before they admire it, as though they preferred an authoritative judgment to their own pleasurable responses. Frequently I find a parent

or teacher questioning whether to hang a child's fascinating drawing or painting because "the drawing is not well-placed on the paper," "doesn't seem well-balanced," "seems ordinary in color," or has some other defect according to academic concepts of what constitutes good work. One often meets parents (and, fortunately less often, teachers) who hesitate to encourage a child to paint or draw or model for fear that the child hasn't enough talent. If you ask, "Enough talent for what?" you find that behind their thinking are misconceptions about "art" and "genius" and "special ability," and that they are worried lest the child may not have whatever it takes to produce unusual or distinguished or important works of art.

These "genius" or "talent" ideas, in conjunction with the very competitive nature of our culture, color the thinking of most of us to a surprising degree. Even people who are sincerely concerned with children's all-round development often seem unduly interested in the degree to which a child's work is above average or shows talent. Not long ago I had the following revealing experience. I was attending open house at a nearby public school, and along with many parents I was enjoying the children's paintings and drawings that had been put up to decorate the rooms. One particularly impressive group of paintings caught my attention; they were of Halloween and depicted witches riding through the sky on broomsticks (Figs. 2 and 3). One very complex painting had

2

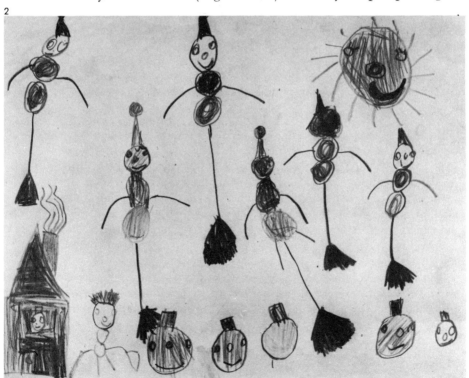

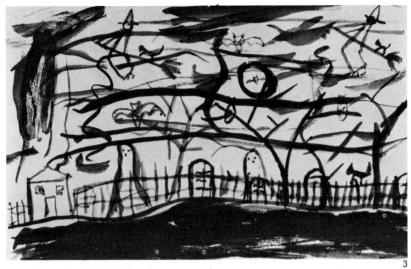

3

2. Crayon, 18 x 24. Age 6 years.
3. Black cold-water paint, 12 x 18. Age about 10 years.
 No two children react in the same way to their experiences. A six-year-old sees humor in pumpkin faces and witches riding broomsticks, whereas a ten-year-old conveys the excitement and "spookiness" of Halloween. The evolution of space concepts that occurs between six and ten is very evident in these two pictures.

been carried to an impressive state of completion, and, more important, it was full of spirit and excitement. The father of the child who had painted the picture, seeing me surveying his son's work, came over to hear my reaction. "Well," he said, "my son's painting must be very childish to a professional artist like you." "Childish in a wonderful way," I responded. "Your son is quite a fine artist." He glanced at the painting and then said somewhat apologetically: "He paints a great deal, but I haven't paid much attention to it." I remarked that I thought the work was very good and pointed out some of its virtues. The father listened with true parental pride and pleasure, and then responded: "Well, I still don't think much of the painting, but if he's better than average perhaps we ought to give him lessons and develop his talent."

Obviously, this well-meaning father was interested in his son's drawings to the degree that they represented a special level of ability. Because he loved his child and was an intelligent and receptive parent, it was easy to explain to him that at his son's age it was the activity and its meaning to the child, not the "above-average ability," that was important. The attitude of this father is far from unusual. Many a child comes home from school full of enthusiasm, painting in hand, and mother, with a glance at the painting, will ask, "Was teacher pleased with your work this morning?" The implication is clear: "Does the

teacher approve? Was your work outstanding?" Behind such questions there is the idea that only the art work of the exceptionally talented child is important, that his abilities should be encouraged, but that for children with only average abilities the arts represent no more than an innocuous way of passing the time.

This emphasis on talent increases in the intermediate and junior high school years, when a part of the workday, or a special place in the room, is set aside so that talented children can develop their artistic ability (not themselves!). The valuable special programs for exceptional children that are being developed in many schools today can, if not carefully handled, intensify this trend and result in diminishing the opportunities for self-development for nonexceptional children. This is particularly alarming in view of the fact that exceptional interests and abilities are frequently not revealed before late adolescence.

This restrictive concern with special talents indicates a basic misunderstanding of the role of art activities in a child's development. When a child comes to you to tell breathlessly of a wonderful experience he has had, you do not decide that the episode is worth listening to only if he expresses himself with more than average literary ability. A child's paintings, drawings, and sculptures are some of the many ways by which he expresses his reactions to his living experiences (Fig. 4).

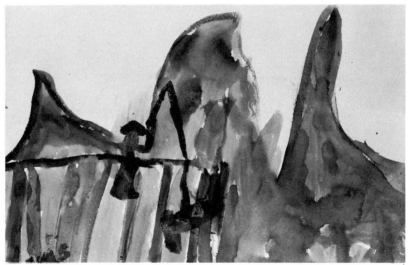

4. Watercolor, 12 x 18. Age 7 years.

That which is experienced with intensity is described with vigor. Fishing from a pier during a storm had been an exciting experience, but the child's subsequent verbal description of the event had not revealed, as did the painting, the awe and fear with which he had reacted to the roughness and size of the waves.

Children also find outlets through play-acting, storytelling, gestures, sounds, and mimicry. Through these various avenues of expression the child gives form to his experiences and thereby crystallizes his ideas about the world in which he lives. This "giving form" to experiences, as we choose to call a child's natural, spontaneous, imaginative play, is his most important activity. A thoughtful observation of children at play reveals much concerning the nature of the activity that is taking place. There is an imaginative exploration by the child of the world he sees about him, a creative copying of adult actions and conventions, a series of impromptu rehearsals that serve as preparations for eventual participation in the adult world. The arts have particular significance in relation to this play activity.

Play and the Arts

Most adults intuitively encourage familiar types of play and do not question their importance and value. They sense that the serious pursuit of play in the child's miniature world prepares the child for life in the adult world. The exhilarating interplay of ideas and actions, the inventive thinking, the talking and moving in imitation of adult behavior, are accepted logically as a childlike exploration of the world, as an activity that stretches the muscles of the mind as surely as it does those of the body.

Unfortunately, many adults do not realize that children's artistic activities are an important part of this play experience. Healthy, uninhibited children participate eagerly in all forms of artistic expression. They sing, dance, draw, paint, model, build, and write naturally and unself-consciously. What adults call "children's creative expression" is, as far as the child is concerned, merely playing with paints, crayons, plasticine, clay, or other media. If a child hesitates to express himself with paint, crayons, or clay, it is probably because adults have inhibited his free participation in these forms of play. Maybe he has been scolded for scribbling on a wall or in a book. Maybe so much stress has been put on the need to color the picture book neatly and to stay within the outlines that he is afraid to trust his not very well coordinated muscles. Maybe he has felt censure in a quizzical frown or a disappointing "What's it supposed to be?" Or he has been shown the "correct" way to draw. The "correct" way is strange to the child, a pattern to follow instead of a means of expression. Trying to draw in a way to please others obstructs his expression and eventually he may give up attempting to express himself at all and instead will repeat the patterns that constitute adults' ideas of "correctness."

It has been pointed out that the artistic expression of children, like all of their spontaneous activity, is a kind of play. Eric Erikson in his book *Childhood and Society* says: "To play it out is the most natural self-healing measure childhood affords." The habit of using artistic expression as an emotional cathartic, a way of relieving tensions and resolving difficulties, if established in early childhood, can contribute greatly toward an emotionally relaxed and healthy personality. One way the child can "play it out" is by painting it out. Having "painted it out," he will find emotional release. A number of psychologists and psychiatrists have testified to the effectiveness of drawing, painting, and modeling as an element in psychiatric therapy. In cases of severe maladjustment, the artistic activities are part of a complex psychiatric treatment in which they not only provide great emotional release, but serve the valuable additional purpose of revealing, through the content of the art work, the areas of conflict and concern. (The use of artistic activities in psychiatric therapy is well described in Margaret Naumberg's monograph, *Free Art Expression of Behavior Problem Children*.)

However, the normal child is our main concern here. Normal children also have their areas of fear, stress, and conflict (Figs. 5 and 6),

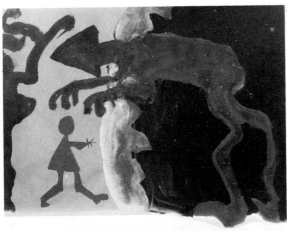

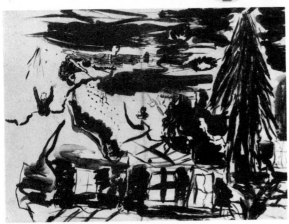

5. **Cold-water paint, 18 x 24. Age 11 years.**
6. **Cold-water paint, 18 x 24. Age about 12 years.**

An assignment to illustrate "big and little" stimulated an eleven-year-old girl to a pictorial expression of fright that she might not have permitted herself verbally. Whether afraid of his own potential violence or frightened by real or vicarious war experiences, the vehemence with which a twelve-year-old boy painted this war scene suggests that the expression must have provided intense psychic relief.

and characteristic of normalcy is the ability to resolve conflicts through socially accepted activities. When artistic expression is part of a child's normal pattern of activity, it provides such an avenue of release.

One might ask why it is necessary to "paint out" certain concerns and problems. Why are these areas of tension not healed by other kinds of play? Obviously, the more areas of activity open to him, the likelier it is that the child will achieve the needed release from emotional tensions. Some tensions are best released by dramatic play, others by constructional activities, while still others seem to be most easily relieved by painting and drawing. It is obvious that certain kinds of personalities express themselves more readily in one artistic medium than in another. One child verbalizes easily, another likes to dance, while a third paints without inhibition. For one, hammering nails may sublimate the desire to hit someone, whereas another child may achieve the same satisfaction by painting out a face. As more comes to be known about personality structure, more will also be understood about why various means of expression function differently with different people. For the present we must be satisfied with knowing that if a child likes to paint, the experience is important for him, and that the medium of painting is effective in relation to his personality and provides avenues through which his intelligence, emotions, and experiences find expression.

Social Attitudes That Inhibit Artistic Expression

While it is generally accepted in theory today that artistic expression through paint and clay is as normal an attribute of childhood as expression through words, in practice there are still many pressures that inhibit the full use of the arts in our homes and schools. Many of these pressures emanate from deep-seated influences within American culture. We have inherited a certain suspicion of artistic activity from our Puritan ancestors, who associated the arts with paganism, popery, and aristocratic extravagance. The rugged demands of frontier life put a premium on austerity and utility, and left little time or energy for the cultivation of the refined interests and pleasures of old and established communities. American culture was in its most formative stage during the nineteenth century, a period when scientific, industrial, technological, and social progress challenged men's imagination and took preeminence over the arts. Education, of course, reflected the standards both of the Puritan-frontier community and of these nineteenth-century interests, and though educational concepts have changed, many of the old attitudes and practices still prevail.

Until very recently American educationists have been interested pri-

marily in the physical and social sciences. The fields of study relating to technological and commercial progress and to physical well-being have appealed to our pragmatic temperament. The visual arts were first introduced into American public schools because of their practical contribution to learning in other fields. Drawing was taught as a tool useful for the study of science. Design and art history were introduced to train designers to improve the appearance of our industrial output so that it could compete with European products.

The arts have also suffered from a strong anti-intellectual current in American life that started in the frontier communities, where brawn and bravery seemed more important than brain and sensitivity. In the twentieth century the mass media of information and entertainment have reinforced this suspicion of the intellectual. Motion pictures, radio, television, popular magazines, and newspapers glorify the ideal of the "average" man, the athlete, the extrovert salesman, the lighthearted, lucky entrepreneur, and make little of the "egg-head" professor and the artist and thinker who explore new avenues of thought and experience.

The buying and selling phase of our culture, concerned with mass production and mass consumption, profited from the uncritical attitude of great masses of people who were ready to consume endless quantities of easily produced and rather unvaried clothes, home furnishings, machines, entertainment, and even standardized literature and art. Such a success-oriented attitude, with its emphasis on money-getting and quantitative consumption, had little use for individuality, artistic integrity, originality, or self-sufficiency, the virtues that distinguish the artist and intellectual.

This attitude, shared by too many parents and teachers, is communicated to children and does not create an atmosphere conducive to the development of artistic abilities. The child's imaginative life reflects the values of the adult community, and if the community at large admires the athlete, the daredevil driver, and the glib salesman, the child will hesitate to project himself into the role of the patient craftsman or reflective artist. Even the child who loves to paint and draw, particularly as he comes into adolescence, may suffer acute ambivalence, for he knows that the world around him, whose admiration he seeks, places little value upon what he loves.

When one sees the art work of Japanese children, one is inevitably impressed by the sustained interest reflected in the paintings and drawings (Plates IV and VI). In contrast to former methods, Japanese children today are encouraged to paint in a spontaneous, undirected manner similar to that employed in American and progressive European

schools, but their work frequently reflects a complexity and attention to detail in striking contrast to the hurried and relatively undeveloped quality that characterizes much of the painting of American school children. Many factors contribute to this difference, but one important one is the traditional reverence in which the Japanese hold the arts and crafts. The Japanese child can throw himself wholeheartedly into the act of painting, undisturbed by the feeling that what he is doing is considered unimportant by the community at large.

Other inhibiting influences, in both the home and the school, stem from a lack of familiarity with the nature of children's art work. Too often vigorous expression is repressed in order to develop a sterile precocity involving the ability to copy, a practice that can completely sap inventive power in children. Similarly, setting up mature aesthetic goals by stressing the need for balanced compositional arrangements, rhythmic repetitions of line and pattern, or systematic planning of color harmonies can be inhibiting to the free flow of images and ideas, as can be an overemphasis on habits of neatness and high standards of craftsmanship. Such qualities may be desirable, but only when the child feels they are needed to express what he has to say, when they are not restrictive, and when they do not become ends in themselves.

Interestingly enough, the idea that the arts are an unstable professional field also influences parents to discourage the artistic expression of their children, as does the whole lurid concept of Bohemianism. On the other hand, an artistic environment can at times be an equally inhibiting factor. Very often the presence of a professional artist in a household, or an overemphasis on techniques in the classroom, arouses in the child a too critical attitude toward his own work. The child feels in competition with the adult, or feels inept, and ceases to participate in artistic activity. I know of one artist whose child refused to paint because he felt that his pictures were "not good enough to mat and frame like Daddy's." The artist's wife, seeing the problem, took down a large framed picture by the father, replaced the painting in the frame with one of the child's, and hung it back in the same spot. This gesture reassured the child as to the worth of his own work, and he resumed painting, drawing, and modeling. However, the sense of competition still caused certain emotional conflicts, and he finally concentrated on clay modeling (a medium that his father never used) and achieved some very interesting work.

Inadvertently, then, we often say or do things which make a child feel that he cannot paint or draw or build or make things with clay. When this happens he ceases to participate wholeheartedly in these activities, and emotional blocks are set up that inhibit artistic expression.

As time passes, this negative attitude solidifies into what is known as a lack of ability or talent. Almost every college teacher of art can recall a talented student who ceased to draw and paint in childhood after some teacher had laughed at or had been unduly critical of an early effort.

Talent and Achievement

What about the talented child? First, let us distinguish between talent and genius. The dictionary defines talent as "a special natural ability or aptitude" and the talented person as one who is "gifted, clever, accomplished." Genius, on the other hand, is defined as an "extraordinary capacity for imaginative creation, original thought, invention, or discovery." Often contrasted with talent, as implied by the word "extraordinary," genius is rare and undoubtedly the result of an unpredictable configuration of fortunate and even unfortunate circumstances. Probably it is not possible for the home or school to provide the circumstances that produce geniuses. The most we can do is to create an atmosphere favorable to the fruition of abilities and to welcome invention and discovery even when it challenges and upsets established standards.

Talent, on the other hand, is abundant, and the culture which encourages talents creates the atmosphere in which genius can flower. There are certain popularly held ideas about talent that need refuting. In the first place, talent is not a rare and special aptitude that runs in certain families. Talents are not inherited; there are no genes by which artistic abilities are transmitted from parents to children; and the so-called talented child is often a child with only an average endowment of the intellectual, emotional, and physical attributes of the artist. The talented child, simply enough, is a child who has received, for one reason or another, sufficient satisfaction from a certain kind of activity to participate in it more frequently and with more intensity than most children in the same age group and so has developed his capacities beyond the average of his group. When a child receives intense satisfactions from an activity, either because of the admiration he receives from adults and other children or because of a personal pleasure in the results, an ego-centered cycle of dynamic development is set up. Increased activity creates above-average performance, which results in more satisfaction, which results in more participation. Before long the child's abilities have developed far beyond those of most children of his age, and consequently his interest in the activity is greater than theirs. This is called talent.

The talent cycle operates in all areas. One child finds himself effective in catching a ball. His facility gives him pleasure and elicits the

admiration of his playmates, and so he concentrates his energies in this area until he is exceptionally skillful. Another child gets satisfaction from making models or from singing. In each case the talent will develop most readily if the child has an average or better endowment in the particular muscular, intellectual, and emotional capacities demanded by the particular activity. The ballplayer needs physical coordination, the singer a sense of pitch and good vocal cords, the young painter needs good eyes and average manual dexterity, but the importance of these physical attributes can be greatly exaggerated. Very often a child develops a great skill in the attempt to overcome physical inadequacies. What the young artist needs most is a love of pictures, particularly the activity of making pictures. When a child has the love of picture-making, good eyes, and a high level of intelligence, he has a rich endowment that should bring abundant satisfactions. This endowment is certainly not rare.

The child who achieves a high level of competence in any area derives certain very important satisfactions from his performance. He receives attention and approbation both from other children and from adults. What adult has not witnessed the healthy, calm satisfaction that radiates from a child when he finally swims across a pool alone, catches a fly, or takes part in a theatrical performance? The child knows within himself that he has earned this attention and approbation through his own persistent pursuit of the activities he loves. That is why talents are important.

There is almost no relation between children's interests or talents and adults' ways of making a living. Talents are important for most children, but not vocationally. They constitute areas of experience in which the child achieves a high level of competence and thereby exercises his physical, mental, and emotional facilities to the maximum. They are the means by which he expresses himself as a personality in interaction with the things and people that make up his world. The habit and experience of absorbing oneself completely in an activity and of affecting people and places to the maximum of one's abilities is important: the capacity to do this constitutes success in life for most adults.

Talents, then—and the word simply means an above-average level of achievement—provide young people with the opportunity to experience success, and this is a most important childhood experience. Not only are the emotional satisfactions that result from talents and successes important to the child, but each kind of activity in which a child participates develops different potential sensitivities, awarenesses, and understandings. Just as, during childhood, all the bone, muscle, and nerve potentialities of a body should be developed to the maximum, so all the

capacities of the individual for experiencing and expressing must be developed before the full maturing of the personality can occur. Each area of artistic expression concerns itself with certain fundamental areas of human experience, and all children are capable of finding many types of artistic activity through which they can express themselves meaningfully. Drawing, painting, modeling, and carving are visual and plastic arts, related to our seeing and tactile experiences, and through these means of expression our seeing and feeling experiences are intensified and our understandings of what is seen and felt are clarified. Drawing an object for the first time, or modeling a form, is like acquiring a new word to describe a new experience; it helps to define, describe, and intensify the experience. When a child paints a pink flower, a crystallization of experience has occurred whereby he knows both pink and a flower more consciously than he ever would had he never made the painting. When a child rolls out his first ball of clay he knows roundness with the same fullness of feeling. By drawing, painting, and modeling, he will come to know the world he sees more intensively and extensively. Similarly, participation in any other kind of art activity quickens and develops awareness and sensitivity.

Children's Art and Understanding Children

Not only does the child come to know the visual world more keenly by drawing and painting it, but the parent and teacher can come to know the child better by observing his drawings and paintings. When one can read the works of art created by children, one has acquired new insights into children's feelings and ideas.

A woman in my neighborhood was very piqued by the fact that her six-year-old always painted mother much larger than father. Had she realized the significance of size in a child's drawings she would have understood that father seemed much the less important parent to the young artist. The contents of a child's pictures, the way they are drawn and painted, and the changes that occur in the pictures over a period of time all provide new avenues for knowing the child. Psychiatrists have found that children censor their drawings in other ways than they censor speech, and consequently many of the symbols that appear in children's artistic expression can help us understand children and their problems.

Although both parents and teachers must guard against turning into amateur psychiatrists, it is important to recognize that many insights into the child and his environment can also be gathered from his general attitude toward art activities. Undue fastidiousness, which can

make a child reject finger painting or clay modeling, may stem from a general emphasis on cleanliness, or its roots may go deeper; for instance, it might relate to overzealous toilet training. An unwillingness to paint may reflect a fear that clothes will get stained, or may grow from other middle-class preoccupations with taking care of worldly possessions or "looking nice." The premature emphasis on academic disciplines as preparation for college entrance examinations turns many youngsters from the arts during junior high school years, particularly in college-oriented school systems. A conspicuous preference for "messy" activities or a tendency to turn painting or modeling into an orgy of smearing may indicate emotional problems, but it is important to remember in such cases that the activity provides not only insights into the personality, but, more important, a valuable release for conflicted feelings that might not otherwise find outlets (Fig. 5). The degree to which each child conforms to or deviates from established norms is meaningful, if we have the training and sensitivity to interpret the complexities of child behavior. For the teacher it is important to remember that the school norm may not be that of the home and that performance in school, in the arts as in other areas, cannot be interpreted meaningfully without considering the home background.

Play and Design

Children play at arranging their environment even more readily than they paint and draw. "Playing house," for instance, involves arranging rooms, setting tables, and imitating many other aspects of adult housekeeping. The intense and uncritical imagination of children permits them to manipulate "junk" materials—cartons, crates, empty cans, and a thousand other household discards—and to transform them into any desired objects. Any such play-arranging or play-manipulation involves choosing and using colors, forms, textures, and materials, and as such is a design activity and a precursor to planning a room, a garden, or a home. With wise guidance such activities can start important habits of shaping the environment with logic and taste. In the same way, any small bunch of flowers that a child brings his mother can be an artistic experience for him, particularly if every pattern and leaf, petal and stamen, is observed, and every color shading noticed and enjoyed.

Knowledge and Guidance

Many adults encourage children to draw, paint, model, or carve; and they do so for a variety of reasons. Some hope to see the children reach levels of achievement which they feel they have missed. Many, hap-

pily, have an intuitive sympathy with child life and love the things children say, do, and make. They love the scribbles of a child in the same way that they love watching the grim determination with which a child hammers nails into a piece of wood. They provide paints and plasticine as they provide toys, books, and phonograph records, because they feel good when they see children busy and happy. People like this, seeing the child occupied, feel secure about his development even though they have no particular understanding of what he is creating. But love and sympathy alone are not reliable guides, and even the most sympathetic adult can make serious mistakes in handling a child. Just as physical, social, and mental factors determine the character of children's play and make a pounding toy logical for one age and a doll better for another, so similar factors determine artistic activities. There are definite levels of artistic maturation, and these influence the selection of media, the size of papers and brushes, and the kind of experiences that will be most effective in stimulating the efforts of the child at any particular time. The uninformed person can initiate the premature use of water colors or provide small crayons when large ones would be more logical. Even more important, he can unwittingly say and do things that will restrict and inhibit the child's expression.

Today we are beginning to understand the artistic development of children. Psychologists, artists, and educators have been observing children and systematically studying their work for almost forty years, and much is now known about the pattern that a child's artistic development usually follows. The relationship of the various levels of development to the maturing personality is also more clearly understood, as well as the social and psychological factors that contribute to individual differences and preferences. While a knowledge of the levels of a child's artistic maturation is essential, we must at the same time recognize the wide range of individual differences that grow from social background and personal experiences. There is nothing more harmful to artistic expression than standardized expectations of behavior.

In the past twenty years the importance of the arts in providing meaningful outlets for people in all walks of life has become ever more evident. As our means of production become increasingly mechanized, jobs and professions more routine, leisure more universal, and entertainment increasingly dependent upon the passive consumption of standardized television programs and movies, more and more people appear to seek the satisfactions that come from an active engagement in some personal creative activity. Doctors, lawyers, housewives, business and professional men and women all over the country, are involving them-

selves in painting, sculpting, acting, writing, craft and "do it yourself" activities, for they find that these activities fulfill important needs that are not answered by their professional and family lives, even when these lives bear every sign of success. The following chapters, therefore, are devoted to presenting in simple, nontechnical language whatever knowledge is available about guiding children's artistic development, not so that our children may become professional artists, but so that they may mature as well-balanced adults in a society that will consider artistic expression a natural attribute of all people, young and old.

Summary

Many people employ adult standards in judging children's paintings and drawings, thereby misjudging the educative function of the activity. Children's art expression, like all other forms of play, provides a means whereby children explore the surrounding world and grow intellectually by transcribing their sensory experiences into symbols.

Despite a general increase of interest in the arts in the past two decades, many social attitudes still inhibit the free expression of artistic impulses. Puritan concepts, frontier attitudes, and the American belief in mechanical, engineering, and scientific progress have turned educators away from the arts. The mass media of communication and entertainment have tended to equate democratic values with anti-intellectual and anti-artistic trends. Many adults feel that art experiences are only important to children with sufficient talent to justify considering the arts as vocations. Many misconceptions exist concerning the special nature of talent, thus overlooking the emotional importance of doing something well for its own sake, irrespective of eventual professional goals. Art activities provide not only avenues for discovery, self-expression, and creative behavior, but also habit-forming disciplines that lead to a more fortuitous arrangement of the environment. They also give adults a valuable insight into those areas of concern that children may repress in verbal communication.

In the past thirty years children's artistic expression has been studied, levels of maturation have been discerned, and factors that inhibit or stimulate the growth of children's abilities have been identified. This information now makes it possible to direct and encourage children's expression in a meaningful way, for unless work stems from the natural growth of abilities, it will have little constructive effect on personality.

III PRESCHOOL YEARS:

FROM SCRIBBLE TO SYMBOL

SOMETIME between the ages of two and four most children start to scribble. They scribble with anything they have at hand and on anything convenient. To them a wall seems as good as a blackboard, a stick as good as a crayon. These first scribbles are related to drawing and painting in much the same way that a baby's first babbling sounds are related to speech. The baby enjoys the newly discovered ability to make sounds; the child enjoys holding his stick, pencil, or crayon, and pushing it, pulling it, rotating it, and, most of all, making a mark with it.

Two to Four: The Scribbler

The first scribbling is little more than an output of undirected energy. There is neither the desire nor the ability to control the marks, the lines go in all directions, and the young artist probably has not discovered that the movements of his hand and the marks on the page are related. As the child's muscular coordination improves, the scribbling becomes more purposeful and systematic. He discovers that the marks on the page are related to the movements of his hand, and this discovery leads to an attempt to control the direction of the scribbled lines. The very simple satisfactions that grow out of the first scribbles, the pure kinesthetic pleasure of holding a pencil or crayon and moving it about with abandon, give way to more complex satisfactions. The child experiences the pleasure of seeing the lines that he is making go in the direction that he wishes them to go. The scribbles at this stage might be called controlled scribbles; the lines can go up and down, sideways, or may even be predominantly circular (Fig. 7). Whatever directional control the child achieves is repeated many times, since he derives a great sense of pleasure from this accomplishment. Since the development of motor control and muscular coordination is one of the child's

major growths at this age, the complex act of holding a tool, making it go in certain directions, and watching the emerging lines follow the dictates of his will is an important achievement. It represents a big step away from the undirected movements of the baby toward the controlled physical and imaginative activity of the child. Therefore it is important that the scribbling be encouraged, the controlled and directed lines admired, and the scribbler given materials that will facilitate the activity.

The Scribble Is Identified

Sometime after the scribbling has become controlled, the child begins to tell stories while he is scribbling; now the scribbling represents a kind of imaginative play activity. This play may result from seeing an imagined similarity between the lines put down on paper and an object seen in the outside world, or the child may be influenced by having had adults show him pictures and talk to him about the objects in them. When the child starts to tell stories while scribbling or identifies the scribbles with objects or actions, another important step in his maturation has occurred. He has ceased to think like an animal, exclusively in terms of actions, and has begun to think in man's terms of images. This represents a significant advance toward verbal and symbolic thinking.

An adult, looking at a child's drawing at this level of development, will probably be unable to interpret it. The child, however, should not be made to feel that his scribbles are indecipherable. A simple "Tell me about your picture" will handle the situation: the child will talk proudly and happily. Talking about the scribble picture to parent or teacher is a fine experience. The child will feel their interest and pride in his work, and the adults will discover what experiences are important to the child at the moment. Talking about the paintings will encourage further imaginative play painting.

The shift from scribbling while telling a story to setting out to describe a particular event by means of specialized and directed scribbles comes next. This step often occurs as the result of a particularly impressive experience. A friend of mine spent a week end at a beach resort with her three-year-old son. During an outing on the deserted board-

7. **Cold-water paints, 18 x 24. Age 4 years.**
The unusually thoughtful and sustained character of this scribble painting indicates the importance of the activity to the child. As the child matured, her work showed a strong sense of design, a characteristic already apparent here.

7

walk the child discovered the façade of the Fun House. It was an enormous plaster clown's face with the entrance through a great open red mouth. A circle of painted and modeled white teeth framed the doorway, and at the base of the entrance, both to enliven the effect and to serve as a protective bumper, there were two great incisor teeth modeled in plaster. The child was delighted, and the mother happy to have him while away half an hour there. He climbed on the plaster teeth, sat on them, and jumped from them, he was held up so that he could look through the window eyes, and he felt the great plaster nose. The experience was intense, exciting, and fully realized. During the rest period before dinner while my friend was writing her husband, she handed the child some crayons and suggested that he, too, tell Daddy about his day. Up to this time the child had never done more than name his scribbles, but on this day he took the crayons and excitedly scribbled a circular head (Fig. 8). From the maze of lines that suggested features, the teeth, the eyes, and the two great protective incisor teeth were clearly indicated. The child was delighted with his mother's surprised recognition of the clown's head and proceeded with great pleasure to identify all the parts of the head for her. After this experience he painted and drew for some time with vigor and obvious satisfaction.

When a child is telling a story while scribbling, one can motivate the activity by asking questions that will achieve a maximum of imaginative thinking in relation to the drawing play. If the child says, "I am going riding," say to the child, "Show me what you are riding," "Show me where you are riding," and "How many wheels has your tricycle?"—allowing time for an answer and an accompanying scribble. The aim here is not to encourage the child to attempt to draw recognizable objects, but rather to stimulate the maximum realization from the play situation.

Four to Six: The Symbol Appears

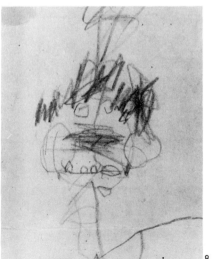

We have seen how undirected scribbling gives way to more directed and controlled activity. The next step occurs when the child begins to experiment with translating experience and concepts, both personal and vicarious, into pictorial symbols. This phase, corresponding roughly to the nursery-school

8. Crayon, 8 x 10. Age 3 years, 4 months.
An intense and exciting experience stimulated this child to make his first representational drawing.

8

and kindergarten years, is characterized by uneven development, by rapid growths, regressions, and great fluctuations in the character and completeness of the symbols. Following this searching and unstandardized period, many children move into what Viktor Lowenfeld called the "schematic" stage. The schematic stage often begins in the fifth year and has two chief characteristics: first, the frequent repetition of fairly standardized symbols for the human figure and other forms (Figs. 15 and 16), and, second, the arrangement of figures and objects along a base line at the bottom of the picture (Figs. 15, 16, and 19). There are, of course, great variations in the ages at which children enter and leave these various levels of development (compare Figs. 8 and 9). Many children start to scribble before two and are working according

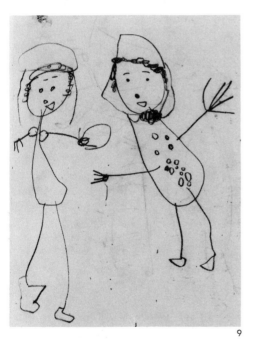
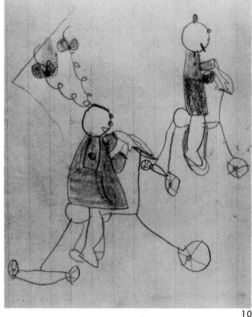

9

10

9. Pencil, 8½ x 11. **Age 2 years, 8 months.**
10. Pencil and crayon, 7 x 8. **Age 4 years, 5 months.**
11. Pencil and crayon, 7 x 8. **Age 5 years, 6 months.**
 These three drawings, all by one child, reveal astonishing precocity. The sketch done at two years, eight months, would represent very satisfactory expression for a six-year-old. The drawing done at four years, five months, reveals an amazing ability to suggest action and to present a complex space concept. The beginnings of perspective appear in the wheels of the tricycle. The third drawing was done about a year after the second. The figure concept has become more standardized, but the variety of costume and gesture indicates that the artist remains observant and imaginative beyond her years.

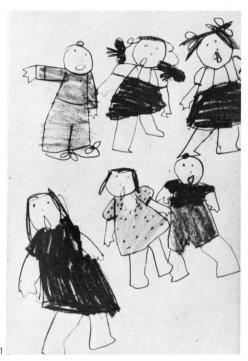

11

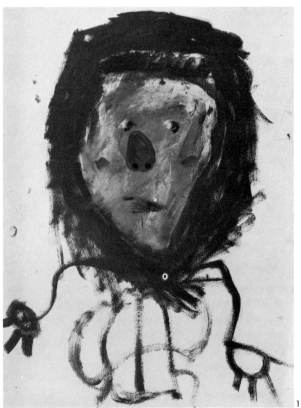

12. **Oil on cardboard, 18x24. Age 5 years.**
13. **Crayon, 12 x 15. Age 5 years.**
Two representations of a human figure by a five-year-old. In each case the motivating idea determined which aspect of the human figure would be stressed. Mother (Fig. 12) is a face with body hardly indicated. In Figure 13 a new cowboy outfit inspired a self-portrait with checked shirt, leather vest, and gun.

12

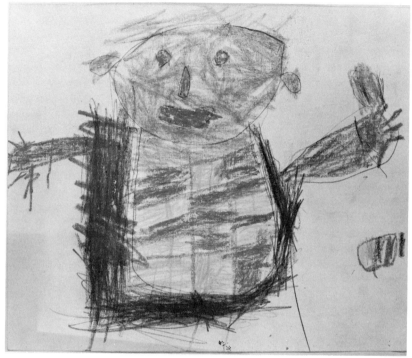

13

to a definite schematic plan by the time they are five; others start late and mature slowly. The ages indicated in this book represent an average development based on the observation of many children and the opinions of many art educators. The period between the identified scribble and the standardized symbol, the nursery-school and kindergarten years, is now our particular concern.

General Characteristics of the Four-to-Six Period

An examination of a number of drawings and paintings done by children ranging between four and six years of age reveals the following characteristics: The favorite subject is the human figure. The people most often drawn are self, father, mother, brother, and sister. Children attending nursery school or kindergarten often draw teacher. A person is usually represented by a circular head in which eyes, nose, mouth, and ears may or may not be indicated (Figs. 11 and 12). Attached to the head are arms and legs with or without hands and feet. The head is usually about the same size as the rest of the figure, although

occasionally a child draws very tall, bean-pole figures with tiny heads. Figures are usually drawn fullface.

This somewhat standard figure is subject to innumerable variations, additions, and subtractions, depending upon the child and the stimulus of the situation being described. Although a body is usually not indicated, it may be drawn with considerable emphasis if the child feels that it is relevant (Fig. 13). One little girl who had never drawn more than a head with arms and legs suddenly began to put a large body in pictures of her mother even though other figures remained bodyless. It turned out that the mother was expecting a baby, and the pregnancy had been talked about at home. At this age, size is a natural expression of importance. A drawing of a boy holding his dog on leash has only one arm with one very large hand attached to it. Obviously the hand that had received the strain of the dog pulling on the leash was the part of his anatomy of which the young artist was most conscious.

A child at this age feels no need to describe the setting in which an action takes place. The figure is drawn without a background and is most often placed somewhere near the center of the page. Whatever properties are necessary for the action being described are placed around the figure, seemingly according to random impulses (Fig. 26). In one painting all the objects will be firmly placed on an imaginary ground line, while in the next painting the same objects may be scattered all over the page with no upside or downside apparent in the picture. Houses, animals, trucks, automobiles, brooms, vacuum cleaners, trees, flowers—any of the many objects that make up the four-to-six-year-old's environment—may appear in his drawings.

Imagination, or the ability to form concepts beyond those derived from external experience, plays little part in the artistic expression of this age. A four-year-old nephew of mine amazed his family by drawing a very fine stagecoach, an object that he had certainly never encountered in real life. His puzzled mother finally discovered the source of his inspiration—a television Western that had featured an old-fashioned stagecoach robbery. While television may provide a child of this age with motives for his drawing, static pictures seldom influence what or how he draws.

An adult who had not thought about the drawing and painting activities of small children might assume that the absence of correct proportions and the omission of details are due to a lack of manipulative skill. This is not so. The child artist, like the adult, creates the symbols relevant to his expressive purpose. Change appears in the child's artistic expression as his purposes and his comprehensions of the world change and mature. If and when his interest in the visual world becomes more

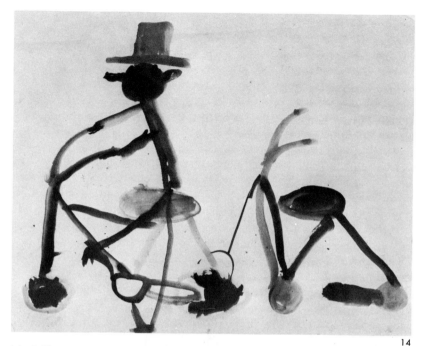

14

14. Cold-water paint, 18 x 24. Age 5 years.
 Though "Riding My Tricycle" has been painted with free, sweeping lines, the
size and placement of objects has been controlled in relation both to one another and
to the paper on which they are painted. The use of a large piece of paper, a big
brush, and cold-water paints has encouraged this child to paint with full arm and
hand movements, at the same time to counter freedom with control.

objective, the proportions in his pictures become more accurate. Each
year brings increased intellectual and analytical powers, and with them
comes the ability to see relationships (what the psychologists term the
ability to sort and arrange visual data). This ability to relate ideas and
experiences (primarily to self) is expressed in a number of ways. Ob-
jects become more related in space, cease to be helter-skelter all over
the page, and tend to be grouped around a central figure or arranged
along a ground line (Fig. 14). An increased amount of detail is inte-
grated into a drawing. Sizes of figures and objects are more related to
one another and to the size of the paper. A high level of intelligence
frequently expresses itself in an early development of these character-
istics. Figures 9, 10, and 11 would represent a precocious development
even in a child four or five years older than this artist. Such artistic
precocity is in essence an expression of interest plus a very high level
of intelligence. It is exciting to see a young mind seeing and relating
so clearly.

Have you ever watched a five-year-old paint, clutching his brush firmly, face close to paper? Completely absorbed in his activity, he works deliberately, without hesitation and without hurry. This young artist is serious for a very good reason: his drawing, painting, and modeling activities are one of the many ways by which he comes to know and eventually gain control over the human and physical environment. Each symbol he creates represents an act of evaluation, a process of selection, emphasis, and suppression, by means of which he isolates and defines his world from the overwhelming welter of sensations around him. By this process of selecting, emphasizing, and suppressing he reduces the continuous flux of sensuous impressions that make up living experience to a few patterns that can be controlled; and in so doing he objectifies and individualizes his experience. First he selects the objects that constitute his world (most of the drawings done by children between four and six are of human beings). Then these objects are reduced to what for him are their essential elements (a human is usually a head plus arms and legs). Because at this age experience is limited, many objects are unfamiliar and therefore incomprehensible. The child cannot portray what he cannot comprehend. Studies have shown that a five-year-old can draw a circle best if it has two eyes, a nose, and a mouth in it: he can understand the circle head, but the abstract circle that means nothing is difficult to understand and therefore to draw. By the same token a jellyfish is incomprehensible except as a human symbol with some jellyfish-like protuberances (Fig. 15).

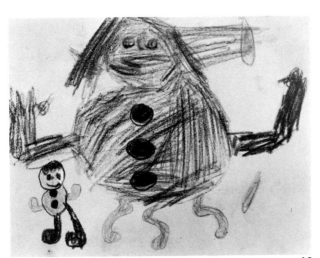

15

15. Crayon, 8½ x 11. Age 5 years.

"The Jellyfish" was inspired by a trip to the beach. Small children often identify an object by only one differentiating detail, hence the jellyfish has only the wavering legs to distinguish it from a person. The creature in the left-hand corner is an ant, smallness being the characterizing factor.

One of the chief characteristics of this period is the unsettled and unsystematized nature of the child's artistic expression; this is, in fact, one of the differentiating factors between this level of development and the six-to-eight-year period. At the six-to-eight-year level children stay with a one-symbol method of drawing a figure, house, tree, or whatever it may be, until there is a very good reason for changing the symbol. However, the four-to-six-year-old often shows erratic changes, astonishing developments, and equally surprising retrogressions. He will seem to have discovered that a human head is best characterized by eyes, ears, nose, and mouth, only to revert to scribbling a featureless face for months. He will establish a systematic space relationship between objects for a while and then revert to a disorganized scattering of objects across the page.

The same variability can occur during the evolution of a drawing. The child may start to draw one thing, the drawing suggests something else, and before we know it, a subject is being depicted entirely different from the one originally contemplated. Helga Eng has given us a very charming description of this imaginative variability in *The Psychology of Children's Drawings*.

> She first drew a circle in the middle and called it a "naught." But after looking at the shape thus produced she said: "It's a coffee pot." She then put a handle on the coffee pot, looked at it, and said: "No, it's a lady with a flat head." She then forgot the head, the handle was already there, and drew another head with eyes over it. She then took the legs in hand. "Just look what ugly legs she has." She joined the legs beneath with a cross stroke; the form thus produced reminded her of the handle of a perambulator and she continued: "The lady is lying in a perambulator, they are pulling it here, she is lying in a fur." Thus, in the same outline, all these different things—a naught, a coffee pot, a fur, a lady, a perambulator—were finally combined to form an impossible picture, a lady lying in a perambulator.

Children at the four-to-six-year level display an equally whimsical approach when drawing specific objects. A drawing of a dog can be changed to a chicken by adding a beak. The four legs will not be disturbing, nor the lack of feathers or any of the other doglike qualities. In the same way a square can be turned into a house by adding a window. If the window is painted out and wheels added, the house becomes a truck. The ease with which the child can change the meaning of a symbol indicates that his ability to differentiate intellectually between objects is very limited and still in a state of flux. He apparently picks out some differentiating detail and in thinking about an object identifies it by this one detail rather than by general differences. The mind is behind the eye.

The role of drawing and painting at this age is clear. The activity serves the valuable purpose of crystallizing visual impressions for the child, putting them into forms the mind can hold. As growth and maturation occur, experience enriches the symbols through which the child expresses himself, impressions become more complex, and objects become differentiated by a multiplicity of aspects. When this happens, the drawn symbols become correspondingly complex, and significant differentiating detail appears. It follows, then, that any kind of stimulation which produces rich and complex symbols contributes to the child's intellectual maturation, since the richness and complexity of the drawn symbols are evidences of growth.

Ways of Stimulating Growth

Research was undertaken by Elizabeth R. Dubin at the University of Chicago some years ago to determine the degree to which stimulation encouraged the growth of abilities in children between two and four years of age. The stimulation took the form of encouraging the children to talk about their drawings to adults. The progress shown by a control group in which there had been no adult participation was compared with that of the experimental group, and it was found that systematic stimulation resulted in a decided acceleration of children's artistic development even at this early age.

The adult's role, however, during these formative years remains that of a catalyzer.

In attempting to stimulate growth there is always a temptation to try to improve the specific drawing—to suggest that a figure has two arms, not just one, to remind the young artist to put features in all the faces. But any suggestions that are made in relation to a specific drawing are irrelevant to the main problem of growth and expression, and there is always the chance that suggestions will be confusing or inhibiting. The only real contribution the adult can make is to provide the child with stimulating experiences and with a physical and cultural environment conducive to artistic activity.

If a child has indicated a desire to draw animals, get a cat and have him hold, feel, and describe the cat. Direct this exploration by asking questions. "What color is the cat? What colors are his eyes, his tongue, and his undersides? Feel his fur, how soft it is! And see how long his whiskers are and how fuzzy his tail is! Feel his ears, his wet nose, the sharp nails on all of his four feet, his strong hind legs." Then suggest that it might be fun to paint kitty. Compare the result with one of his earlier paintings of animals, and you can see what growth has occurred. Notice that many more parts are recorded. At this level, artistic growth

can be recorded quantitatively: the more parts described, the better. The same kind of stimulus will be helpful for painting the human figure. Some morning, make the morning toilet a vivid experience. Talk about washing the face and how good the skin feels after washing, how bright the eyes look, how shiny the teeth. Talk about how the hairbrush feels and how the hair looks after brushing. Discuss the hands, the fingers, the nails; the length of legs and arms. Count the toes and fingers. Discuss other parts of the body. After the child is dressed, suggest painting the subject "I am getting clean in the morning."

If the continued omission of parts in a child's drawing of figures proves disturbing, stimulate his consciousness of the omitted part through play and discussion. If the hands are always omitted, play catch, talk about how the hands come together on the ball, how both hands work when one throws the ball, and then suggest that the child paint "I am playing ball." The suggesting of subjects for painting at this age should be centered upon the child, his activities, and his most familiar relationships. The "I" and "my" should always be used in suggesting a subject for painting, since it helps the child identify his painting with his other play activities (Figs. 13 and 14).

Growth is easily observed at this level of development. The signs are an increase in the number of parts by which a person or object is symbolized, an increase in the number of objects represented, the presence of fewer unidentifiable scribbled parts, and more consistent proportions and relationships between objects. In addition, the drawings are better related to the size and shape of the paper, neither running off the page nor being unnecessarily small or located at the edge of the paper. The child's span of interest increases, so that works of considerable complexity are carried to completion. When color is used, it is used more purposefully and more consistently. The same color will be employed more frequently in the same object or part of the object. The placement of paint will be controlled so that it doesn't dribble or run, and colors will be used pure or consciously mixed to modify their purity. The indiscriminate mixing that occurs when brushes are thoughtlessly placed in the wrong container of paint occurs less often.

Style

Each child has his own distinctive way of working, his "style." Just as the selection of subject matter is a direct expression of the child's reaction to his world, the stylistic aspects are an outgrowth of personality, experience, and even physical make-up. One child will paint with heavy, bold outlines, another with wavering and tentative lines. One makes precise, neat patterns, another delights in great smeary streaks and

blobs. One experiments freely with all the colors available. Another will use only one color, no matter what is being painted, using it over and over again as though afraid of a departure from what he has already tried. Viktor Lowenfeld in *Creative and Mental Growth* illustrates the way in which even physical make-up can be reflected in a child's work. He mentions an instance when "the representative symbol of the human figure developed by a crippled child was distorted on the side which conformed with its own defects."

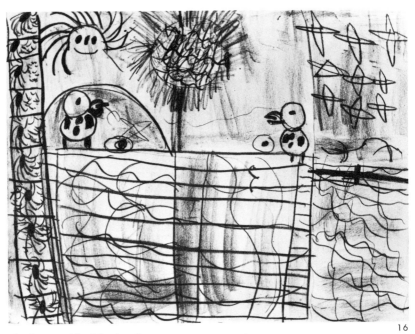

16

16. Crayon, 18 x 24. Age 5 years.
Making patterns by repeating lines and shapes is an important design experience for five-year-olds. Not only does the repetition of certain motifs reveal a feeling for the decorative disposition of patterns, but the division of the paper into dominantly rectangular areas that relate to the page shape indicates an emerging sense of order.

Some children even in their earliest work tend to prefer color and pattern to representation, and will paint circles, dots, chevrons, and other patterns rather than the more usual representational symbols (Fig. 16). Since what children do is influenced by adult activities, abstract pattern-making by children may well appear more frequently now that abstract painting is such an important part of modern art. Children of five and six also enjoy experimenting to test the textural, color, and pattern potentialities of the various media. Colored papers can be torn, pasted in

collage, crinkled, dyed, and otherwise manipulated. Colored cellophanes and tissues lend themselves well for experimenting with transparency, light transmission, and color mixing. Water color can be combined with wax crayon, colored inks can be floated on wet paper, and an infinite number of other explorations to produce patterns and textures can be undertaken. The sensitive adult has to determine what degree of direction, freedom, and control is most stimulating to the particular child or classroom. After experimenting with new media, children should be encouraged to discuss their work, since this is one of the best ways of determining the impact that the activities have made on their aesthetic awareness. Too often the activity is regarded as an end in itself with little effort to get the child to consider the character of the results.

Modeling

Three-dimensional activities are also very satisfying to small children, and the same sequence of development can be observed in shaping clay, plasticine, or other malleable materials as in painting. Three-year-olds enjoy pounding, kneading, and otherwise manipulating materials, and this uncontrolled kinesthetic activity corresponds to the first scribbles. As the child develops the ability to control the activity, a more purposeful shaping of the material will take place; and he will begin to carry on imaginative play as he shapes the clay or plasticine. It will be formed into balls, long, wormlike rolls, or other shapes, and these modeled forms will be played with and named according to whatever object interests the child at the moment.

Between four and six the random shaping of clay or plasticine gradually gives way to a more systematic creation of identifiable forms. Rolled-out pieces of clay will look like snakes or worms to the child; a spherical piece of clay suggests a head, and this suggestion will be reinforced by poking eyes and a mouth into the clay and adding the nose, ears, and other parts. Very crude doll shapes will probably appear next, and often beds, chairs, and other pieces of furniture will be modeled to accommodate the clay dolls. Many modeled forms will be suggested when playing house, such as fruits, vegetables, plates, and cooking utensils. Since children have no prejudices about what constitutes a proper subject for modeling, they will often model trees, houses, and many other objects that adults would not associate with the medium.

The same methods can be used to direct and stimulate growth in modeling as were suggested for painting and drawing. The wise adult will refrain from suggestions for improving specific forms and, instead, will encourage the child to talk about what he is modeling, thus making

the experience more meaningful and complete. By directive comment and questioning the adult can stimulate a greater variety of forms and sizes. "Oh, what a long worm. Can you make a short, fat one?" Or "That looks like an apple. What other fruits would you like to make?" can elicit a greater range of activities than the child might undertake without outside stimulation. The most important part the adult can play is to provide materials and vivid experiences, and establish the habit of giving well-realized expression to such experiences.

Physical Maturation and Art Media

Before the age of six the child has little control over his small muscles; consequently holding and directing pencils or small crayons cramp the hand. Large size crayons are easier to hold and to manipulate; very large pencils with blunt, soft leads are also logical. A large, stiff bristle brush used with cold-water paints or poster paints provides a very satisfactory painting tool for the child. "Cold-water" paints is the popular name for the tempera paints that are specially prepared for children. They come in powdered form and for use they are mixed with cold water to a creamy consistency. They are inexpensive, come in a good range of colors, can be purchased from most art supply houses, and, being in powder form, cannot dry out. Poster paints are made of similar materials, but are more refined and consequently more expensive. They come in jars in a liquid form and dry out if they are not carefully stored; they also spill easily. A bristle brush and the thick, opaque cold-water paints produce vigorous heavy lines, which encourages the child to work boldly. Some of the new semi-greasy chalks are also excellent, since they can be handled freely like colored blackboard chalks and yet are neither so dusty as blackboard chalks nor so hard as wax crayons. Water color is less satisfactory than cold-water paints because the child is too young to control the amount of water added, and with too much water the color becomes pale and weak.

There are contradictory opinions concerning the value of finger painting for this age group (Fig. 17). Those who recommend it feel that having the fingers and hands make marks directly on the colored surface of the page provides the child with a valuable sense of direct control. They also point out that no other medium so easily produces such a wide variety of textures, shapes, and tones, nor so directly channels the small child's love of playing with messy, mudlike material into constructive activity. Those who disapprove of finger painting for this age claim that the child can scarcely distinguish between playing in the paint and playing in mud. There is not the satisfaction of manipulating

a tool, and it is very difficult for the child to distinguish between the lines made by the fingers or hand and the background tone. The validity of both points of view indicates that the question should be decided by the responses of the individual child. If a child seems to respond to finger painting, it should be encouraged. If he is repelled by it or prefers to manipulate a pencil, crayon, or brush, then it might wisely be deferred to a later date.

If a blackboard is available, the child will work on it happily, using chalk, either white or colored. For drawing and painting, large sheets (12 by 18) of absorbent paper such as newsprint are excellent. The back of wallpaper also provides a nice absorbent surface. Rolls of discontinued patterns can be obtained inexpensively from wallpaper stores, and the roll can be cut into convenient sizes.

Up to four or five, most children use color indiscriminately and without premeditation. They enjoy color for its own sake and get pleasure from identifying colors. They do not need a wide range, but should have at least the three primary colors—red, yellow, and blue. In addition to the primaries, most five-year-olds will profit from working with black, white, orange, green, and violet as well.

Plasticine is the most satisfactory modeling material for small children. It is less sticky and messy than clay, needs no preparation, does not dry up, and can be used many times. It comes in a variety of colors and can be purchased at almost any art supply store. Clay also has certain advantages. The objects children model, dishes, fruits, vegetables, if made from clay, can be allowed to dry and harden, and can then be painted and played with. Since clay forms the natural material for making ceramics, clay dishes, ashtrays, and other household utensils can be fired for permanence, thereby introducing children to the ceramic processes.

17. Finger-paint, 12 x 15. Age 5 years.
Finger-painting is unique in that it provides tactile experiences and expresses gesture and movement without an intermediate tool. Accompanied by wise direction, it can introduce children to many decorative and expressive experiences and concepts.

There is an infinite number of fascinating new materials available today for any child or adult interested in the arts. Richly colored and textured papers, brilliant metallic foils, transparent tissues and cellophane, a wide range of paints, crayons, and chalks, new plastic and synthetic media, as well as modeling materials that harden into stone-like permanence, all increase the range of possible activities. A visit to your local art supply house will suggest many exciting and constructive projects for children.

Design and Construction Activities

More than a hundred years ago the importance of constructive play with a rich variety of forms, tools, and materials was recognized and made an essential element in the education of small children. Before Frederick Froebel recognized that rich, sensuous experiences were fundamental to later intellectual development, formal education was almost completely restricted to verbal and numerical exercises. Froebel and his followers broke away from such limited concepts of education, and many of the statements made by the nineteenth-century proponents of the developing kindergarten movement sound like axioms of the Bauhaus, as when Susan Blow says, "We must gain the mastery of material before we can use it as a means of expression" (Logan, *Growth of Art in American Schools*, p. 79). Central to Froebel's educational program were a series of activities organized around the use of colored balls, blocks, rings, and sticks that were combined with various pliable materials to "abstract the essential qualities of objects by the representation of striking contrasts," as well as to "present typical forms" and "stimulate creative activity" (Logan, p. 77).

Much of the repertoire of contemporary play school and primary grade activity was envisaged in these early programs for small children. Working with colored papers, sewing, weaving, folding, intertwining, and perforating, as well as drawing, clay modeling, and building, were all envisaged as means of achieving "a harmonious play of heart and mind in actively educating" (Logan, p. 75). Elizabeth Peabody, another nineteenth-century proponent of education through activity, points out that "childish play has all the main characteristics of art, in as much as it is the endeavor to conform the outward show of things to the desires of the mind."

The rich variety of play materials available today, far beyond the dreams of Froebel and his followers, can be used to encourage almost limitless experiences with form, color, and texture. Building, assem-

bling, taking apart, arranging—selecting like forms, unlike forms, creating patterns—all can be used to provide children of preschool and kindergarten age with important aesthetic experiences. Arranging and building with blocks, boxes, and furniture provide the first opportunities to experience squareness, roundness, straightness, height, regularity, irregularity, heaviness, lightness, similarity, variety, balance, and stability, as well as an endless number of other qualities. In observing colors, children can be made conscious of brightness, dullness, lightness, and darkness in relation to the primary and secondary colors—red, yellow, blue, green, orange, and violet. When handling materials, children of this age can be helped to sense simple tactile qualities such as smoothness, roughness, hardness, and softness, and they can also experience some of the elementary structural characteristics of various materials.

As before, the adult's role is that of a catalyzer. The wise parent or teacher provides the materials, stimulates activity, and intensifies the consciousness of what is being experienced. When the child picks out some of the square blocks, sit down and help him experience squareness. Encourage him to pick out all the square blocks, to show you which blocks are almost square, which blocks are least square. Help him find out if square blocks build well, if they fall over easily; have him count the sides, count the corners; have him try to roll them, try to push them. By intelligent direction very simple experiences can result in a tremendous awareness of qualities that otherwise may remain only partially realized throughout life.

It is interesting to ask a group of adults to list the differences between paper and cloth. Many, for the first time, will put into words concepts of which they have been half conscious all their lives. If, in childhood, they had consciously experienced paper versus cloth, had thought of how many things can be done better with paper than with cloth, and vice versa, they would probably have used both materials more effectively throughout life and would certainly have appreciated their properties more fully. Curiously enough, most people must be directed by conscious analysis to become aware of materials: that paper folds and tears, that cloth drapes and is hard to tear, that stone is smooth, heavy, and hard, that wood is dry, feels friendly, and occasionally breaks. The more fully the child comes to know the world about him, the more prepared will the adult be to live in this world. In our day of cosmic ideas and atomic machines, we are inclined to forget the intimate materials and sensations that make up our immediate surroundings.

A Favorable Environment

A love of pictures is the first step in art appreciation. The picture book can be an important factor in building the habit of looking at and enjoying pictures, but its mere presence in the hands of a youngster does not ensure that its full potential as an agent for growth will be realized. The things parents and children do together, the shared experiences, are the most important habit-forming acts. Too frequently a child is given a picture book to look at in order to free the parents from having to read to the child. In such circumstances the picture book can be an unhappy substitute for the warm fun of being read to. Even when children are happily engrossed in looking at pictures alone, their responses may be less complete than when the seeing is shared, for the shared experience intensifies discoveries and enthusiasms. Such simple remarks as "How many things can you name in the picture?" and "How many colors do you see?" stimulate a more thorough observation and digestion of the visual experience.

Observation of small children reveals that they tend to look myopically, and this close-up scrutiny is best satisfied by pictures with much detail. The content of pictures is much more meaningful than the style of illustration, which often appeals more to the adult buyer than to the child user, the most meaningful subjects being those that relate to the child's own experiences. Thus pictures of foreign lands mean far less than those picturing familiar sights, and much of the imaginative whimsy served up in children's books fails in its intention of stimulating the imagination.

It is extremely important at this age that the child have a suitable place in which to work. The two-to-six-year-old still has little control of his gestures and movements, and lacks any conventional sense of where paint or clay is welcome and where a nuisance. Consequently, he is capable of creating an astonishing mess. A friend of mine left two children painting in her patio for a few minutes. She returned to find they had abandoned their paper and had happily painted the side of the house and the pad for the chaise longue with bright red smears. Since it is important that the painting activity be vigorous and uninhibited at this age, the place where it is done should be one that can be cleaned easily or does not require cleaning regularly. Clean water, paint rags, a wastepaper basket, and a place for washing hands should be nearby.

Both at home and in the nursery school and kindergarten, simple, sturdy tripod easels function very effectively. Since they are easy to

fold and store, they do not occupy space permanently. They permit the child to stand erect and move his hands and arms freely, and thereby contribute to a broad and uninhibited style of working. They enable children to view their own work from a distance and thus to see big relationships, and they also permit others to view the work while it is in progress, thus encouraging discussion and general interest in the painting and drawing activities. In the absence of easels, children work well at large, low tables or on the floor, and in either case the work surface should be of some material like linoleum or should be protected by a large sheet of oilcloth. These precautions will avoid messes and, more important, will do away with the need to caution children continually. If an activity is hedged in with admonitions and prohibitions, it ceases to be fun and the child may stop working for fear of creating a reprehensible mess. A satisfactory studio can often be set up in a corner of the classroom, on the playground, in a garage, in the laundry, in a bathroom, or in the kitchen.

One of the most important factors in stimulating expression is adult interest, particularly parental interest. Often children will bring home paintings from school only to have the teacher's constructive influence nullified by parental indifference or censure. Drawings, paintings, and pieces of modeling should always be looked at and discussed with the child. There should be ample opportunities to talk about each work, and a portfolio for work should be kept. After each painting session the child should decide, in conference with a teacher or parent, which drawings should be kept and which discarded. Since at school there is seldom time or space for an adequate appraisal of each child's work, parents can do much to supplement and reinforce the influence of school. When the child has indicated that a work has particular interest for him, put it on the wall, preferably in a changeable mat and frame arrangement, and leave it up until a more meaningful piece can replace it. A simple bold frame holding a piece of neutral-colored wall board provides an excellent surface for displaying children's paintings. The area of wall board should be about six inches greater in height and width than the paper on which the child works. This area then serves as a mat. The frame should be bold and simple and, of course, not glassed. Paintings can be attached by thumbtacks or scotch tape. One friend of mine has set up a gallery of children's work in the children's playroom. This has given not only charm to the room, but material for observation and discussion for the entire neighborhood. Many of the neighboring children have contributed paintings and drawings, and very stimulating discussions are held whenever a new picture is put up.

Here group interest provides an unusual incentive to expression, and the art work produced by the children in this area is correspondingly vigorous and fine.

Many classrooms feature an art gallery in a corner of the room, either in the form of a frieze above the blackboard, or in specially designed display space. One teacher whose kindergarten room always produces an abundance of fine art work has established a practice known as "pictures of the week." The entire class participates in choosing which pictures will be displayed, and this particular device contributes to the success of her art teaching.

Summary

The importance of the early years in establishing the attitudes that go to make up adult personality is generally recognized and applies in art as in other fields. If home, preschool, and kindergarten experiences establish the habits of painting, drawing, modeling, building, and looking at pictures as normal play activities, these habits will most probably be meaningful in later life.

Scribbling is at first undirected, later directed, and then becomes symbolic in intent. People are the subjects most frequently represented. A large circle head, arms, and legs serve as standard figure symbols, hands, feet, facial features, and other parts of the body being added as children approach the schematic stage of development. During the preschool years the space relationships between objects tend to be random and unstandardized.

Three-dimensional modeling activities follow the same pattern, starting with undirected manipulating of malleable materials and eventually assuming symbolic intent; this is also true of simple assembling, arranging, and building activities. Adult participation in all these activities intensifies the child's responses. Care must be taken to avoid stressing adult goals (neatness, planning, realism of form, etc.), for these will block the child's native flow of activity. Since at this age children have imperfect muscular control, big sheets of paper, large brushes, crayons, and efficient tools avoid cramping and strain. Art activities should be located where there is a minimum need to be cautious and to avoid messes.

A PORTFOLIO OF
CHILDREN'S PAINTINGS
FROM MANY LANDS

The color plates reproduced here come from many parts of the world: the United States, Ireland, Belgium, Japan, India, Israel, and the U.S.S.R. These countries exhibit the greatest possible contrasts of culture, representing extreme differences in age, economic development, educational traditions, religion, and general ways of life. But though the paintings reflect the differences, they reveal even more clearly the universality of children's artistic expression. With only a little knowledge about children's art one can make a good guess at the age, sex, and sometimes even the temperament of each artist. Although each culture colors the way its children react to their environment, the visual language of childhood remains universal in its power to communicate ideas, experiences, and above all the intensity of feeling with which the growing child discovers the world. All of us who live with children look with nostalgia at the fresh wonder and excitement that seem to be the essence of childhood. Through the art of children we can recapture their delights and also share their evolving perceptions, concerns, and even fears; through their art we can come to enjoy, know, and guide them.

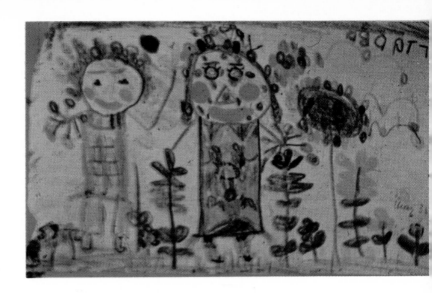

Plate I. The Flower Garden. U.S.A. (*above*)

The identity of the author of this crayon drawing is unknown, but the artist was probably a girl in the primary grades. A stroll in the garden inspired this lover of flowers and patterns to create flowery patterns everywhere, on the plants and dresses, in the hair and cheeks, even in the eyes. The sustained interest with which the gay decorations are spread over the surface of the paper reveals a creative and resourceful child.

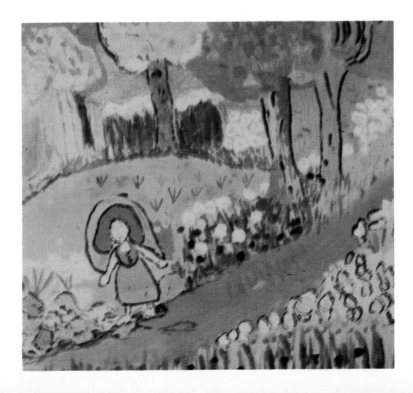

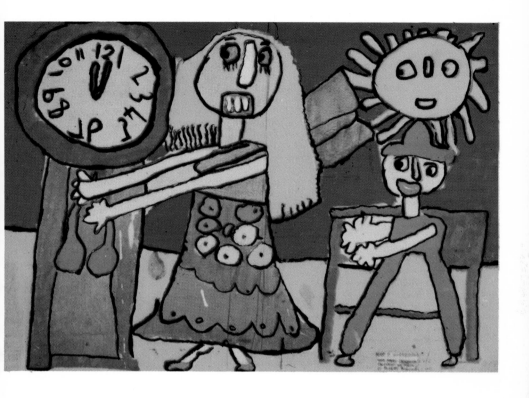

Plate II. Keep It Quiet, Cinderella! Ireland (*above*)

A six- or seven-year-old girl created this vigorous, dramatic picturization of the plight of Cinderella. The unencumbered vehemence of expression found here is remarkable; Cinderella's alarmed face, the fateful hour of twelve, the imploring Prince, all communicate their concern to us, in fact even to the moon. Whereas "The Flower Garden" (Frontispiece) transmits a lyric delight in the poetry of patterns, "Keep It Quiet, Cinderella!" is fraught with drama. Every work of art is the expression of a temperament, and already one young lady finds life pretty, while another finds it exciting.

Plate III. At the Brook. Belgium (*left*)

A nine- or ten-year-old girl created this idyllic pastoral scene. A lucid and untroubled intelligence appears to be at work here. The cool, pleasant color is handled in large, logically disposed masses, firm outlines define the forms, and the pattern and space relationships are clear and unambiguous. The same clear perceptions that are expressed in the firm style of this painting dictate the naturalistic size relationships and the clear separation of front plane, middle distance, and far distance. The prose of fact can be as satisfying in its way as the poetry of fancy.

Plate IV. Mother Sewing. Japan (*left*)

An eleven- or twelve-year-old produced this moving document of family life in postwar Japan. Here depth of feeling transcended limitations of skill and enabled the artist to express the hopeless pity of the child, helpless to do more than witness the tired mother's labors. No facility or calculated artifice softens the sad reality or distracts the observer; instead urgent feelings shape the awkward forms, and the very lack of facility intensifies the communication of feeling. Most Japanese art in the past has achieved its beauty by sublimating such emotions to elegance of calligraphic line and subtlety of tone. Released from the restrictive traditions of the past, the Japanese children of today display a new and enviable vitality of expression.

Plate V. Roofing a House. Japan (*below*)

Again we have no information about the author, and can only guess. A love of activity pervades the painting. Not only is the subject matter taken from active, daily life, but an aggressive energy is exuded by the bold patterns, the lively shapes, and the striking contrasts of tone and color. Even the sky, usually shown by children as a passive, smooth surface, has a radiant, vibrating, dotted texture. These qualities suggest a boy about ten years old, a busy extrovert, who probably sees himself as the small daredevil who walks boldly out on the unsupported board above the roof.

Plate VI. The Red Balloon. Israel (*left*)

A thirteen-year-old boy created this dramatic masterpiece after seeing the French movie of the same name. An innate sense of organization seems to have dictated the arrangement that spirals up through the figures to culminate in the brilliant red balloon. Almost every accepted concept about how to achieve a dramatic composition is violated here. The focal point of the composition is placed in the exact center. The major planes, which tend to lack variety, move back in regular sequence. The dark-and-light pattern also lacks variety. Yet the total effect—intense, undistracted, and unified—has the certainty that comes only when expression results from the spontaneous interplay of thinking and feeling.

Plate VII. The Market Place. India (*below*)

The philosophers of the East believe that life becomes meaningful through detachment. The eight- or nine-year-old child who created this painting unconsciously reflects this attitude by depicting the familiar market place as a thing of wonder, seen from afar. This commonplace scene from daily life is transcribed into an elaborate spectacle in which the drama of individual events becomes submerged in a panoramic pageant. The small, sharply defined forms and bright, hard colors recall the vast processions in which for many the bejeweled splendor of the maharajah symbolized eternal truth in contrast to the squalor and poverty of daily life.

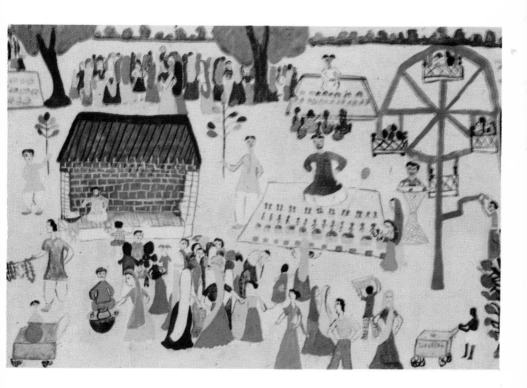

Plate VIII. A Girl's Head. U.S.S.R.

A fourteen-year-old boy painted this water-color portrait. Soviet art teachers have accepted social realism as an aesthetic goal and teach children at an early age the traditional skills and techniques. This sensitive portrait would represent an admirable achievement at any age and in any medium, but for a fourteen-year-old to have painted it in water color is truly remarkable. The control, knowledge, and sensitive objectivity displayed here are worthy artistic qualities, but they are neither more nor less valuable than the more childlike insights and sensitivities revealed in the preceding paintings.

IV SIX TO NINE:
THE SYMBOL IS FOUND

M A N Y important things happen to a child between his sixth and his ninth year. Arnold Gesell, in *The Child From Five to Ten,* puts it this way: "Society has sanctioned the sixth and seventh years for a significant induction into the higher strata of culture. This induction cannot be indefinitely postponed because the child must transcend the limitations of home and also the primitive strata in his own psychological make-up. The race evolves; the child grows."

The event that symbolizes this introduction into the higher strata of culture is, of course, the beginning of regular schooling. Even though kindergarten and nursery school are a generally accepted part of today's schooling, they are still regarded as optional, and the real induction comes with six years and the first grade. With regular schooling comes a gradual adjustment to the broader social world outside of self, family, and home. As time passes, this process takes place less in the schoolroom and more in the community, and eventually the adjustment creates the mature social being. The six-year-old child enters the world a complex psychological being with definite emotional, intellectual, physical, and cultural attributes which, through heredity and the home environment, have been determined by the family. This complex being is now projected into an ever widening social situation, and the habits of social behavior which will be followed through childhood and youth and which, therefore, will determine the kind of adult the child will become are established during these years from six to nine. Habits of play and of work, patterns by which the child entertains himself and others, creative resources that he builds in himself, sensitivities to sights, sounds, words, and ideas—all these elements of the social personality are established during these important years.

Of particular significance are the habits of creativity now developed by the child, habits that contribute immeasurably to his social, intellectual, and emotional development. The importance of creative patterns of behavior in developing originality, productivity, and the ability to think critically, as well as the particular power of the arts to develop general patterns of creativity, has already been indicated. Such habits contribute to a person's effectiveness, no matter what his eventual field of endeavor may be. But in addition to these general contributions to personal effectiveness, the arts contribute peripheral values, often described by the trite and somewhat prissy-sounding phrase "the worthy use of leisure time." Interest and involvement in the arts results in an intense, happy, and absorbing use of time, leisure or otherwise, which is truly educational because it stimulates a development that leads continuously to higher levels of skills and expressive ability. Further, the leisure-time activities of a creative nature become increasingly important as the child matures. They constitute an adult's most valued social acquisition, since excellence in almost any area makes a person interesting to himself (self-reliant) and to others: we can all think of friends whom we like to be with because they are masters of a musical instrument, or they paint, collect, or play a certain game very well.

Parents and teachers, both individually and collectively, determine whether the child's attitudes toward the arts, established during these first years at school, will be active or passive. One child gradually abandons the productive activity that came so naturally to him earlier, and his artistic and intellectual life consists of watching television, going to movies, listening to the radio, and reading comics. Another child writes and illustrates books, writes and produces plays, paints, carves, plays a musical instrument, and collects insects, stamps, and stones. I know one mother who, feeling the children in the neighborhood were not having the experiences in self-expression that she considered important, and not wishing to make her children "different," organized a play period for one afternoon a week in which a number of neighborhood children painted, modeled, drew, and put on puppet shows. Besides the costumes and settings for the shows, the children made Christmas cards, place settings for parties, and many similar things. The project was completely successful. The children were happy to leave the television sets and radios for the creative fun, and the entire project cost less than a weekly trip to the movies per child. It was housed in the garage and required little equipment beyond two large garden tables.

The difference in the amount and nature of artistic activity between homes is no greater than the difference that can be observed between classrooms. Under one teacher's stimulus, rich and varied activities grow from every unit of study. Drawing, painting, modeling, and con-

struction, as well as singing and writing poems, stories, and plays, provide the means by which children give form to their new discoveries and experiences. In another classroom the sole purpose of learning appears to be to enable the learner to answer questions and do assigned exercises. One type of classroom establishes habits of doing something about learning, the other accepts learning as an end in itself, one might almost say a dead-end.

The Figure Scheme

No period of artistic expression has more clearly defined characteristics than the one we are about to discuss. Sometime between the ages of five and six, the "schematic stage," or the "symbolic stage" as it is also called, begins, and this continues to the age of eight or nine. It is characterized by two main features: the use of a standardized formula for representing the human figure and the use of a base line to indicate space relationships among objects in a picture. A third significant development at this time derives from the expanding nature of the child's social experiences. Children at this age draw isolated figures less frequently and reveal their growing interrelationships by picturing groups of people, both children and adults, and interactions between children and things (Plate III).

Every child, having gone through the preliminary period of investigation described in the preceding chapter, settles on his own specific formula for drawing familiar objects and, particularly, people. This formula—the "schema" or scheme—expresses the individual child's concept of a human being in a way that is temporarily satisfying to the child. Consequently, each child has his own scheme, which he repeats many, many times, varying the details but always using the same general formula (Fig. 18 and 19). There are strong similarities between

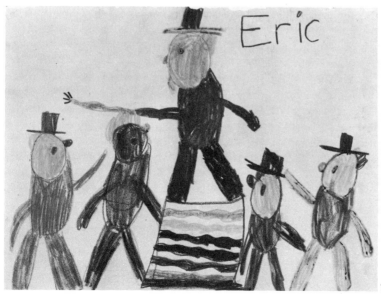

18

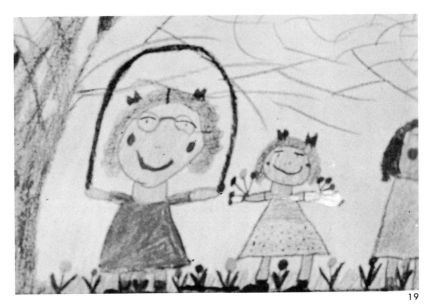

19

18. Crayon, 12 x 18. Age estimated at 8 years.
19. Crayon, 18 x 24. Age about 7 years.
 Two drawings that illustrate the tendency of six-to-nine-year-olds to develop
a standardized symbol for the human figure. This symbol is repeated with little
variation except when some expressive urgency moves the artist to emphasize some
part such as the lengthened arm of the speaker. Both illustrations also show the
arrangement of figures along a base line, usually at the bottom of the page, which
typifies this level of development.

all these figure schemes. Usually they have a large head and a small
body, the arms and legs often remain single lines, and there is no for-
mal indication of clothing. Hands and feet may or may not have fingers
and toes; faces usually have features, although hair, teeth, and other
lesser details may or may not be included. Some children will create a
profile scheme, some will draw the head in profile and the body full
face (as the Egyptians did sixty centuries ago), and most will draw the
entire figure in full face. The various parts of the body are identified
by their placement in relation to the other parts of the figure; the shapes
the child uses are arbitrary and not related to an analysis of what he sees.
The drawing is "ideational," not visual, in its inspiration. As a conse-
quence, there is wide variation in the shapes used for the various body
parts—square, circular, or triangular shapes may be used for heads,
bodies, hands, feet, or features; straight or curved lines, single or
double, may be used for arms and legs. Each child's scheme for the
human figure is an outgrowth of his ideas, experiences, psychological
structure, and physical make-up, and as the child grows and changes,
so must the scheme. Similarly standardized symbols are used for houses,
trees, the sun, and other frequently drawn objects.

Growth: Enlarging the Scheme

A child deviates from his scheme only when it proves inadequate to express either general concepts or some particular experience. The deviations take the form of exaggerating the size of some part of the anatomy (Fig. 18), changing the shape of it, adding details to it, or possibly omitting it. Such deviations, signs of growth, appear when some aspect of the figure has become sufficiently emotionalized or dramatized for the child so as to demand more emphasis. As an example, if a child who has played ball enough to be conscious of the catching act draws a figure catching a ball, he may draw the arm long, the hand large, and even add the extended fingers of a hand about to grasp the ball. The experience and the intensity of interest that the child brings to the drawing stimulate him to go beyond the somewhat passive scheme and to energize, as it were, the symbol of the involved parts. Sometimes elaboration of detail, sometimes changing the shape of a part, will serve the same purpose. The fact that the exaggerations of size or changes of shape create a figure that is unbalanced from a naturalistic or literal point of view should not disturb adults and should not be pointed out to the child or regarded as faults. Instead one must learn to interpret such exaggerations as expressive devices that indicate the expanding interests and awareness of the child. Rather than saying that one arm is too long for the other, one should admire the vivid depiction of a man catching a ball.

When a scheme is repeated without variation for a long time, a sign of a lack of growth, the only valid way of stimulating the child is to project him into new and exciting situations, and then to encourage him to draw and paint these experiences. Departures from the scheme are meaningful only if they grow out of a desire on the child's part to say more than can be said by the prevailing formula. Explicit admonitions to "stop doing the same thing over and over" or "try to improve your figures" will result in blocking his expression or encouraging him to achieve a meaningless copy of some conventional pattern of figure drawing.

The Space Scheme

The second important characteristic of a child's art work at this age is the systematic indication of space relationships. Just as he now begins to employ a standardized kind of figure to represent people, so he also develops a consistent way of relating objects to one another. This relationship is usually achieved by means of a "base line," a line running across the bottom of the paper, which relates all the objects on the page (Figs. 18 and 19). This base line is to the six-year-old what the

horizon line is to the ten-year-old: a symbol of the earth. For the six-year-old the base line provides the support for all human activity. Figures, trees, flowers, buildings, machines, and animals are arranged across the page on this line. At the top of the page the sky is indicated by another horizontal line, and between the sky and the base line of earth are placed birds, airplanes, and the other inhabitants of the air. At first there are very few differentiations of size (people, houses, and flowers are all the same size), and objects are seldom arranged so that they overlap one another. As the child moves toward the next period, space becomes more real, and a rudimentary type of perspective appears. The sky comes down to the earth, the base line moves back and becomes a horizon line, and objects show differences in size and overlap one another more freely.

Just as the desire to express certain actions necessitates deviations from the human scheme, so the desire to express more complicated space relationships leads to deviations from the base line (Fig. 20). For instance, wanting to show the houses on *both* sides of the street, or the two banks of a river, will occasionally motivate a child to draw a base line down the middle of the page so that, by using this central line as an axis, he can draw the two sides of the street or the two riverbanks, one on each side of the new base line. He will usually turn the page as he works, so that each side is up while he is working on it, and very often will put a strip of sky at each "top" of the page. This deviation comes easily to a child because the idea of the top side of the paper representing "up" and the bottom side representing "down" is not yet firmly established. In the same way a child will use a point on the page as a base line and radiate objects in a concentric ring around this point (Fig. 21). The desire to describe the experience of dancing around the Maypole or riding on a merry-go-round may motivate such a concentric arrangement of forms around a base-line point.

The desire to show the inside of a cave, an underwater scene, or an animal burrowing underground often stimulates children to use a kind of X-ray arrangement in which the base line is lifted up from the bottom of the page so as to expose a cross section of the earth showing the underground action. Children frequently use a similar cross-section arrangement to show what is going on inside a building. The front walls are left off, revealing the action that is taking place in the interior.

Two other deviations from the standard base-line arrangements are commonly employed by children. First, a base line will be slanted to suggest a mountain or some other sloping surface, and the objects resting on the slanting surface will be placed at right angles to it. Second, a series of base lines will be used one above another to indicate a se-

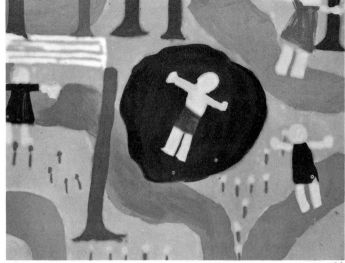

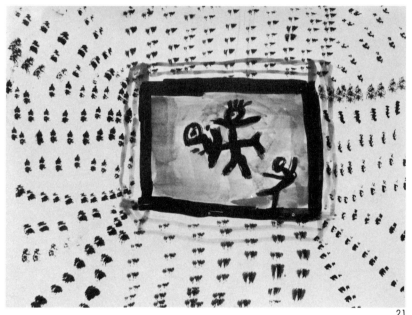

20. Cold-water paint, 18 x 24. Age about 8 years.
21. Cold-water paint, 18 x 24. Age about 8 years.

When a space concept is too complex to be expressed by the usual simple base line, an inventive child will create other systems for indicating space relationships. Thus in "Park Scene" (Fig. 20), the artist employs a bird's-eye view of the swimming pool and pathways, but the people and trees are arranged as though on superimposed base lines. "The Boxing Match" (Fig. 21) uses a central point as the base line, and objects are arranged concentrically about that point. As usual the stimulus toward invention and the enlarging of the repertory of expressive devices grows from the desire to express increasingly complex aspects of experience.

quence of events, a device employed by many early cultures such as those of the Egyptians and the Assyrians and still retained in comic strips today.

Clearly, all these diagrammatic devices for describing space relationships are developed by the child because he is still not ready to use perspective, or, in other words, to be visually analytical in relation to space. It is, emphatically, a mistake to thrust conventional ideas about perspective upon him, either by pointing out perspective in nature, or by showing him tricks such as converging railway tracks or diminishing telephone poles. Since he does not see perspective ("see" in terms of comprehend), he will be unable to incorporate these isolated ideas with his natural manner of drawing, and the inability to reconcile the two ways of working may precipitate conflicts and undermine self-confidence and natural expression.

The wise adult will indicate an appreciation of any imaginative solution of space problems by showing the child that the space ideas have been communicated effectively. When a child uses an X-ray arrangement to show the interior of a house, he should be encouraged by some remark like "That is a fine way of showing what the people are doing inside of the house. I am glad to see that you can invent a way to show anything you want to." The adult should realize that the more inventive the child proves to be in devising ways of suggesting space relationships on the schematic level, the more imaginative he will be on a more mature level. Being inventive, like any other power, grows through exercise. What we wish to develop are habits of creativity and inventiveness, rather than a precocious maturity.

Compositional Relationships

During the six-to-nine period, children begin to picture much more complex situations. Often a picture will have a dozen major objects or will illustrate a quite complex relationship of people, buildings, landscape forms, trees, and animals (Plate I, and Fig. 18). We therefore witness the beginnings of composition during this period. A well-adjusted child, working uninhibitedly, intuitively adjusts the sizes of objects to the size of the page on which he is working and places the objects in relation to one another so that ideas are clearly conveyed. Composition at this level of development might be defined as the direct communication of an idea within the confines of the sheet of paper on which the child is working.

Since the child of six to nine is able to talk about his ideas and may show considerable ingenuity in arranging his compositions, it is easy to assume that he employs a more systematic and controlled set of pro-

cedures than is actually the case. Even trained art teachers make this mistake and assume that primary grade children can be taught to appreciate and use compositional concepts or design elements. These children are often told to try to achieve a balanced feeling, or a rhythmic relationship of line, or to plan the picture so that an interesting variety of sizes and shapes is employed. Or they are instructed to "keep the color bright and cheerful," to "avoid dull and depressing colors," or to "relate parts by repeating certain colors." Because small children do not employ systematic procedures but create intuitively from impulse, this conscious striving for aesthetic values not inherent in the child's natural expression obstructs expression and destroys the vigor of the work.

There are, on the other hand, certain aspects of composition about which something can be done. If a child tends to work so large that his drawing runs off the page, he may have poor coordination and therefore be unable to restrict his drawing to the size of the paper on which he is working. In this case he should be given larger paper, and brushes or crayons that are large enough to be held without cramping the hand. If he still cannot control the sizes, clay modeling might be substituted for painting or drawing, since clay is easy to manipulate and control. When the tendency to wander beyond the boundaries of the page is the result not of poor physical coordination but of emotional turbulence or a generally undisciplined temperament, the emotional release achieved by painting over boundaries and by the violent smearing that often accompanies a lack of control is probably beneficial. In other words, painting beyond boundaries is most likely to cure painting beyond boundaries, and smearing cures the need to smear. It is also important to remember that smeary, vehement work, sustained and brought under adult control, constitutes the kind of direct, uninhibited expression that is the basis of expressionist painting. One cannot help wondering how many potential expressionists, forced to do neat drawings as small children, have been lost to the world.

When the opposite tendency occurs, and the child draws in a small, cramped way or confines his work to a small area in the center of the page, his expression is probably inhibited by fear, particularly the fear of making a mistake or a mess. Any parent or teacher confronted with this tendency should examine the general home and school atmosphere to see if it has not been unduly controlled, with too much stress laid on neatness, quietness, orderliness, and conformity to the desires of others. Occasionally small, tight drawings are the result of using too hard a pencil or crayon, or of painting with too small a brush.

Here again one must guard against standardized adult expectations. Although freedom of execution is generally desirable, some children

gain security from methodical and controlled procedures. By working carefully and systematically they frequently produce complex, detailed, and elaborate works, and gain great satisfaction from such activities (Plate VII). The merit of such work should be recognized, and the child who prefers it should not be forced to work in a way alien to his personality.

The Role of the Adult

Most adults feel a continuous temptation to help children by suggesting more realistic proportions, by adding elements of perspective, and by bringing in other elements of adult realism. Such help should be given only when a child requests it. If a child seems dissatisfied with something he is doing and asks for assistance, it should be provided—but only on a level one step removed from his own level of development. For instance, if a child at the schematic level asks "How big should a man be, compared to a house?" do not tell him that a man would be one-third or one-fourth the height of a house. This would establish a problem of size relationships that would be too complex to maintain consistently at this age level. The adult might reply: "Well, what do you think—a little bit smaller or quite a bit smaller?" Whichever answer the child gave could be affirmed, and he could proceed with this assurance. When a child is disturbed by the gap between the blue sky at the top of his picture and the objects on the base line, and asks "What comes below the sky?" suggest that he look out of the window and notice how the sky "goes behind everything." This will usually help him bring the sky down to the base line.

Adults must remember that the value of the creative act is in direct relation to its expressive power, and that any device developed by the child to increase the expressive power of a drawing represents development. Adults have an unfortunate tendency to conceive of development only in terms of conventional adult values—realistic proportions, perspective, rhythmic or balanced compositions, color harmony, or skillful use of media. All such elements can become the basis for a critical evaluation that is unrelated to children's expression and even unrelated to good adult art.

A very common shibboleth of this type is an undue emphasis on technique. Such an emphasis is almost always a hindrance to free expression. Restrictive procedures such as outlining and filling in outlines with color, or planning on one page and subsequently carrying out the plans on another page, should be avoided. When children are told to use crayon so that the strokes go in one consistent direction, the drawings lose the expressive force that occurs when the lines are directed by the child's feeling (Fig. 13). A crayon drawing is most exciting when

the lines reflect the tempo of activity, when a dynamic scribble in one spot contrasts with a placid and methodical application of crayon in another. Media that demand controlled systematic procedures, such as water color, should be avoided. The runny and blurred effects—so attractive to adults—that occur accidentally in water-color painting can be disturbing to a child when they are not related to what he is trying to accomplish, and to use the medium without any blotches demands more control and skill than children as a rule possess at this particular age.

A child who has formed the habit of expressing himself through paint can produce a tremendous number of paintings with very little outside stimulus. Often one particular subject will be painted many times with almost no changes; at other times the child moves easily from one subject to another. When a child has painted a subject repeatedly with no variation over a considerable period of time, a new experience with the subject may stimulate a change of handling. One child I know painted the front of a house about a dozen times in two months in an almost identical fashion. She seemed happy about the paintings, brought them to her mother for admiration, and showed no desire to paint anything else. On the day she saw her grandmother come home from the hospital in an ambulance, she painted the ambulance and the hospital attendants carrying Grandmother into the familiar house of the paintings. After this event she never painted the house again unless it provided the background for some new action.

When a subject is repeated monotonously, without variations, give the child who loves animals a trip to the zoo, the child who loves boats a ride on the lake. Afterward suggest that the animal lover paint "I pet the pony at the zoo" and the boat lover paint "I row the boat on the lake." The suggestion of a picture subject should always be made so that the child is conscious of himself and his body ("I pet" and "I row") in relation to other people or things ("the pony" and "the boat"), and in relation to other places ("the zoo" and the "the lake"). This method of suggesting a painting topic, by creating a maximum awareness of relationships, is a very effective way of motivating the child's expression. Don't suggest "Paint kitty," but rather "Paint yourself giving kitty some milk in the garden."

Children often follow a period of intense painting activity with a period of indifference. These interludes of inactivity seem to serve as rest periods during which new forces germinate. The child can grow during them, and when work is resumed a distinct advance may be evident.

Frequently the introduction of a new medium can stimulate an individual or a class into renewed activity. After black and white, a

change to color can be exciting, after chalk, a change to paints, and after painting and drawing, a change to clay modeling. A "trick" process, such as crayola scratchboard, can also be used to revive waning interest. (In crayola-scratchboard techniques, paper is covered with a heavy coat of light, bright colored crayon, and this in turn is covered with black crayola, india ink, or poster paint. The design is scratched through the black surface to reveal the color beneath.) An undue dependence on changes of media or trick processes to stimulate interest indicates that the basic motivation for artistic expression is weak.

Modeling and Carving

Modeling and carving are important both because some children work more readily in three-dimensional media than in paint, and also because these media provide expression for experiences and ideas that cannot be expressed in paint. The sense of such sculptural qualities as roundness, weight, and solidity that can be developed by working in clay or plasticine cannot be experienced in an identical way by painting or drawing. Clay or plasticine allows for two kinds of procedures. Starting with a solid piece of the material, one can squeeze out the details that extend beyond the main mass and press in the idented details (if a head were being modeled, the ears, nose, and lips would be pulled out of the solid mass, while the openings of eyes, mouth, nostrils, etc., would be pressed in). Or one can shape a general form, then model the details, and attach them to the main mass. Either method is valid, the first tending to produce a unified and harmonious mass, and the second a vivid and lively effect.

Children at the schematic level of development seldom achieve much action or movement in their modeled figures. However, because clay is pliable, a modeled figure can be pressed into almost any position. As a consequence, children often model figures to use as puppet actors. They press them into sitting positions, lay them down, stand them up, and model many "props" such as clothes, household objects, or sports equipment to use while playing with the figures.

Faces also can be modeled and "given expression" by pressing the mouth into a laughing or sad position, and masks provide opportunities to create simple spherical or oval head shapes enlivened with bold and imaginative features. Because very effective masks can be made without attenuated extending parts that might break off from the main mass, they provide a good means of introducing children to the use of papiermâché and sawdust as modeling materials. Masks can be made fairly large, allowed to dry, and then painted. The making of masks can be

motivated by studying the masks of primitive peoples, thus stimulating the children's imaginations by the use of an historically significant art form that is at the same time meaningful to this age level.

This is also a good time to introduce carving. The knife is a fascinating object to many small children, especially boys, and by the age of eight many children are capable of carving with a knife and will derive much satisfaction from the activity. Soap, balsa wood, and synthetic carving materials provide opportunities for cutting away from a mass to reveal form, thereby adding another dimension to the aesthetic experience. Needless to say, carving and whittling activities are dangerous and are best introduced at home or to small groups at school where full supervision is possible.

Design and Construction

At no time in the child's life do the habits of making and decorating provide greater pleasure than in the years between six and nine. During these years children have gained sufficient control over their larger muscles to permit the use of a greater variety of tools and materials. They are sufficiently mature to follow simple directions, and can initiate rather extensive projects and carry them through to completion without continuous supervision. Now is when the habits of "making things," rather than buying them, can be formed, habits that can do much to keep many aspects of social life from being dull and standardized. Instead of using the banal commercial decorations that appear at too many parties, mothers and teachers should encourage the children to make table decorations, place cards, birthday cards, and flower arrangements, not only for their own parties but for an occasional adult party (Fig. 22). Using food colorings, decorating cakes and cookies, making fancy sandwiches, and sharing in many other kitchen activities can be turned

22. Crayon on paper napkin, 13 x 13.
Age about 6 years.
The sensitive placement of the borders, the radiating lines, and the central block of patterns in this paper napkin decoration indicate a developing sense of aesthetic logic, orderly yet not mechanical.

22

into delightful color and pattern experiences. Only too often children are denied the pleasure of helping to prepare for a party simply because a conventional, somewhat competitive standard of taste demands that the food have a professional expensive appearance.

At this age children enjoy a great number of sewing, pasting, paper-cutting, carpentering, and other constructional activities. Since even nine-year-olds do not always have perfect muscle coordination, frustrating tiny tools and small pieces of material should be avoided. Big needles, heavy thread, big box nails, large soft pieces of wood, large scissors, big sheets of construction paper, will all help the child to make things with satisfaction. These are still the years when children enjoy playing in their toys rather than with them, and so they tend to make things that are large enough to be used in their play activities. Whereas a nine-year-old girl will enjoy sewing dolls' clothes, a seven-year-old probably will prefer making herself a costume; the nine-year-old boy likes making model planes, the seven-year-old prefers building a toy plane in which he can sit and pretend he is flying. An important part of the fun of these "making" activities is developing an awareness of quality. Children have intense sensory reactions and with encouragement will enjoy the "feel" of velvet, tweed, satin, fur, or terry cloth, or of wood, stone, steel, cement, or corrugated cardboard. In the same way a word about the brightness of yellow, the richness of purple, the astonishing pattern made by the shadow of a pair of scissors on a piece of paper, the energetic shape of pliers, and the pleasing crispness of cut-out paper patterns help to awaken the sensitivities that enable some people to enjoy every simple sensory experience.

Shaping the Environment

Six-to-nine-year-olds are also at an age when they can profit greatly from participation in decisions concerning their clothes, and concerning the gardening and decorating problems that arise in most homes. Usually we take the easier course of selecting clothes and furnishings by ourselves; and then—perhaps as a feeble concession to our feeling that we should have allowed our children to participate—we ask them if they like the garment or object we have chosen, after it has been purchased. Participation in these decisions not only develops aesthetic taste and judgment, but also establishes the important habit of making cooperative decisions about matters of taste that affect the entire household. The child, who often is made to feel that he only has a destructive role in relation to things in the house, can thus play a constructive part in determining the appearance of the home.

A friend who decided to allow her daughter to choose her own wallpaper at first complained that she had involved herself in unnecessary complications, since the child seemed unable to come to a decision. However, when the wallpaper was finally selected and hung, our friend discovered that the investment in time paid excellent dividends, since the child was very proud of the wallpaper and therefore much more thoughtful about the appearance of her room.

When we make these group decisions about color schemes, materials, the arrangement of rooms and gardens, or the selection of decorative accessories, it is important to go beyond the "Do you like it?" level of thinking, since little growth occurs unless there is a real evaluation of the factors involved. Is a color too warm for a sunny room, too somber for a dark room? Is a shirt too bright for a child with blond coloring, or is the child's pale color an asset that should be emphasized? Is the decorative motif on a dress too big for an oversized girl, a lamp too pretentious for a simple playroom? Will a rearrangement of furniture create more play-space? A seven- or eight-year-old is quite capable of understanding the elements involved in questions of this type and of helping one to arrive at sensible decisions.

Media, Materials, and Tools

The years between six and nine witness a tremendous expansion of children's interests and abilities, and as always there are great individual differences. Today there are almost too many art materials manufactured for home and school use, and almost every library has "how-to-do-it" books describing art and craft processes for this and every other age group. It seems wise, therefore, to establish some general principles to help parents and teachers choose appropriate activities both for individual children and for groups.

The physical maturation of children is a primary factor in determining what constitute logical activities. Six-year-olds have little control of the small muscles, consequently activities that involve the use of small tools, small pieces of material, or objects like hard pencils and small crayons cause cramped hands and a general tenseness of the body. This inhibits free, relaxed activity.

Large crayons, cold-water or poster paints, bristle brushes, colored chalk, large sheets of newsprint or Manila paper, plasticine, and modeling clay remain the standard materials during this period. Around the age of nine, children gain control of the smaller muscles and are better able to direct and coordinate movements. An artistic maturation usually accompanies this physical maturing, and the child begins to introduce

much smaller details in his work. As these smaller details appear, the child may become impatient with the clumsiness of the big bristle brushes or large crayons; regular-sized crayons, smaller paintbrushes, and pencils can be provided at this time. In general, children at this level of development do not need to be stimulated by new media; in fact, too great a variety may prove distracting.

Furthermore, any activity that demands careful adherence to patterns, outlines, or diagrammed directions can be harmfully restrictive, though by nine years many tools and activities that are too difficult for the six-year-old can be managed with pleasure. Only careful observation by the supervising adult can determine whether an activity is premature and therefore causing strain, or the opposite, not sufficiently challenging to sustain interest.

Great changes in the level of emotional maturity also characterize these years. The six-year-old, remaining babylike, prefers large-sized toys in which he can play. His vivid imagination endows objects with desired qualities: boxes can be transformed into automobiles or airplanes, cartons into houses. His play tends to focus on the family and home. The nine-year-old moves out into the community in his play. He chooses smaller toys and prefers replicas of actual objects. Since children prefer making the kinds of things with which they play, these preferences can serve as a guide in selecting activities.

At six boys and girls play together and enjoy the same activities; by nine each sex prefers its own company. Girls play house, play with dolls, sew and cook, while boys prefer their own masculine games. Increased maturity brings increasing group participation. A well-directed group of nine-year-olds can work together effectively to carry a complex project to fruition. Six-year-olds derive more satisfaction from working alone. Lastly, nine-year-olds, because of increased intellectual maturity, have a greater span of interest and can follow fairly complex step-by-step processes such as the previously described crayola scratchboard. The six-year-old's span of interest is short, and an activity that cannot be completed in one sitting will probably not hold his interest. These generalizations can help determine the suitability of various activities for this age.

Appreciation Activities

It is more important for children to develop a love of pictures and the habit of observing and collecting them than to acquire some isolated facts about the masterpieces of art. Too frequently the so-called art appreciation or picture study programs in elementary schools have introduced children to the great historic masters by means of pictures

whose subjects are only superficially related to children's level of interests. Thirty years ago Raphael's "Madonna of the Chair" was considered appropriate for the primary grade room because it was about mother-love. Today if a masterwork graces the room it is more apt to be Manet's "Boy with Flute" or Renoir's "Girl with the Watering-Can." The selection has some justification in that the pictures are about children. But admirable though such paintings may be, their presence is unlikely to influence the children's tastes because the children's role in relation to the pictures is passive rather than active; they have not participated in the selection, nor can they identify vividly with the person or activity depicted. However, a meaningful involvement can be achieved if children are brought into a room bare of pictures and, in conjunction with teacher (or parent), are asked to discuss and select the pictures that will decorate the room for a period of time; they should be given a wide range of possibilities including reproductions of paintings old and new. I once conducted a study of children's tastes and discovered that a favorite painting was a seventeenth-century masterpiece portraying a farmyard full of curious old-world types of barnyard fowl. It was dark and dull in color, tight in execution, but its strange fowl were fascinating to the children. Photographs of sculptures, masks, and ceramics, and reproductions of photographs, drawings, and prints in addition to reproductions of paintings, increase the richness and variety of possible fare.

The most meaningful involvement with works of art probably occurs when the child's own work, suitably matted or framed, decorates the walls of home or classroom, for the mat or simple frame represents a commitment far beyond verbal praise to the child. The painting on the wall is an act of confirmation, an acknowledgment of the importance of the child's expression as an integral part of the cultural life of the group. Such acts of confirmation and belief are more important to a vital aesthetic life than preserving a harmonious decorative ensemble. They are a tribute to growth, change, and the child's future, rather than to the masters of the past.

I recently had occasion to visit the post office in La Honda, a small community in the Santa Cruz mountains of California. Imagine my delight on seeing the small post-office lobby, which opened off the general store, decorated with a lively selection of drawings and paintings in an impressive variety of media. They were labeled "Work of School-children, Kindergarten and Second Grade, La Honda." Two vivid pictures of cowboys and three farm scenes reflected the colorful local scene. On inquiry I discovered that the postmistress had a continuously changing exhibition of the work of local schoolchildren in the lobby of the

post office, a practice that had not only stimulated the program in the schools, but generated community interest and pride in what the schools were doing. Here one can perceive the significance of a program that cultivates artistic activity as a normal attribute of a civilized society and the relative unimportance of the frequently overstressed distinction between the artistic works of gifted and ungifted people in the development of an artistic culture.

Summary

The sixth to ninth years are of particular importance in developing in children the attitudes and habits that will characterize the mature personality. During these years children move from parents and home into school and community. Creative patterns of behavior and aesthetic interests, established at this time, do much to determine the resources of the adult. Around the sixth year many children settle on a somewhat standardized symbol or "scheme" for representing people, houses, and other familiar objects. Around the ninth year these symbols become more naturalistic in proportion, in the number of parts, and in the amount of characterizing detail. Children depart from these standardized symbols when they find them inadequate to express some particularly intense experience or complex idea. Such departures represent growth, but only when they result from inner motivation rather than outside direction. Also developed during these years is a space scheme in which objects are arranged along a base line at the bottom of the page. Deviations from this base-line space scheme, such as a bird's-eye view of the scene or an X-ray view of an interior, are also valuable indications of growth. Around nine years, too, overlapping forms and the raised horizon lines indicate a growing awareness of visual space (perspective). Three-dimensional modeling and carving projects, as well as a wide variety of construction and decorating activities, can be undertaken during these years to develop aesthetic awarenesses concerning form, color, texture, and materials, and to awaken a simple sense of aesthetic logic. Improved muscular control, increasing social maturity, a more mature sense of sex differences, and a longer span of interest are governing factors in determining the tools, materials, and processes that can be used effectively in art and craft activities by children during this period.

V NINE TO TWELVE:
THE SYMBOL IS ANALYZED

WHEN boys start to make thoughtful, precise drawings of boats and airplanes and trains, and girls draw ladies' faces or dresses or houses with carefully indicated details (Figs. 23 and 24), it is evident that they are leaving the free and spontaneous expression of the six-to-nine period and are embarking upon the more strenuous and inhibited phase that characterizes children between nine and twelve years of age. This change in artistic expression is an outgrowth of physical and psychological changes that occur at this time, the most obvious being the control and coordination of the small-muscle movements and a greater consciousness of sex differences. At this age children prefer playmates of their own sex and often express a violent prejudice against the company of the opposite sex. And partly as an outgrowth of these two factors, and partly as an expression of a more mature social attitude, participation in group activities becomes much more important: children tend to become members of a gang, join clubs or organizations, and adhere closely to the group values of their club or gang.

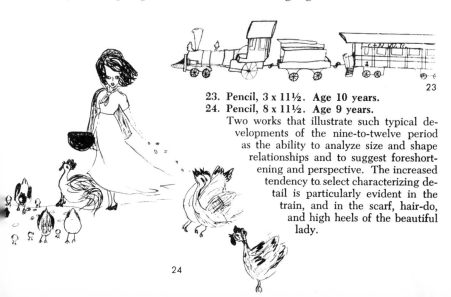

23

23. Pencil, 3 x 11½. Age 10 years.
24. Pencil, 8 x 11½. Age 9 years.
Two works that illustrate such typical developments of the nine-to-twelve period as the ability to analyze size and shape relationships and to suggest foreshortening and perspective. The increased tendency to select characterizing detail is particularly evident in the train, and in the scarf, hair-do, and high heels of the beautiful lady.

24

General Characteristics

These growths are expressed in many ways; for instance, improved muscular control expresses itself in a more skillful manipulation of tools and toys. Children begin to use needles, knives, rulers, and carpentering tools; and various sports—yo-yos, jacks, and marbles—also provide an outlet for this newly acquired deftness. Both boys and girls begin to prefer playing *with* little things to playing *in* big things, and they make and select toys on this basis. This development of the small-muscle skills influences the nature of the art work during these years. The drawings begin to be smaller, an increased number of small details appears, and pencils, pen and ink, crayons, and small brushes are selected in preference to the large brushes and cold-water paints of the earlier period (Fig. 25).

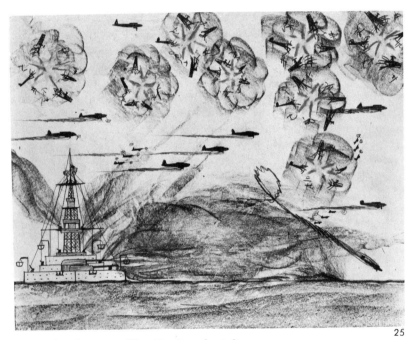

25

25. Pencil and crayon, 8½ x 11. Age about 9 years.
The preference on the part of many children in the intermediate grades for a detailed, accurate, and complex way of working is well illustrated here. The sense of scale and the sustained development of all the parts, even to the ruled lines used on the boat, has not inhibited the dramatic impact of this battle scene. The way in which the composition has been organized for narrative clarity provides an interesting contrast to the composition in Figure 33, in which all the lines convey the lyric abandon of the playing horses.

The consciousness of sex differences appears in the choice of subject matter and in the way people are drawn. Whereas the six-to-nine-year-old rarely indicates clothes, the nine-to-twelve is conscious of clothing and carefully differentiates between the dress of boys and girls. Boys tend to draw scenes of conflict, vehicles, sports activities, and feats of adventure (Fig. 25), while girls draw houses, clothes, flowers, and birds and animals with their young (Fig. 24), and enjoy illustrating tender and sentimental fantasies.

The "gang" consciousness, or greater social dependence, often expresses itself artistically in a conformity to group tastes and conventional standards. Children tend to reject the more idiosyncratic aspects of their work at this age, and often those who have been most independent and original in their previous expression suddenly seem to be satisfied with very commonplace work.

Along with the physical and social changes comes an increasingly analytical attitude, evidence of the child's greater intellectual maturity. Drawings and paintings begin to reflect a more adult and critical attitude toward self-expression; for instance, more naturalistic proportions are used, along with greater differences of size between objects, and color is used less freely and more literally than in the earlier period. A six-year-old will paint a face red or yellow without hesitation, whereas a ten-year-old is apt to strive for "flesh" color. As mentioned, there is a great increase in the use of details. Faces are drawn with eyelashes, teeth, nostrils, wrinkles, and hair. Dresses have sleeves, belts, buckles, buttons, and even the patterns of prints or plaids may be indicated. Whatever is drawn—ships, houses, or airplanes—reveals an increased observation of parts. Because there is more analytical observation behind the drawing of this period, the details that are used to characterize an object retain their identity even when they are isolated and seen out of context. Thus an eye, which in the preceding period can only be identified as such by its position, now remains an identifiable eye even if it is seen outside the drawing of the head.

These are the years when the first precursors of perspective usually appear; objects are no longer shown only in full face or in profile, but both a front and a side view of an object may be included in one drawing. As perspective is suggested, the ground line of the schematic period disappears and becomes a ground plane. Houses, trees, figures, and the other elements of the picture are placed on the ground plane. Often the objects overlap one another, and the sky comes down behind, meets the ground plane, and creates a horizon line.

Since in this period children concentrate upon such visual qualities as size relationships, sharply characterizing details, and perspective, the

creative act is less free than it was. They now think longer about what to paint or draw, are more apt to feel that something they have drawn does not look "right," and often become discouraged because their paintings do not come up to their ideas of "how a picture should look." As a consequence, achieving satisfactory artistic expression involves more difficulties for both the child and the adult who is helping him, and many children lose confidence in their ability to express themselves during these years. The wellsprings of creativity appear to be drying up, the desire for self-expression occurs less frequently, the child's schedule seems too full to allow time for carrying on artistic activities, and when he is moved to draw, paint, or model, the work is often less free, zestful, and imaginative. The adult working with children of this age, whether parent or teacher, shares the frustration. Children frequently request assistance that demands skills beyond the capacities of nonprofessionals. They are often not content with the enthusiastic "How nice!" that satisfied the younger child and the adult is expected to praise work that seems stiff and trite as compared to the child's earlier work. Many times even the most sympathetic person is tempted to say: "You used to do such free, vigorous paintings, why do you fuss now with all these tight details?" or "You used to do such nice drawings without perspective, why spoil them now with bad perspective?"—forgetting that this would be equivalent to saying "Quit trying to play baseball, you used to have such fun *pretending* you were playing." The child is moving into a more complex and mature orbit of expression; the difficulties facing him are artistic growing pains, and the solution is not retrogression. Often an adjustment of aesthetic values is necessary on the part of the adult before a sympathetic attitude is achieved toward the artistic development of children at this age level.

Nowadays most teachers and artists have been made conscious of the expressive qualities of the splashy, uninhibited, free work of small children, but they have not become sensitized to the gawky and awkward preadolescent expression. Children's classes in creative art often fail to carry children through this period because the teacher demands a charming type of freedom that conflicts with the maturing sense of fact. The creative aspects of the art of this age group are overlooked partly because our age tends to think of creativity as being synonymous with free, uninhibited execution. The dictionary definition of creative is "having the power to create." As long as expression is undictated and does not follow a pattern imposed by an outside person or group, it can be factual, detailed, even mechanical, and still be creative (Figs. 26 and 27). The perpetuation of the free, bold style of the earlier years, after that style has lost its expressive purpose and no longer calls on the full

26

27

26. **Pencil, 9 x 17. Age 9 years.**
27. **Poster paint. Fifth-grade child.**
　"Home Laundry" is an exciting expression of a love of elaboration and detail, as well as an inventive and ingenious fitting together of parts. This is usually considered a characteristic of mechanical or engineering, rather than of artistic, talents. Figure 27, equally creative, reveals observation more than invention. Here, successively, the child is the operator of the bulldozer, the scoop shovel, and an observer of the entire building operation.

physical, intellectual, and emotional resources of the child, is without value. It is like baby talk—an infantilism that represents some emotional immaturity. The first attempts at perspective, at naturalistic size relationships, and the first overly detailed drawings are like the child's first sorties into adult vocabulary—charming and very revealing bits of gaucherie to those who have the sympathetic insight to appreciate them.

　The most important thing in relation to children's artistic develop-

ment during this period is to maintain their habit of expressing themselves through the arts. If the child can be kept working with brushes and paints, with colors, materials, patterns, forms, and textures, and be kept confident of his powers to make and do things, there is a good chance that the creative interests will be sustained through adolescence.

Group Projects: The Mural

Between nine and twelve years of age children tend to move out from the close family unit in order to become members of the broader social groups of school, church, and community. Peer group relationships contribute increasingly to social maturity, and children gravitate naturally toward group activities and profit from working together on complex projects. Large-scale decorative or pictorial murals provide an excellent means of organizing group activities at this age, since such projects carry children beyond the capacities of any one child to summarize the total capacities of the group. In so doing they can alleviate some of the tensions that occur during these years when the growing critical awareness of youngsters makes them dissatisfied with their own awkward efforts.

One of the difficulties faced by the art teacher in the intermediate grades is keeping all children active despite their varying levels of skills. Some children show considerable precocity in solving problems of perspective and figure representation. Others reveal a well-developed sense of color, design, or composition. Some manipulate scissors or drafting tools effectively. The well-organized mural project provides a means for integrating all these various capacities and also allows those children who have no outstanding skills to participate, since they can be called on to paint in large areas of background colors and to help with the assembling of units and other mechanical tasks. Often in the course of a complex project children who have lost confidence in their artistic abilities rediscover neglected capacities and skills. An important part of all such projects is group and class discussion about perspective and drawing problems, color and compositional relationships, and the techniques to be used to achieve certain effects. Under skillful direction such discussions can do much to heighten new sensitivities.

The subject matter for group projects is usually drawn from the social studies program, but a trip or any other memorable occasion is equally suitable. Decisions about subject matter, media as well as general procedure, should be made cooperatively by the class and teacher, and in the same way committees should be set up to assign work and direct the assembling of the many parts that make up the completed

work. Murals in the intermediate grades are usually executed in crayon, chalk, cold-water paint, tempera, or cut-paper collage, and frequently a number of these media are combined in one work. They can be executed upon craft paper, wallboard, or large sheets of corrugated cardboard.

In schools with particularly talented teachers, more unusual techniques can be used. I recently saw a mosaic mural, measuring almost eight by twelve feet, that had been conceived by a group of sixth grade children to illustrate the geological epochs in the earth's development. The final design was created by combining many designs in superimposed layers, each layer representing a geological period. The finished mosaic was of ceramic fragments, made largely from broken tiles and dishes. Although the design and execution was a sixth grade project, the whole school of more than four hundred children had helped collect and break up the materials for the mosaic. The project provided an inspiring artistic experience for the entire school, a handsome permanent wall decoration, and a valuable lesson in cooperation as well as in the utilization of waste materials.

Projects of this type can extend beyond the classroom into the community at large. The most impressive community project that I have witnessed occurred in Villauris, France, in the autumn of 1961. At this time the small village of Villauris planned a large retrospective exhibit to honor its most renowned citizen, Picasso. Under the direction of a group of local school teachers, all the children in the intermediate grades submitted designs on Picasso's bullfighting theme. A composite plan was arrived at, and a committee of teachers was set up to ensure that all the local school children took part in carrying out the project. The final giant collage, flanking the entrance to the exhibition, not only provided a moving testimonial of community feeling for this great artist, but stood up as an aesthetic experience in its own right amid the assembled masterpieces by Picasso. Seeing this mural made me realize that the most retarding factor in the development of youthful ambitions is the limited nature of adult expectations.

Adult Guidance

During this period it is more important than ever for adults to provide experiences that will broaden the child's tastes and appreciations; for only in this way will he be sensitive to the expressive values in his own work that do not conform to conventional standards. Unless the family lives in an unusually sophisticated environment, the general pressure from school, friends, neighborhood, popular magazines, television,

and similar sources will encourage extremely conventional artistic tastes in the child—the ideal in pictures will tend toward "prettiness" or picturesqueness of subject matter, and the creation of an illusion of photographic exactness will probably be considered the ultimate aim of an artist. Technical dexterity in handling media, fineness of workmanship, commercial value (how much an object costs), elaboration, and complexity are the rather typical middle-class artistic criteria that children accept unless they are made sensitive to other qualities.

To counter these ideas children must be shown works of art which, though on their own level of understanding and appreciation, will extend their artistic perceptions beyond conventional tastes. Such broadening of tastes will be the more effective if it is planned in relation both to specific problems the child may have and to his general artistic personality. The child who is having difficulties with perspective should be helped with the problem and at the same time shown works of art that do not depend on traditional perspective for space relationships. The paintings of such "primitives" as Paul Kane, Grandma Moses, and Henri Rousseau, Japanese prints, Egyptian wall paintings, Persian miniatures, and a host of paintings by contemporary artists fall within this category, since they all achieve their effectiveness without using scientific perspective. If children are encouraged to enjoy these works and are then made conscious that the space concepts in them have been achieved by methods other than the one that our culture has tended to accept, perspective will seem much less important. Perhaps at the same time children can be made to realize that the entire concept of photographic realism has been important as an artistic criterion only in one small part of the world and then only during a short span in that area's cultural history.

The child who despairs of ever achieving the elusive and seemingly adult qualities of neatness, precision, and control should be reassured as to the relative unimportance of these qualities by being shown the broad, free seascapes of Albert Ryder, the "Kings" and "Judges" of Rouault, and the simple, strong paintings of Daumier. On the other hand, the child who is fascinated by technique, who likes detail, precision, and skill, can be reassured about the validity of his tastes by observing such Flemish and Dutch masters as Van Eyck, Breughel, and De Hooch, modern primitives like Bambois, and perhaps even such pure expressions of discipline as Mondrian and other neo-objectivists. Pre-Columbian ceramics, African and South Sea Island sculpture, modern abstract sculpture, paintings by Klee, Picasso, and Chagall, and the works of a host of other modern painters can be used to show children the great range of emotional expression that exists in the realm of the arts and how limited and narrow most popular ideas about art are.

At first, many children will not react favorably to unconventional works of art. They will complain that the free paintings are "messy," or that the paintings which do not employ conventional perspective "look unnatural"; but they will often prove surprisingly sensitive to the expressive aim of the artist (like the child who described a Klee as "cute and spooky," or my own son's reaction at nine years to a big Picasso exhibition in Paris, "It's surprising how much form he can get into senseless things").

More important than the immediate acceptance of this wide range of artistic expression is the fact that the memory of these unconventional works of art stays with the child, encourages departures from the banal and the conventional, and helps him to recognize and accept unusual elements when they appear in his own work. Children who feel no particular urge to express themselves through representational means may be stimulated to develop inventive tendencies and to express a sense of order in design by seeing examples of abstract art (Fig. 28).

28

28. Crayon, 8 x 10. Age 9 years.
In this highly integrated and complex composition, tersely described by its maker as an "abstrak," interestingly varied shapes in six colors have been interlocked and fitted together. Its maker, a boy precocious in mathematics and science, did not care to do representational paintings but enjoyed creating abstractions.

Although any broadening of taste that can be achieved is valuable because it provides a greater range of experiences and understanding, children should not be urged to express themselves in a way that does not come naturally to them. When a child shows a desire to use perspective, his interest should not be deflected, but instead enough assistance should be provided so that the immediate problems can be solved to his satisfaction. Help should be given in general terms, but with specific reference to the problem at hand, and always on a level that will help the child analyze his seeing experiences and thereby help him express his space perceptions (Figs. 29–32). Most children will start to show perspective by drawing a structure or object front view and then adding one side almost as a continuation of the front. At this point, particularly if the child seems dissatisfied with the effect, he will probably profit by being directed to look at some rectangular form from a position in which the front is seen almost full face and the side recedes into perspective. "See how the side goes away from you so that you see much less of it" may be sufficient to suggest a way of making the side go back into space enough to satisfy the child.

Other simple ways of helping a child express space relationships are to observe that closeness makes objects appear big, and distance makes them seem small (one's own hand in front of the eyes may cover a house across the street). It can be easily demonstrated that forms close to one often cover parts of objects farther away (so an overlapping object in a drawing always stays in front of the overlapped object). Another important realization is that the shape of any object (except a sphere) changes as its position in relation to the viewer changes. (Sometime when a child is drawing an object, put it in a number of positions and have the child comment on the changes. Place a carton at eye level, hold it way above the child's head, then place it at floor level and have him describe the changes that occur in what he sees.)

In the same way, if a child has difficulty in drawing a human figure, some simple suggestions may help. Often heads are drawn too large and bodies too straight to suggest action. Children are usually better able to draw a figure in action if they take the position themselves and feel the position of their own back, legs, arms, and head. Another device that helps is to have someone pose and have the artist run his finger along the main body forms to visualize the "lines of action."

It is during the intermediate grades that the tyranny of the pencil begins, a factor that seriously inhibits vigor of expression. The habit of using rather hard pencils, depending upon outlines, and avoiding erasures becomes strongly ingrained when children are learning to write and to do arithmetical calculations, and this cautious approach is trans-

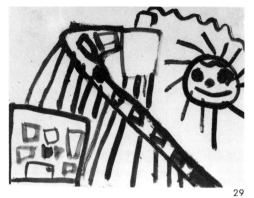

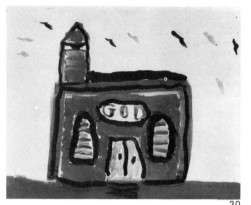

29

29. Cold-water paint, 18 x 24.
Age 5 years.
30. Cold-water paint, 18 x 24.
Age about 7 years.
31. Poster paint, 12 x 18. Age
about 12 years.
32. Pen, ink, and dry brush.
Age about 16 years.

Four steps in the development of perspective. A five-year-old establishes the space relationships between objects by having them touch one another. The painting communicates vividly that driving over a bridge gave the child a strong sense of moving in deep space. In Figure 30 the seven-year-old places his church firmly on a base line. In Figure 31 elements of perspective appear: the front and side of the barn are shown at one time, forms overlap one another, and as objects move back into space they appear closer to the horizon line. The sixteen-year-old (Fig. 32) employs such mature perspective concepts as lines converging to vanishing points to describe forms in space.

30

31

32

ferred to their art activities. Most classrooms are crowded, and the periods set aside for art are usually too short to permit the rearrangement of the room to facilitate the use of large pieces of paper and such unrestrictive media as tempera paints, compressed charcoal, or chalks. Thus limitations of time and space, in conjunction with increased small-muscle control and an intensified interest in characterizing detail, create habits of working in a tight, outlined manner, which many young people take years to throw off. Whenever possible space should be set aside in the classroom and media supplied that will permit children to work freely and without pencil guidelines. Drawing figures in action, using the side of a piece of chalk or compressed charcoal, painting action movements in tempera without preliminary drawing, and modeling forms in three dimensions are some of the activities that keep children from becoming dependent upon the hard, inhibiting pencil. Such freely executed, vigorous paintings as we see in Figure 33, or in Plates II, III, and VI, show that there is no contradiction between a child's growing control and expanding sense of realism, and his uninhibited expression.

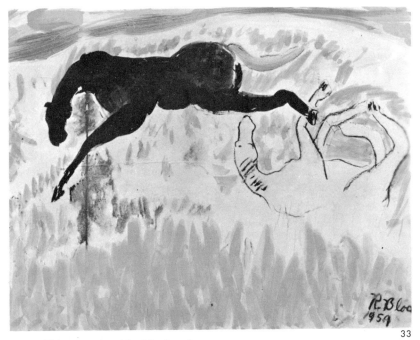

33

33. Cold-water paint, 18 x 24. Age 9 years.
 The maturing sense of scale, perspective, and characterizing detail need not inhibit freedom of execution nor restrict expressive power, as can be seen in "Two Horses." Freedom of handling has here reinforced the rhythmic compositional movements that relate the narrow strip of sky at the top of the painting, the cavorting horses, and the suggestions of grass texture.

Motivation

Since children frequently cease to express themselves through the arts during the years spent in the intermediate grades, motivation is particularly important. There is a constant need to emphasize that the arts are a necessary, important, and normal part of everyday life, and not a rarefied abstraction removed from the bustle of daily activity. The role of the artist in illustrating magazines, newspapers, and books, in assisting architects, motion-picture and television producers, and in designing industrial products and shaping the containers in which food, clothing, and other daily necessities are packaged should be stressed and made alive by all possible means. A film was recently made showing how industrial designers work through drawings, paintings, and models in consultation with engineers and sales personnel to determine the form of modern industrial merchandise. This film, shown to a sixth grade class, made most of the children aware for the first time that the forms of industrial merchandise are consciously planned and that artists shape these forms. As a result, many of the children attempted to re-design and improve certain locally manufactured objects as a problem in design.

A continuous reference to paintings, sculptures, architecture, and handicrafts by parents and teachers will predispose children to being active as artists. During World War II the fact that artists were commissioned to paint the war and the showing of reproductions of the commissioned works in schools did much to encourage children to paint the impact of the war on city life, industry, and so on. Almost any exciting excursion, a trip to an industrial concern or a nature-study outing, can provide a vigorous stimulus to expression, as can visiting an art exhibition or watching a painter or sculptor at work. After any such experience, the teacher should indicate a wide range of possible types of expression—drawing, painting, sculpting, designing, as well as collecting reproductions of works of art related to the experience. Group murals can also motivate productivity, since the desire to be part of a group will often encourage the participation of children who might otherwise remain inactive in the arts.

Extracurricular Instruction

If neither the public school nor the home can provide the facilities, help, and direction necessary for continued growth during these years, children must secure help from a professional source—otherwise their interest and activities will be diverted into less frustrating areas. Organized and systematic instruction is seldom necessary in the earlier pe-

riods, but at this age many children profit from it. Sources of help exist in most metropolitan areas, and some are available in smaller towns. Museums, art schools, and art clubs now have special classes for gifted or interested children. Many artists augment their income by giving private lessons in painting, drawing, modeling, or carving. A parent who is looking for a source of instruction will probably find that the public-school art supervisor or art teacher can suggest someone who is sympathetic to children, understands their work, and can give the needed direction and stimulation. Teachers who find themselves unable to assist children in solving the representational problems that obstruct their expression should take special training.

Occasionally children will profit even from a stereotyped and uncreative situation. I know a twelve-year-old girl who took a series of painting lessons from an elderly woman who had the children copy her own paintings. Although instruction of this type can have very unfortunate consequences, this particular child gained considerable assurance from this short contact because of the technical skill she developed in handling water color. On completing the series of twelve lessons she began to paint original and interesting pictures that represented a vigorous reaction against the conventional nature of the instruction she had just received. Much of the positive outcome in this situation was due to the intelligent direction of the child's mother, who continually pointed out to the child that she was learning a technique that would help her to express her own ideas when she finished the class. This was particularly necessary because the child enjoyed the class and tended to accept the teacher's aesthetic concepts along with her technical skills.

The introduction of a new tool, technique, or medium often provides a valuable stimulus to continued expression, and since this age group has a strong desire to be "grown up," the use of adult tools and media is an effective antidote against boredom. A girl who had shown herself to be very precocious in her art expression at an early age, and who afterwards became disinterested, was stimulated to enter a very energetic period of expression by the gift of a set of oil paints, oils being her idea of the ultimate medium. The son of a friend of mine became discouraged because he could not draw trucks, wagons, and airplanes to his own satisfaction. His father did not feel equipped to help him draw these machines, but knowing the boy's temperament and his feeling for tools he bought his son a drawing board, T square, triangle, compass, French curve, and ruler. He then collected a number of illustrated brochures on trucks and encouraged the boy to measure and draw the trucks, using his drafting instruemnts to work in a very precise and mechanical fashion. The youngster derived a great deal of satisfaction from

this activity, and since he was of a temperament that found satisfaction and security in a methodical and systematic way of working, the mechanical tools and procedures helped to sustain his interest in drawing during a period when he might easily have become discouraged.

Almost any of the standard adult media can be used at this age to stimulate the child who is bored with pencil, crayon, and cold-water paints. Colored chalks, pastels, water color, colored inks, colored pencils, sets of poster paints, and even oils can all be handled effectively, although a medium such as oil should only be given to a child with orderly work habits, who is prepared to wash the brushes after use, clean the palette, and give adequate care to the expensive equipment and materials that are used. The tempera paints that are packaged in tubes and squeezed out on a palette like oils are an excellent alternative for the child who wants a professional and adult-looking set of paints. Since they dry rapidly and dissolve in water, they are less messy and can be used with less caution than oils.

Evaluation

By pointing out areas of increasing effectiveness, adults can motivate children who are active in the arts to intensify their efforts and can encourage children who are disinterested or discouraged to renew their activity. The evaluation of children's work should always stress achievement: that is, areas of increased effectiveness should be pointed out with enthusiasm, after which weaknesses can be discussed. This procedure establishes a positive atmosphere and helps the child accept the negative aspects of criticism without becoming defensive. The following simple list may help direct attention to areas of increased competence:

Does the child draw and paint a wide variety of subjects?

Does the child employ an increased number of figures and objects in his work?

Are the size and shape relationships between objects described with increasing objectivity?

Are more characterizing details used to describe objects?

Are space concepts (overlapping, perspective, foreshortening, etc.,) handled effectively?

Are compositions more successfully organized for descriptive and expressive purposes? Is the entire area developed?

Are colors used freely with increasing control of effects?

Is there increasing control in the effective use of various media?

Is activity sustained and varied (as opposed to intermittent and monotonous)?

Has the work unique and personal qualities of style and subject matter, and are these qualities being retained and intensified?

Is art activity important to the child?

Most of these questions can be applied with equal meaning to the three-dimensional activities discussed in the following section.

34. Carved driftwood, 10 inches high. Junior high school.
Modeling and carving provide basic experiences in three-dimensional expression. This driftwood mask first demanded an imaginative viewing of nature's materials, after which it introduced its maker to the craft of wood-carving.

34

35. Painted papier-mâché, about 12 inches high. Age about 11 years.
Size helps to give importance to children's work. Papier-mâché provides a medium for large, light, modeled forms that can be easily preserved.

35

36. **Plasticine mask, 3 inches high. Age 10 years.**
The problem of creating a creature from Mars stimulated resourcefulness and imagination in the use of familiar materials. Nuts, bolts, screws, and broken parts of toys were used, both for their patterned imprints and for their own forms, in making the plasticine mask.

Three-Dimensional Media

Working in three dimensions is particularly interesting to most children of this age (Figs. 34, 35, and 36). No two children enjoy the work for the same reasons, but almost all children are stimulated by the shift from paper to three-dimensional media. Children who have difficulties with perspective and foreshortening may enjoy the freedom that one finds in modeling or sculpture. Boys often take to carving because it involves using a knife. Children with a high level of manipulative skill usually enjoy working in some moderately difficult material such as wood. The carving of wood challenges them by demanding a disciplined and orderly procedure with chisels, rasps, files, and sandpaper. In making ceramic sculpture the changes that occur in firing and glazing provide a valuable element of dramatic interest. Plasticine, papier-mâché, soap, synthetic carving materials, plastics, wire, pipe cleaners, sheet metal, and a host of other materials can be used to make figures, animals, masks, abstract forms, as well as useful objects such as bowls, dishes, ash trays, and lamp bases. The weight and solidity of sculptural forms (Fig. 37), the strong tactile appeal of modeling and carving, the fun of bending an intractable material to one's will, the potentialities of wire and metal as media for contemporary expression (Fig. 38)—all these experiences can be had only by working in three dimensions.

Making the materials for use in modeling can add considerable interest to the activity. One can obtain many clays and synthetic modeling materials that become malleable with the addition of water. Papier-mâché can be made with strips of paper and flour-paste. Modeling sawdust, a sturdy lightweight material, is made by combining sawdust,

37. Clay modeling.
 Fifth-grade children.
38. Wire sculpture.
 Tenth-grade boy.
Sculpture stimulated by nature can range from modeling earthy volumes in heavy masses of clay to creating open, dynamic forms that exploit the linear energy of wire. The nature of the materials being used, the interests of the child, and the artistic conventions of the day all influence the form of a child's expression.

flour, salt, and any desired coloring material, and then gradually adding boiling water and blending thoroughly until the mixture resembles a sticky dough. A simple modeling material for home use can be made from the following recipe. Mix two cups of table salt and two-thirds of a cup of water in a saucepan, stirring until the mixture is well heated. Remove from heat and add one cup of cornstarch that has been mixed with half a cup of cold water. Stir quickly. The mixture should be the consistency of stiff dough. If it does not thicken, place over a low heat

and stir, about one minute, until it forms a smooth, pliable mass. Leave it a natural white, or divide it into portions and add regular food colors until the desired shade is achieved. Modeled objects may also be painted or decorated when dry to give surface color. The mix can be kept' indefinitely if wrapped in clear plastic wrap or foil.

Design and Craft Activities

Craft activities assume increased importance during the nine-to-twelve period. The fun of using new tools and materials, the complexities of new processes, and the reward of producing things have great appeal to children approaching adolescence. Increased strength and muscle control make it possible to use the tools and materials employed by adults. Children of this age can read sufficiently well to follow directions, and they have enough self-control to take a process through a sequence of steps in a methodical fashion. The objects produced provide concrete evidence of the maker's skills, and the satisfactions of having one's talents enshrined in permanent form are great.

Further, craft activities help to counteract the inhibiting effect of newly acquired critical faculties, an aspect of growth that frequently makes children dissatisfied with the childlike qualities inherent in their painting and drawing. When this occurs, and children stop trying to express themselves, properly motivated craft activities can engage their interest so that they continue to work with colors, forms, textures, and materials. In this way the crafts contribute to continued aesthetic awareness and keep children productively involved in the arts.

The variety of crafts available to children between nine and twelve is extensive, and almost every classroom and family can offer some materials, equipment, and skills in which children will gladly participate. We often hear the complaint that "modern" children have lost the art of entertaining themselves; that they do nothing but sit and watch television, look at movies, and read funny books. But one usually finds that children follow the same pattern of entertainment as their parents and teachers. In homes and schools in which parents and children do and make things together, there is a dynamic atmosphere, a sense of energy expended in productive fun, that can be sensed as soon as one steps into the room.

Most of us have certain craft abilities that we can teach our children. (Before you say "Not I," think of simple sewing, embroidering, gardening, carpentering, and furniture-refinishing activities.) Excellent how-to-do-it manuals exist for the family or teacher who wishes to acquire new skills (see the recommended references). Nothing is more reward-

ing than when a whole family or class explores an area of activity together, the children showing the adults how to do things as often as the adults show the children. In such a situation an astonishingly high level of quality and creativity can be achieved. I know of a household in which a father and two children are learning to make ceramics together. Although the father's bowls and dishes are finer in technique, the children's animal and figure pieces are much more imaginative and colorful. Visitors usually notice the children's ceramics before they do the father's, much to the family's amusement. In another household the mother and eleven-year-old son have cooperated in the making of jewelry. In some instances the brooches, pins, and pendants have been designed by the boy and executed by his mother (Figs. 38 and 39), whereas other objects have been designed and made by the boy. Another ingenious mother used her child's drawings to decorate the glazed tiles and printed textiles that she marketed commercially.

The following list is designed to suggest typical activities in each of the major craft media.

Woodcrafts.—Simple pieces of furniture, a lean-to or playhouse; model planes, automobiles, boats, and trains; chessboards and checkerboards can be carpentered with simple tools and equipment. Toys and jigsaw puzzles can be cut out with a jigsaw and assembled. Carving or whittling puppet heads, marionettes, chessmen, buttons, buckles, letter openers, ornamented garden stakes, human and animal forms, is not difficult and is fun. Woodcraft activities provide an opportunity for children to become familiar with the various kinds of hard and soft woods, with the logical uses for each, and with the materials that are used for finishing and decorating wood, such as wax, shellac, varnish, stain, paint, quick-drying enamels, lacquer, and other commercial finishes. Refinishing old furniture, painting and restoring the interior and exterior woodwork, and cabinet work can be a satisfying family or classroom experience. Experimental structures using cocktail toothpicks fastened together with model cement can produce fascinating "constructions," "mobiles," or abstract sculptures (Fig. 53).

Textile Crafts.—Weaving with yarn, string, strips of cloth, raffia, or reed, to make purses, rugs, wall hangings, hot pads, beanies, etc., can be done at home on simple homemade looms. Sewing doll's clothes and costumes, making stuffed toys and dolls, appliquéing patterns, and stitching and embroidering panels, bags, pot holders, and samplers with wool yarn on burlap or more refined fabrics require only simple materials and average sewing skills. Other popular activities are decorating wall hangings, curtains, draperies, luncheon sets, skirts, blouses, handkerchiefs, and scarves by means of stenciling, tie-and-dye, batik, block

39. Pencil, 4 x 6. Age 9 years.

40. Silver and semiprecious stones. Pendant and two pins.

The sketches in Figure 39 were made by a nine-year-old boy after he had seen a collection of pre-Columbian jewelry. A natural interest in design was stimulated by his mother's hobby of making jewelry. The pendant and pins were made by the mother from designs by the son, with the boy assisting in the making. Later he became quite expert in both designing and making jewelry.

printing, direct painting, and ironed crayon. Perhaps the most effective of all is for children to make their own clothes, curtains, and bedspreads.

Paper Crafts.—Making cut-paper decorations for parties, Christmas trees, holiday favors, cardboard boxes, screens, portfolios, book covers, painted paper plates, and wrapping papers provides a wonderful experience in combining colors, textures, and materials.

Paper sculpture, a stimulating medium for developing ingenuity, provides abundant opportunities for experiences with form, color, and texture. Dry paper is shaped, and then fastened with staples, paste, or scotch-tape. The most common materials are colored construction papers and light cardboard, but the addition of metallic foils, cellophane, paper cups, plates, straws, paper spools, and other prefabricated paper forms expands the potentialities of the medium. Paper can be folded, cut, curled, rolled, twisted, torn, woven, braided, or pleated. Cylindrical forms can be made by rolling the paper and then pasting or stapling it. By creating basic forms and then attaching cut-out details in contrasting colors, whimsical masks, dolls, animals, vehicles, toys, and a wide variety of other forms can be created.

Metalcrafts.—Simple jewelry, hammered metal plaques, bowls, trays, ash trays, wire sculpture, and mobiles can all be made by the child with an unusual degree of interest and perseverance. Many boys who are not interested in other types of activities are challenged by metal and the metalworking processes (Figs. 38 and 40).

Ceramic Crafts.—Ceramics are among the most popular craft activities, and children can make bowls, plates, ash trays, candlesticks, tiles, masks, and sculptures. Today the distinctions between ceramics and sculpture have almost disappeared, since many contemporary bowls, vases, planters, and related objects are conceived primarily as non-functional sculptural forms, and sculpture, in turn, is frequently abstract and nonrepresentational.

Nature Crafts.—Party favors, lapel decorations, and amusing doll and animal forms can be made from shells, pine cones, seed pods, mosses, branches, driftwood, and stones. Charming planter boxes can be arranged by using small indoor plants, succulents, and cacti in conjunction with stones, shells, pieces of driftwood, etc. Many modern ceramic artists design interestingly shaped and textured containers, which can form the settings for bonsai-like compositions made out of living or inert nature materials. The fishbowl or aquarium should not be overlooked as a challenging opportunity to arrange plant forms, rocks, shells, and fragments of coral into beautiful hide-and-seek playscapes for the fish.

Waste Products Crafts.—Doing things with waste products is a valuable challenge to the imagination. Utilizing buttons, spools, odds and ends of fabrics, packing materials, metal foils, etc., in decorative ways can develop the qualities of ingenuity and resourcefulness in a child (Fig. 40).

Plastic crafts, basketry, beading, crocheting, leatherwork, knitting, and an endless variety of other activities could be added to the list. It is a great mistake to think that boys and girls share the prejudices of many adults about what constitutes men's work and what constitutes women's. Boys enjoy weaving, basketry, beadwork, and many other activities that are often considered feminine, while girls can be equally enthusiastic about whittling, carpentering, and metalwork.

When one sees the many badly designed and poorly made objects on exhibit at the average hobby show, one realizes that practicing a craft does not ensure good taste or a sense of design. Negative learning and negative attitudes can result only too easily from bad practices, bad examples, and a superficial approach. Too many crafts are undertaken merely to pass time, and often the most valuable experiences are bypassed for quick results, as when precut materials are assembled to make useless, cheap, "cute" objects that serve only to debase a child's appreciation of craftsmanship, functional design, and decoration. Many of the packaged kits for making jigsaw toys, for weaving, sewing, making jewelry, etc., fall within this category. Designs are supplied for the

children to trace or copy, all parts are precut, often the materials are shoddy, and the child is discouraged because the parts do not fit properly or fall to pieces as they are being put together. Assembling poorly prepared, cheap materials to make useless gadgets and decorating them with trite, tawdry, and commonplace devices too often constitute children's craft experiences—certainly no way to acquire worthwhile values.

The importance of using good materials and tools cannot be over-emphasized. There is a tendency to provide children with toylike tools and third-rate materials. Such equipment and materials would defeat a skilled adult, and children, needless to say, become completely frustrated and discouraged when they attempt to work under such handicaps.

When our children want to decorate an object, we can encourage them to create their own decorative motifs by calling their attention to the wonderful variety of patterns that exists in the world around us. When children create decorative patterns directly from their own environment and experiences, the patterns mean much more to them than such trite and conventional motifs as flowers, leaves, birds, or fish. (A young boy recently designed a very charming wallpaper for his playhouse in which he used a bicycle motif. Imagine my consternation on hearing his mother say "Bicycles aren't appropriate for wallpaper. Why don't you use flowers like the ones on the paper in your bedroom?") Parents must watch out lest their own conventional attitudes squash originality, although it should be pointed out here that an undue emphasis on the need for originality can make the creative act too self-conscious. "Original" should not mean unique or unusual so much as expressive of the personality that originated the object or the design. Encouraging originality by accepting it when it appears is healthier than suggesting it as an aim.

The ideal time to show children fine examples of a craft is when they are working in the medium. At this time their interest is aroused, and examples of distinguished achievement will both develop their taste and inspire them to increase their efforts. However, to be effective the examples should not be out of harmony with the character of children's art, but in a style within the child's potential. If a child is planning to use block prints to decorate a textile, for instance, pictures or samples of tapa cloth, Mexican serapes, Indian rugs, or vigorous contemporary prints can suggest a kind of bold and unrefined pattern that will correspond with the child's design abilities and the potentialities of his block-cutting and printing techniques. In the same way, a young ceramic artist will benefit more from seeing simple, bold Tarascan ceramics than such elegant and refined examples of the ceramic arts as

Meissen ware. Chinese ceramics from the Han dynasty, simple and earthy, would mean more than the elaborate nineteenth-century Oriental porcelains. In each case the simple ware could influence the child's taste in relation to what he might do. The elaborate, highly refined, and sophisticated examples would inhibit or discourage him by establishing an ideal that would seem either irrelevant or completely unattainable. Trips to museums, visits to craftsmen in the area, and visits to gift shops and other merchandising centers are always valuable and enjoyable, but they have a particular pertinence when they involve some particular craft in which the child is working at the moment. The same is true of the many good books that cover almost all types of craft activity; relevance to the activities at hand seems to determine the degree of interest a child will take in a particular book.

General criteria that an adult might use to evaluate or direct craft activities are:

Has the particular craft activity been selected with reference to the child's tastes, manual skills, and home or school facilities?

Have the materials employed been used logically and in such a way as to bring out their character and beauty?

Have the tools been used efficiently?

Has the child shown ingenuity and imagination in relation to the processes, tools, and materials involved?

Has the activity helped him to work independently of both people and patterns?

Has the activity developed a respect for good craftsmanship?

Has the activity developed greater sensitivity to color, form, texture, and pattern?

Have the decorative elements involved in the project been created by the child?

Has he accepted the "style" potentialities of his own level of ability, or is he striving to imitate adult values?

Has he been unduly influenced by parental tastes or the desire for adult approval?

Has he seemed pleased with what he has made and has the family shown an appreciation of the accomplishment?

Has the activity been fun? Has it been carried on with zest and enthusiasm?

Summary

Between nine and twelve, children's drawings, paintings, and sculptures lose the free naïveté of the earlier years. Figures become more

41

41. Puppets.
These puppets were produced by a group of children under the supervision of a neighborhood mother. The top puppet, made of a discarded sock, buttons, and a shell, was a six-year-old's first venture. The nine-year-olds who made the other two puppets received some adult assistance. Puppetry involves many artistic and dramatic gifts and consequently is an excellent way of getting a group of children to do things together.

complete anatomically, become clothed, proportions between parts are more literal, and much detail is incorporated into the figure symbols. Proportions between figures and the other elements in a composition become more consistent, and the first signs of space perspective appear. The sky comes down behind objects, a ground plane frequently replaces the ground line, and more than one facet of a three-dimensional form will be indicated, though without conventional perspective.

Because of increased critical faculties, many children at this age are dissatisfied with their artistic achievements and need more direction, assistance, and encouragement. Both parents and teachers are more frequently called on to help with problems of drawing and composition, and if this is needed and not forthcoming in the home or at school, special instruction may help sustain interest. Group mural projects provide an effective means for coordinating a variety of capacities and at the same time can satisfy the growing desire of children to be part of a social group.

Craft activities become an important means for utilizing small-muscle skills through these years. Well-executed crafts provide important satisfactions for fourth, fifth, and sixth graders, and often will sustain a child's interest in the arts and in creative activity during periods when the interest in drawing, painting, and modeling seems to be waning.

During the nine-to-twelve period, pressures toward group conformity often result in the development of very conventional standards of artistic taste. This is therefore a good time to begin showing children unconventional examples of modern, historic, and primitive arts that are related to their growing skills and interests both in the fine arts and in crafts. This expanding of their art world until it encompasses a wide variety of kinds of expression helps children to realize that significant art can be produced despite limitations in skills and techniques. They will also begin to be aware of the wider cultural world that exists beyond that of their immediate social group.

VI THE ARTS AND ADOLESCENCE

ADOLESCENCE! Parents today approach the adolescence of their children with almost more trepidation than they face the birth of their first child. Articles, books, lectures, and community forums stress the problems of the adolescent and, even more, the problems of being the parent or teacher of adolescents. The dictionary defines adolescence as the period between childhood and maturity. As such it stretches from the junior high school through the high school and undergraduate college years. Though most of what follows also applies to college students, our focus is on young people of junior high and high school age.

When you complain about the difficulties of bringing up your five- or seven- or ten-year-old to friends with teen-age children, they assure you that the worst is yet to come: automobiles and liquor, dates, money and the lack of it, social cliques, unrealistic professional dreams, all the problems and conflicts of this tumultuous and dynamic period of the child-adult's life as he is projected into the unsettled social milieu of our day.

The Search for Self-Identity

One of the outstanding contemporary analysts of youth, Eric H. Erikson, makes a brilliant summary of the crux of the problem of adolescence in his book *Childhood and Society*, when he says: "What the regressing and growing, rebelling and maturing youth are now primarily concerned with is who and what they are in the eyes of a wider circle of significant people as compared with what they themselves have come to feel they are; and how to connect the dreams, idiosyncrasies, roles and skills cultivated earlier with the occupational and sexual prototypes of the day."

When one looks into one's own past, one remembers the period tenderly; the elation, the wild enthusiasms, the feeling of unlimited capabilities, the thrill of discovering the world through books, music, drama, painting, and sculpture, and the equally poignant memories of emotional conflicts, social insecurities, and the disillusion and difficulties experienced in finding outlets for one's abilities.

Whether the adolescent enjoys the arts as an observer or as a creator, their contribution to his maturing personality is equally great. For the observer, the youth who reads, sees paintings and sculpture, listens to music, and enjoys the theater and the dance, the arts provide a most sensitive instrument for discovering the nature of man and society. For the creator, the young person who paints, sculpts, sings, play-acts, or dances, the arts provide a means of defining and expressing the maturing perceptions and feelings that constitute growing up. In addition, these various areas of expression allow adolescents to achieve recognition and approval both from their peer groups and from the adult world —to reconcile their desire for independence and uniqueness with the need to conform and achieve recognition. Finally, the arts help to broaden young people's cultural outlook, to lessen group prejudices, and to reduce social tensions.

One area of tension in our society is the presence of national, racial, and religious minority groups who feel apart from the dominant white Protestant community. The painful sense of social inferiority that these groups frequently suffer becomes intensified during the junior and senior high school years, when dating begins and social fraternizing acquires greater significance. Anything that can be done in the school to create status and esteem for the minority groups helps assuage wounded sensibilities, builds self-esteem, and contributes to social harmony. Thus, in classes in which there are members of minority groups, the arts and crafts native to the original culture of these groups provide valuable instruments for building individual and group self-esteem (Fig. 42). One of the most effective programs of this type I have witnessed was developed by a southern California teacher who had a number of Mexican children in her ninth grade art class. Many of these children had been put in the art class because of personal and academic difficulties. Perhaps their greatest single talent was their sense of color and design, and so a program was planned to capitalize on this ability. A continuously changing display of historic and modern Mexican art and crafts was arranged in the classroom, the display being tied in with the class's own design and craft activities. As these children participated successfully in this program, many of them ceased to be withdrawn and indifferent to school and began to take part in the social as well as the

42

42. Watercolor, 12 x 18. Age 14 years.
 This design, done by a girl in a school for Indian children in Arizona, has utilized the motifs, stylizations, and arrangement found in ceremonials and paintings traditional to this area. We may hope that this creative use of traditional elements will contribute to social stability by maintaining a degree of cultural continuity in a situation in which changing standards threaten most established values.

creative aspects of the classroom. A visit to a nearby museum was particularly effective, since the entire class was deeply impressed at seeing a collection of pre-Columbian ceramics given prominent display space.

Even when there is no immediate problem of minority groups, stressing the contributions of many different peoples to contemporary culture stimulates an appreciation of cultural diversity. Introducing students to the special character of various ethnic groups by helping them enjoy the color and flavor of unfamiliar ways of life enables the adolescent to see life as an aesthetic spectacle, to achieve what the philosophers describe as "aesthetic detachment," and thereby reduces prejudice.

Art Appreciation

While the physical activities of adolescence are developing the bony structure of the adult body, imaginative activities settle into habits that will make up adult personality. A strong bony structure in adolescence ensures an adequate support for the mass of muscle that continues to develop through maturity; similarly, when the habit of achieving intense experiences through the arts is an important part of adolescent imaginative activity, continuous intellectual and emotional growth is ensured throughout the years of adult life. The capacity of the arts to stimulate this intellectual and emotional growth by providing intense vicarious imaginative experience is extremely important, but this role is often overlooked in our utilitarian age. Our culture tends to conceive of the arts as agreeable embellishments to practical living rather than as basic instruments for developing emotional and intellectual maturity. In school the arts are often conceived of as a dessert on the educational menu, as a preparation for what the advertising men call "gracious living." When students are encouraged to learn about the arts, it is to help them furnish their homes with some degree of taste, dress becomingly, provide areas of interest to occupy their leisure time, and enable them to move comfortably in sophisticated circles. This narrow, philistine viewpoint is reflected by the number of junior and senior high school curriculums that make art, music, and drama elective subjects, but require physical education, which does for the physical being what the arts do for the cultural being. Artists, using the word in its broadest sense, provide the means whereby people can explore the thinking and feeling of the perceptive and articulate personalities of today and of the past. This is particularly meaningful during adolescence, since this is an age of great sensitivity to ideas and feelings.

It is important, therefore, that throughout these years young people

should read, see plays, listen to music, look at pictures, and enjoy other types of artistic expression. However, to be constructive these experiences must involve a positive response to the work of art, must be pleasurable and entertaining, free from boring overtones. Many a visit to a museum or art gallery carries an aura of "uplift" that defeats its purpose, probably because the event is planned more as an aesthetic obligation than as an exciting experience. Many conventional and well-meaning people, attempting to stimulate in children artistic interests that they themselves do not have, will hide their indifference behind an artificial façade of reverence and respect. This false respect accounts for much of the joyless and obligatory visiting of museums, memorizing of facts, and collecting of reproductions of old masters that can smother an enthusiastic adolescent's love of art. Too often, knowing about art becomes an educational substitute for receiving intense experiences.

More important than an occasional venture into the cultureland of the museum is to acquire a love of pictures on a familiar, commonplace level. To develop in children the habit of drawing on artistic resources for pleasurable intellectual and emotional experiences we must discover and utilize the popular interests and resources that exist in the child's environment. Many a child who has no interest in visiting museums or collecting reproductions of old masters (and rightly, since these masterpieces were created for adults from a culture alien to ours) does, however, have an interest in "comics" and "funnies," and will gladly collect examples of drawing, cartooning, and caricaturing from comic books, newspapers, and magazines. These are the sources from which an American child receives his day-to-day aesthetic experiences. This material is not without intellectual content, since it usually offers some kind of comment, either criticism or praise, on the culture of which the student is a part; he moves naturally and easily in this familiar milieu, knows its idiom, and is more apt to react sensitively and spontaneously to it. Therefore such materials provide a natural source from which to collect drawings and pictures. The habit of collecting and observing, even on this lowly level, if it grows out of a genuine liking for the material, will stimulate more growth in judgment than an indifferent viewing of masterpieces, no matter how great and important they may be.

One discovers in reading the biographies of many artists that an intense love of pictures rather than any superiority of taste distinguished their childhood. If the pictorial interests of adolescents are encouraged and permanent interests created, these people will be discriminating about pictures when they reach maturity. Collecting, displaying, and talking about illustrations, advertisements, cartoons, caricatures, prints, and photographs, as well as paintings and sculptures, are activities that

can translate a general liking for pictures into a rewarding adult interest that can be carried on in almost any community. Reading books on painting and painters requires the reading habit plus maturity of interest, and visiting museums and art galleries demands facilities that are not present in most small communities, but every child can collect pictures from magazines, newspapers, and other popular sources. Unfortunately the artistic development of children is frequently hampered by parental attitudes. Whenever parents cannot take time to admire a magazine illustration or to enjoy a cartoon with a child, or fuss about the thumbtack holes made by pin-ups on the wall, the natural expression of artistic interests is discouraged. Art teachers are frequently guilty of smothering youthful interest by a critical attitude that overrates sophisticated taste and undervalues adolescent enthusiasm.

Just as an interest in drawings, illustrations, and cartoons can lead to a more mature taste in graphics and paintings, so any level of interest in styles can be used to stimulate a sense of design. The girl or boy who likes clothes or furniture or homes (most girls and many boys are interested in these subjects) can be encouraged to collect pictures and samples of the things they like. I know of a fifteen-year-old girl with a wonderful collection of textile samples. She probably knows as much about textiles and color as many professional dress designers or interior decorators. Boys often save pictures or models of automobiles, airplanes, trains, and boats—to mention the obvious—and they may enjoy collecting stones, samples of wood, metal, synthetic building materials, or fine tools. No matter what is collected, if it is observed and enjoyed, discrimination and taste will follow.

During these adolescent years the things that are the symbols of success—clothes, homes, home furnishings, automobiles, household equipment—become tremendously important. We have all heard the charming conversations in which fifteen-year-olds declare their allegiance to the modern house and point out the horrors of the parental abode, or discuss the superiority of an imported sports roadster to a conventional American sedan. During this period of genuine interest in "things" it is easy to direct the adolescent's attention to books and articles on good design and to stimulate discussions on what constitutes taste and discrimination. And once a rational basis has been established for selecting clothes and home furnishings, the adolescent will become independent of those shifts in fashion that are designed to stimulate sales rather than to give lasting pleasure and satisfaction to the consumer.

During the impressionable and enthusiastic teen-age period, adolescents should be given opportunities to look at, discuss, and, if possible,

select clothes, homes, household furnishings, automobiles, watches, and even jewelry for the self they dream of becoming. In this way their deep self-concern can to some degree be objectified and related to the expanding world and its material substance, while the great material world can in turn be related both to self and to abstract aesthetic standards. In order to build enduring taste, young people must be genuinely interested in good things and good design over many years. In addition they must have an aesthetic philosophy in harmony with contemporary social values and scientific concepts. Such a person will have a distaste for the "conspicuous expenditure" that produced such horrific conglomerations as the typical Victorian home. Any modern with a belief in hygiene will inevitably shun elaborate, intricately carved furniture with deep-piled plush upholstery, since its dust- and dirt-catching propensities are offensive to hygienic, and hence to aesthetic, taste. Any person today with a feeling for the machine and for efficient functioning should find the pretentious streamlining of household gadgets offensive. To cultivate in adolescents a feeling for the honest use of materials, a sense of good design and propriety, and an imaginative approach to the solution of contemporary living problems is to provide them with attitudes that will help them create an environment in which they can live happy lives.

Artistic Activity

While the habits of collecting, observing, and enjoying the arts can make an important contribution to the intellectual and emotional growth of all young people, creative activity in the arts has a unique importance during this period of transition from childhood to adult status.

Primitive societies have feats and tasks that the adolescent performs to remove the stigma of "child" and prove his adult status. In our complex society there are too few accepted tokens of maturity available to the adolescent. He is still in school, is dependent on parents for food and shelter, and cannot marry and have a family; whereas very often he feels too mature for school and thinks himself capable of working and supporting a family. Long after our young people are physically mature our society keeps them children, and this ambivalent status creates many emotional tensions. Adolescents are apt to feel in conflict with parents who restrict their activities, with school and teachers who treat them as children by keeping them at their studies, and with the economic powers of our age which refuse them adult jobs. In addition to these conflicts they are, despite the appearance of maturity, still insecure in matters of love, sex, and social behavior and are continually discovering areas of both personal and vocational inadequacy.

As a counterbalance to these frustrations and disappointments, adolescents need to experience success and find areas in which they can achieve recognition. Sports provide such opportunities for some young people; but they leave many emotional and intellectual needs unanswered, and adolescents often find artistic activities more satisfying, both as a means of expression and as a way of winning approval from the adult world on its own terms. Each medium of artistic expression has its particular area of intellectual and emotional appeal, answering to the needs of a different personality, and each demands its special sensitivities and skills. Often young people have great difficulty in finding the areas of expression that are satisfying to them: superficial childhood experiences color their feelings, failure in some previous attempt makes them afraid to try again, and emphasis in high school on college preparatory courses discourages exploration in the arts in school. Often parents discourage experimentation on such flimsy grounds as "there has never been any talent in our family," or, feeling that the arts represent precarious professions, they admonish their children to devote themselves to something practical. Since no successful tests have been devised by which to measure the probable success (and, even more important, the probable satisfactions) that a person will achieve through participation in a particular art form, young people should be encouraged to explore many areas of expression and to pursue any which they find enjoyable and satisfying. Certainly there is no reason to assume that a lack of previous participation in a certain field indicates a lack of aptitude. Any visit to a class in art for adults will reveal people from all walks of life who are belatedly discovering capacities that they never dreamed existed.

The arts also serve adolescence by helping to bridge the gap between uncritical play activities of childhood and the critical attitude toward imaginative activity that characterizes adults. One of the interesting differences between children and adults appears in this clear separation by adults of the world of imagination from the world of fact and everyday action. Adolescents, like adults, tend to censor their actions according to the conventions of the society in which they live; they become critical of their play activities and hesitate to act out their daydreams and fantasies in the manner of smaller children. Little children can wave their arms while running and imagine they are flying; they do not hesitate to translate their imaginings into actions. Adolescents may daydream they are flying, but their maturing sense of fact and their increased respect for the conventions of the grown-up world keep them from waving their arms and making airplane sounds. They may picture themselves in an airplane, they may live vividly in a heroic rescue or a

romantic escapade, they may lose themselves through complete identification with the hero or heroine of an aviation story, but they will not act out these dreams in public. In "The Poet and Daydreaming" Freud presents the hypothesis that imaginative creation, like daydreaming, is a continuation of and substitute for the play of childhood. The arts provide one means for translating this rich imaginative life into forms that are accepted, approved, and respected by the world of adults, thereby allowing both adults and adolescents an inner life that is not quite so restricted by convention and fact as are their day-to-day activities.

Adolescent Expression and Artistic Conventions

As adolescents abandon the free, uncritical play of childhood for the conventions of the adult world, so their artistic expression is shaped by the conventions of the artistic world they see about them. Consequently, most junior high and high school children stop making pictures based on their play experiences, their family, their home, and their pets, and proceed to paint or draw subjects they have seen painted or drawn by professional artists: landscapes, still lifes, figure studies, portraits, story illustrations, and today—since the example is often before them—abstractions. Their style, too, becomes imitative, being based on the work of certain artists whom they admire (Fig. 43). Just as hero worship, an

43. Oil, 16 x 20. Age 17 years.
"Three Riders and Child" was inspired by Picasso's "Three Musicians." Though the composition and style remain close to the source of inspiration, a trip home from school on the subway provided the subject matter. The boldness and freedom with which the soldier, the man with a child on his lap, and the workman reading a newspaper have been transposed into cubist patterns shows the powerful influence great works of art can have on youthful expression.

43

acknowledged phase of adolescent development, determines the dominant ideal of behavior, so artistic hero worship determines the adolescent's artistic style. But whether the teen-age artist imitates the subject matter and mannerisms of some popular illustrator or comic-strip artist, or of Picasso or Matisse, the tendency toward imitaiton need not alarm us, since this is a natural step in his artistic development. André Malraux, in his trilogy *The Psychology of Art*, asserts that artists are not so much people who love life as people who love art. The young artist, he says, is inspired to paint by pictures rather than by daily living, and he usually starts his career under the influence of much-admired works of art, patterning his early work after the object of his admiration. Artistic maturity (the forging of a personal style) is achieved by a painful revolt against the original inspiration. This theory is convincing in that it parallels what we know about the general development of personality in adolescence.

But alongside the need to admire and idealize is an equally great need to achieve independence by rejecting authority. This paradox provides a key to some of the idiosyncrasies of teen-age tastes. It often seems as though parental and academic disapproval were the principal factors in determining the artistic ideal of an adolescent. If the parents like craftsmanship, the son chooses "action painting"; if the teachers enjoy photographic realism, abstraction becomes the ideal of the teen-age rebel. Parents and teachers can logically accept these divergences of taste as a natural and easy expression of the growing need for independence.

Our age is characterized by fantastic variety in artistic styles and movements; in no other age has so great a variety of painting been accepted. At any large competitive exhibition one sees examples of photographic realism, complete abstraction, violent expressionist distortion, and imaginative surrealism, side by side. From this potpourri of styles, movements, and influences the children of today must select a way of working. Additional avenues of self-expression are suggested by the advertisements, cartoons, caricatures, and illustrations that surround them. This diversity has both advantages and disadvantages. Young people are made too self-conscious about "style" and change from one way of working to another in an effort to find themselves. Claims of partisan groups about the importance and meaning of each particular style confuse the inexperienced young artist: abstractionists will call the "subject matter" artists old-fashioned; representational artists will say that the abstractionists cannot draw; expressionists will call both other groups sterile; and so on. On the other hand, the existing catholicity of taste means that almost any style can find a sympathetic audience and

any way of working can be confirmed by precedent. In addition, since art is essentially an intellectual rather than a manipulative activity, the discussions and arguments for and against the various styles contribute to maturity by stimulating thought and analysis.

It is important to realize that no one style or way of working is more basic than another; any style can provide for development, since it is the creative act that stimulates growth rather than any particular method, style, or medium. In trying to guide our children we should encourage them to work in any way they find stimulating and satisfying. Partisans of abstraction will say that working with abstract shapes allows for concentration on fundamentals uncomplicated by drawing problems; advocates of more traditional methods claim that until one has mastered certain basic skills of drawing and perspective and color, one cannot achieve meaningful expression. However, if we observe the development of many young artists, we see that no one pattern is fundamental and that a healthy development occurs whenever there is a sincere attempt at self-expression.

Visual Versus Expressionist

Viktor Lowenfeld, in his two great books, *The Nature of Creative Growth* and *Creative and Mental Growth,* distinguished between two types of artistic personalities that he termed "visual" and "haptic." Simply stated, the visual artist tends to paint what he sees, the haptic artist how he feels about what he sees. Since the artist who paints how he feels about what he sees is generally described as an "expressionist," and since the terms "expressionist" and "expressionism" are more familiar in an artistic context than the more psychologically oriented word "haptic," I shall use them in preference to "haptic."

Visual expression is primarily dependent on sight; the artist has an objective and analytical attitude toward what he sees; he observes and records the scene before him, but tends to remain somewhat emotionally removed from it. This type of expression has constituted the dominant tradition in western European art from Renaissance to modern times, with emphasis placed more often upon strength of illusion than upon intensity of feeling. What Lowenfeld termed haptic expression drew more upon the tactile, kinesthetic, and emotional experiences of the artist, and therefore expressionism is concerned more with the expression of feeling than with the facts of appearance.

Since Lowenfeld's time much psychological research has been directed toward the problem of space perception, and this research has confirmed much of his thesis and provided clues to these differing responses. Experiments have indicated that people respond to and per-

ceive space in different ways: some people seem to depend upon visual clues rather than upon sensory and postural ones, whereas others appear to be more dependent upon tactile and postural factors in their interpretation of visual experience. Of course most people draw freely upon a combination of visual, tactile, and bodily clues. Subsequent studies have revealed that habits of upbringing, mother-child relationships, and sex roles, relate to these varying modes of space perception. There is also evidence to indicate that habitual ways of perceiving space are learned responses and can be modified by directed experiences. Finally, as one would expect, there is evidence that dependence upon postural rather than visual clues, and vice versa, is part of a larger personality make-up and is coupled with differing reactions to authority, differing degrees of rigidity in response to new situations, and so on. All these factors relate closely to art education practices, especially in the junior and senior high school years when art instruction is more systematized and directive than in the earlier years and, being more persuasive, can also be more conducive to conflict.

In general, the following characteristics differentiate the two types of artistic expression. The visual artist usually prefers to draw or paint a subject that can be observed—a posed model, a landscape, or a still life; the expressionist draws readily from imagination, indeed often prefers to work from imagination since this does not necessitate reconciling

44. Oil, 18 x 24. Age 16 years.
Essentially visual in its inspiration, this handsome landscape gives evidence of an ability to observe and analyze size, shape, color, and texture relationships, an ability that is the result of both training and temperament. Though literal, the painting reveals deep feeling for nature's spacious grandeur.

44

45. Oil on paper, 7 x 12. Age 14 years.
This painting of a scene in the Japanese Tea Garden in the Golden Gate Park was done the first time the artist attended a sketch class at the De Young Museum, San Francisco. The expressive quality of the painting results from the absence of classroom clichés. The way that foliage, branch patterns, paths, and architectural forms have been suggested indicates a strong empathetic response to movements and textures, that is, the visual experience seems felt rather than analytically observed.

visual impressions with feelings and ideas. The visual artist works for accurate proportions and perspective by analyzing the relationships of size, shape, color, and light and dark (Fig. 44). The expressionist prefers expressive exaggerations to accurate proportions (caricature is a popular form of expressionism) (Fig. 45). The visual artist instinctively strives for correct relationships of size and placement, whereas the expressionist often paints important objects large and unimportant ones small, as in caricature, where the characterizing feature is drawn large and those which do not give the subject its visual identity are drawn small. The visual artist tends to characterize objects by observing the forms and relationships of the main masses; the expressionist seems more sensitive to detail and achieves the character of a subject by an accumulation of telling details. Because the expressionist is less analytical toward his seeing experiences, objects are often represented by standardized symbols that are remembered as flat patterns and drawn without much variation.

Color is represented by the visual artist as it is seen, affected by light, shadow, distance, and its relationship to surrounding colors. The expressionist will color an object according to the color it actually is, or employ the color that he feels to be most expressive of the emotional qualities he wishes to communicate. For instance, a visual artist in painting a head notices the green and violet tones of the shadows and the pink and ochre tones of the lights, and tries to record the exact color relationships

that he sees existing between the lights and the shadows. The expressionist tends to paint the skin pink or olive or tanned (depending on the model's complexion) with little reference to the light and shadow, or he may select his color for the head according to an idea or feeling. In this case, a head might be painted green (to suggest a diabolical nature) or yellow ochre (to suggest poor health).

To illustrate the differences between the two types of expression still further one might refer to the work of two famous nineteenth-century artists, Degas and Van Gogh. Degas, even at his most impulsive, always relies on sharp observation and accurate draftsmanship, whereas Van Gogh, even at his most analytical, reveals by the swirling brush strokes and undulating contours the strong physical empathy that motivated all his work.

Actually, few people are purely visual or purely expressionist; most people have elements of both types of expression in their work, with one attitude slightly in predominance. In the past the majority of people who expressed themselves through drawing, painting, or sculpture were predominantly visual in their emphasis. This can probably be explained by the fact that since formerly expressionism did not correspond to conventional European artistic standards, the expressionism of youth had usually been discouraged before it reached maturity.

We realize now that the two types of expression are equally valid, that each expresses perceptions and qualities that are unique and valuable, and that it is important for each to be recognized and encouraged. Neither group should be forced into adopting attitudes and ways of working that are not meaningful to them, and all adolescents should see works of art of both types. El Greco, Van Gogh, Epstein, African masks, and Sternberg caricatures can suggest ways of working to those inclined toward expressionism; Velasquez, Vermeer, Jo Davidson, and classic Greek sculpture can inspire the visually oriented youngster. Methods of stimulation should be employed that will develop both attitudes. When a child is sketching a figure in action, his facilities for visual analysis can be encouraged by having him observe a posed figure (observing oneself in a mirror is an excellent device) and getting him to see the relationships of the body parts to one another—the diagonal line of an arm and leg in action, the countermovement of twisted torso, head, and neck. Sighting the body along a pencil held first vertically and then horizontally in the hand is one device whereby the artist can perceive how the angles of the various parts of the body create the illusion of movement. The expressionist capacities will be stimulated if we encourage the child to take the pose, think of how the arms, legs, and body feel, and sense the tenseness of muscles, the twist of abdomen, and the bend-

ing of neck, or if we stimulate the imagination by encouraging the artist to imagine himself in the situation that is being drawn, to act out the situation, to feel the poses vividly, and then to start his drawing, painting, or modeling. Furthermore, since it is now recognized that people are not born with either tendency dominant but are shaped by experience, teachers can broaden the range of perceptions and expression by providing all children with stimulating experiences of all types, visual, tactile, and postural.

General Characteristics of Adolescent Expression

Whether the adolescent is a potential expressionist or likes to draw "what he sees," whether he wants to be a Michelangelo, a Picasso, or a Gus Arriola, certain common characteristics distinguish the artistic expression of teen-agers. The most fundamental characteristic was touched on when the changing point of view about play was discussed: the increasingly critical attitude of the adolescent toward his own work. Partly because adolescents are becoming intellectually mature and therefore have adult critical faculties, partly because their insecurity demands the approval of friends, teachers, and parents, their work is extremely important to them, and their feeling about it moves in cycles of elation and depression. They are therefore very sensitive to criticism.

Parents in particular must be thoughtful in their reactions to the art work of adolescents, since young people are irritated as much by what they consider uncritical parental pride as by a hypercritical attitude. Sincere effort should be made to take any work seriously, even if it is only a quickly scribbled cartoon. When a piece of work is presented for consideration it should be studied thoughtfully and the good qualities mentioned; the weaknesses and faults should not be stressed unless criticism is requested. Criticism should be specific but not dogmatic and whenever possible should help the young artist discover the weaknesses for himself. For instance, if a parent were asked to criticize a drawing of a human figure in which the hands and feet appeared too small (a fault commonly found in adolescent drawings of the human figure), he would be wise to start the criticism by pointing out the good qualities and then to say "But the hands and feet disturb me." This might lead to a discussion that would help the artist discover that the hands and feet were too small. Such an approach is better than saying "The hands and feet should be bigger," although either statement would be preferable to "I don't like it, but I don't know why." Most discouraging of all to young people are the remarks that, through their complete lack of sympathy, betray jealousy and hostility. Such remarks as "Don't try so

hard to be different" and "Quit wasting your time, you'll never be an artist" fall into this category, and even sympathetic parents in moments of impatience can react in this way. Adolescents accept critical remarks more readily from teachers, since criticism is an acknowledged part of the teacher-student relationship; but here, too, a constructive and sympathetic approach is essential.

Besides the self-critical tendency and the sensitivity to criticism so characteristic of the adolescent period, there is a strong expression of the newly awakened sex drives. This appears at its most obvious in the frequent drawing of idealized heads and figures of the opposite sex, as well as in a taste for idealistic, romantic, or sentimental themes. The choice of macabre, morbid, or violent subjects and effects can be a negative expression of the same drives, sometimes revealing fear or timidity in relation to sex and sentiment. This censoring and sublimating of sex impulses is frequent, particularly in early adolescence when girls draw and paint horses, while boys, like Adonis, reject Venus to pursue the chase in drawings of sports cars and racers. When one studies the nonrepresentational work of teen-age artists, one discovers that many of the abstract or stylized motifs and symbols employed are also sex symbols, unconsciously disguised. Not all the adjustments the adolescent makes to his newly awakened sex drives are so obvious: the intense interest and enthusiasm that teen-agers bring to their creative activities are an expression of this same emotional growth. This role of the arts was stressed in a study made by the Progressive Education Association Commission on the Secondary School Curriculum in 1940, *The Visual Arts in General Education.*

Another strong need is that of asserting the ego and establishing personality characteristics that both conform to group standards and yet stand out as individual, and to a degree even eccentric, traits. Thus the adolescent artist strives for unique elements of style, personal kinds of subject matter, a characteristic way of drawing the human head or figure, a highly individualized monogram, and at the same time seeks for recognition by employing his talents where they will receive the most attention. Illustrating and cartooning for school publications, making posters to advertise school events, and designing and painting sets for school or community plays are usually preferred to "art for art's sake" activities by extrovert personalities. Students less sure of themselves, in the attempt to avoid any test of public approval, may cling to "art for art's sake" and intensify the singular character of their work.

With the increased intellectual maturity of adolescence and the more sustained span of interest comes a more independent and disciplined approach to acquiring knowledge and techniques. The teen-ager, when

personally interested, is capable of a sustained and systematic inquiry into such fields as figure drawing and human anatomy, perspective, and theories of composition, as well as into the methods of using various media. We have all seen adolescents acquire professional abilities in some skill that interests them intensely. Recently, a boy of about eighteen brought me a very impressive collection of oils, water colors, and charcoal and pencil drawings, all of which had been done in relatively isolated circumstances and without instruction. When I asked him how he learned to handle the various media, he said he had sent to the state library for books and had simply followed the suggested procedures.

Both parents and teachers will be wise to encourage independent explorations into new techniques or new types of expression. As young artists develop beyond the confines of home and of the teacher's skills and resources and learn to work seriously on independent lines, the groundwork is established for mature achievement. Much serious exploration by youthful enthusiasts has been stamped out by the "that's not the assignment" attitude, as though any imposed assignment were ever as important as self-motivated growth. As the world opens up to the adolescent, its endless resources represent both an enticing wealth of exciting experiences and an intimidating maze. Freedom of choice must exist for the teen-ager, but firm direction and willing assistance must also be available. Many people who try unsuccessfully to guide youngsters during this trying period of growth are themselves still too adolescent to prove adequate to the challenge. Perhaps more than any other age group, adolescents need adults.

Summary

Because adolescence is the transitional stage between childhood and adult life the role of the arts in shaping ideals and expectations is of particular significance. The arts provide a means for extending experience beyond the boundaries of self, family, and community so that the adolescent may achieve an intellectual, emotional, and social growth commensurate with the physical growth that is occurring. Since strong personal involvement is more important than formal knowledge, young people should be encouraged to collect, observe, and comment on pictorial materials drawn from many areas of culture, including that of familiar, daily experience. Enthusiasm for magazine illustrations, advertisements, caricatures, prints, and photographs can lead to a discriminating love of paintings and other forms of art in later life. An interest in fashions, homes, and automobiles can be used to develop aesthetic

insights into architectural design, industrial design, community planning, and related fields.

Achievement is as important during these years as appreciation. Our society provides too few areas in which adolescents can assume adult roles that distinguish them from children. The arts provide such opportunities. Success in the arts does not depend on academic degrees or age, but on performance. The adolescent feels that by achieving distinction in the arts he places himself on an equal footing with adults, professional and amateur, whom he emulates and with whom, at the same time, he competes. The arts provide socially acceptable channels through which the adolescent can express his rebellion against his elders and the conventions of their world. The arts are also natural outlets for imaginative play instincts, providing a means for the sublimation of emotional conflicts and sex drives. And they provide a vehicle for crystallizing the adolescent's maturing perceptions about life and society.

During adolescence the art of children who are primarily visual in their artistic expression becomes increasingly distinct from that which is expressionistic in its orientation. It is important that both types of expression be encouraged and recognized. Criticism must be sympathetic and constructive, and teachers must encourage any serious exploration even though such ventures may not coincide with classroom assignments.

VII ART ACTIVITIES IN JUNIOR
AND SENIOR HIGH SCHOOL

O U R age expresses its complex self through a bewildering variety of artistic forms. No school can provide instruction in all of them, but both teachers and parents should remain aware of the great range of artistic experiences that are available today. In this way youngsters whose needs are not answered by the school and community offerings can be introduced to projects suited to their particular interests and capacities. Many a sensitive and creative boy who is not interested in drawing and painting likes to construct models or work with mechanical drawing instruments; a brawny athlete, too energetic to sit still, may like welded metal sculpture. A class in Los Angeles, instituted years ago for problem girls, proved successful because the girls were allowed to design clothes for themselves on life-sized cut-out models. The girls were provided with large sheets of newsprint paper, large brushes, and poster colors, from which they designed and executed yards of patterned papers, which were then cut and draped on the cut-out figures. Many girls who had been completely unresponsive to school showed interest, intelligence, and talent in this class, which capitalized on their interest in their own appearance. Rosabell McDonald, in *Art as Education*, tells how stagecraft, in her capable hands, provided the means for reintegrating potentially delinquent boys into responsible participation in the life of the school. And under the direction of a sympathetic local high school teacher who considered self-discovery more important than class assignments, a very intelligent, outwardly cynical, lonesome youngster found his forte by taking brilliant photographs for the school yearbook.

Examples of this type could be multiplied endlessly, but the point has been made. To realize the full potential of the arts in providing

creative experiences to answer the varying interests and temperaments of young people, a panoramic view of the art curriculum is necessary. The following list has been compiled to present such a view, as briefly as possible, and the subjects have been arranged alphabetically to avoid any inference of degrees of importance.

1. Architectural Design. Architectural design, broadly conceived, includes house design, interior design, city planning, and related fields in both two and three dimensions (model building).

2. Art Appreciation. Art appreciation should be conceived to provide experiences in both the fine arts and the space arts (art in everyday life), and should also include an historical orientation in which the arts are considered as an expression of the life and thought of the culture or civilization that produced them. Activities based on history, such as building a model of a Roman amphitheatre, can make the subject alive for even nonacademic temperaments.

3. Commercial Design. Commercial design includes lettering, packaging, typography, poster-making, advertising layout, and related publicity media.

4. Crafts. Ceramics, jewelry, metalcrafts, textile decoration, leather work, weaving, and stagecraft are the crafts most often found in the high school.

5. Design. A broad and all-inclusive curriculum term covering decorative design, color theory (e.g., color wheels, color schemes), and introductory activities in many professional fields such as costume design, fashion design, and stage design.

6. Drafting and Mechanical Drawing. This usually consists of exercises with mechanical drawing instruments and drafting symbols. These activities are most meaningful when related to architectural design or industrial arts projects.

7. Drawing and Painting. A world in itself, ranging from disciplined representation, through varying degrees of free interpretations of visual experience, to purely abstract expression. A wide selection of media expands the possibilities of this already expansive field.

8. Display and Flower Arrangement. The art of arranging and displaying provides many opportunities for the creative assembling and combining of forms for both decorative and practical purposes.

9. Photography. Photography probably has more followers among young Americans than any other art form. Its possibilities in providing opportunities for creative expression remain almost untouched by most art classes (Fig. 46).

10. Print-making. Block printing, serigraphy, engraving, intaglio

46

46. Color photographic transparencies, 2 x 2. Age 18 years.

The camera is a marvelous instrument by means of which, unhampered by problems of drawing, we can explore the character of the visual world. This photograph of a piece of coral was one of a series made by a high school senior who had taken excellent conventional photos but subsequently wanted to experiment with color transparencies for projection. By photographing details of surfaces and forms and projecting them to the full size of the screen, he created some very handsome abstractions.

processes, and monoprints, all of which can be used either for pictorial or for decorative purposes.

11. Product Design. The term product design is used today to cover much of what was formerly called industrial design. It ranges from designing furniture, automobiles, and household appliances to designing such simple items as ball-point pens and toys.

12. Sculpture and Modeling. Modeling, casting, and carving, either representational or abstract; media ranging from clay to welded iron provide three-dimensional opportunities comparable to those that drawing and painting offer in two dimensions.

No one short book can fully cover the technical and aesthetic aspects of any one of the above dozen general fields, let alone all of them. I shall therefore limit the subsequent discussion to a summary of some of the more important aspects of those arts that are most frequently practiced by young people today.

Painting and Drawing: Representation

The teen-ager who is interested in portraying the world about him, whether on an objective-factual or subjective-expressionist level, usually finds that the problems of perspective, foreshortening, figure drawing, and composition that challenged him between six and nine years continue to plague him, indeed become intensified. The adolescent aim is to make his artistic efforts conform to the conventions of the adult art world. Consequently, awkwardness and naïveté prove disturbing, particularly to the more intelligent and talented students, who precisely because they are intelligent and talented are the most critical of their own work. Feelings of frustration are intensified when they recall the ease with which they handled complex themes in their childhood. When this happens, the adolescent needs to be reminded of the arbitrary and nonanalytical character of the artistic expression of small children, as contrasted to the more mature and complex aims of the teen-age group, and he should then be encouraged to try simple subjects such as a single figure or head, or to treat whatever subject he has chosen in a generalized rather than a detailed and individualized way.

Much adolescent drawing and painting is illustrational, often being inspired by literary sources. School themes (Fig. 47) and school personalities are frequently pictured or caricatured. Portraits, self-portraits (Fig. 48), figure sketches, and stylized or symbolic treatments of the human figure (Fig. 49) are the favorite subjects; animals also are popular, horses being a particular favorite among girls in their early teens. Drawing the human figure and animals demands great skill, and since both human models and animals are difficult to procure, adolescent artists frequently have to turn to other standard kinds of subjects such as landscapes, still lifes, and street scenes, or they must attempt to draw and paint from memory or imagination.

Memory Versus Imagination

In discussing creation from other than purely visual stimuli there is seldom a distinction drawn between working from memory and working from imagination. The term memory suggests simple recollection, and this particular faculty occasionally accompanies a strong visual bent, certain people having the ability to conjure up a very precise visual image. Imagination, on the other hand, suggests creative fervor, an ability to conjure up highly emotionalized symbols, whether they be essentially visual or expressionist in character. Since memory suggests a somewhat passive recalling of visual impressions, it is generally agreed that it remains at best a supplement to actual seeing, and many

47

48

47. Line drawing. Senior high
school student.
48. Colored chalk, 19 x 25. Age 18
years.

Because of his interest both in
self and in the social group, the ado-
lescent finds portraiture particularly
satisfying. This line drawing is un-
usually effective in communicating
the emerging capacity for affection
and sentiment, while the self-portrait
(Fig. 48) reveals an introspective
self-examination.

49. Black and white poster paints. 18 x 24.
Age 14 years.

In this powerful study an adolescent girl
has used the human head as a starting point
from which to develop an expressionist simpli-
fication of form. The bold, almost Gothic aus-
terity of this head provides a striking contrast
to the usual preference for pretty faces.

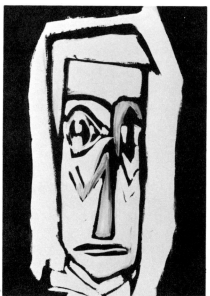

49

artists who are primarily visual in their orientation feel that drawing from memory during the formative years of adolescence discourages the development of powerful, incisive skills and tends to encourage the re-gurgitation of artistic clichés. It must be recognized, however, that art-ists who feel this way are usually themselves very dependent upon visual stimulation, this dependence having been built up through habits of drawing and painting only from models, still-life arrangements, land-scapes, etc.

Working from imagination seems to come most naturally to students who are expressionist in their orientation and who take their cues for expression as readily from postural and tactile experience as from visual. Such people often express themselves more vividly from imagination than from fact and achieve their highest level of creative vigor when they are not confused by the presence of the posed subject. Most stu-dents have both visual and expressionist potentialities, and both re-sources should be developed. If during the impressionable years of adolescence the habits of working both from observation and from imagination are developed, the range of expression is greatly strength-ened, particularly when the two capacities are developed not as sep-arate functions but as interrelated activities.

Imagination seems to be a characteristic of the creative person; in fact the dictionary defines imagination as "the creative faculty." Good teaching can act as a catalyzer of imaginative activity and can help stu-dents establish the habits of projecting themselves into situations that contribute to creative fervor. By encouraging students to read, to listen to music, to observe eloquent and moving works of art, to discuss the experiences they are about to depict, and to project themselves into psychodramatic situations, teachers can stimulate the heightened mood essential to imaginative creation (Fig. 50).

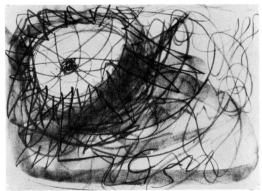

50. **Colored chalk, 18 x 24. Age 12 years.**
Music stimulated this youngster to visualize his response to sound in un-hampered, rhythmically organized lines and tones. Music, literature, and cinema are particularly effective in producing a heightened emotional state in which many normal guards against the direct expres-sion of feeling are removed.

50

Whether students are working from imagination or from direct visual stimuli it is important to encourage the use of immediate personal experience rather than conventional materials. The average backyard provides a more interesting subject than a pastoral landscape; a still life of baseball equipment is more interesting than yet another "Still Life With Vase and Flowers"; and a sketch of three bicycles on the lawn will create a more original and interesting pattern than a painting of a romantic sailboat from other days. The habit of finding material in one's immediate environment provides a way of integrating the adolescent and his creative impulses with the social milieu in which he is living.

Abstract Painting

An increasing number of contemporary painters prefer to express themselves in nonrepresentational (abstract) terms, and this preference is reflected in much of today's painting by adolescents in and outside the classroom. A conscious concern with composition becomes increasingly important to the artist as his paintings become more abstract, for the power of abstract painting is completely dependent on the compositional use of the art elements. Representational painting communicates through two channels: through the composition of the art elements and through the connotations of the objects represented in the work of art. For instance, a traditional portrait conveys its ideas through the colors, forms, spaces, line movements, and textures, and also through the symbol of a human head with all the overtones of sentiment, idea, and feeling that are aroused by that head. Abstract painting, on the other hand, relies for its emotive power solely upon the relationships of line, color, form, texture, and space, much as music relies solely upon the relationships of tempo, pitch, volume, and other qualities of sound. Modern painters believe that by eliminating or minimizing the traditional representational factor, many new areas of sensation and experience can be investigated, and new concepts discovered and communicated.

Many contemporary painters are particularly concerned with certain compositional aspects of space. The picture plane, or surface plane of the painting, is accepted as an inviolate element of painting, and the creation of illusionistic space to destroy the sense of a flat picture plane is discouraged. Instead of the traditional illusionistic space that is created by linear and aerial perspective, the artist creates a sense of space within the canvas by the overlappings of form and pattern, by the advancing and receding qualities of color, and by dark-and-light contrasts. Abstract painters are also very interested in exploiting the expressive

tensions and dynamic qualities that result from all types of contrasts—contrasts of form, line, color, paint textures, and space. And, finally, the exploitation of the significant and expressive aspects of various media is another subject that fascinates most abstract painters, who devote much of their energy to developing the aesthetic factors inherent in each medium. An extensive literature on modern abstract painting is available to those who are interested.

Composition

An essential part of the creative act is establishing the relationships within a work of art that are implied by the word composition. One might define composition as "the arrangement of the art elements for expressive purposes." Every work of art, whether it be a casual sketch or a complex and carefully thought-out painting or sculptural group, has such an "arrangement for expressive purposes" as its organizing factor. The composition, organizing system, or structure (the terms are interchangeable) is present whether the artist is conscious of it or not. Composition may be complex, logical, carefully worked out, or it may be simple, intuitive, and achieved without conscious premeditation; neither type is superior to the other. Adolescents as well as mature artists find that too great preoccupation with compositional theories in the early stages of creative activity blocks the free flow of ideas by retarding and complicating the initial procedures.

The act of composing often evolves in the series of steps described in the discussion of the creative process (p. 10), with the elements of the composition usually arranging themselves readily in the third, or outpouring, stage of creation. A painting, drawing, or piece of sculpture usually begins with an idea or enthusiasm. This may be followed by a series of tentative plans, often abandoned before they are half sketched, in which there is a free playing with lines, forms, spaces, colors, and textures. (If a person thinks in terms of "things" rather than art elements and is planning to paint a landscape, he begins by casually sketching in hills, trees, clouds, buildings, roads, and the like.) After an initial arrangement has been established, there follows the rapid and rather certain development of the main features of the work, as well as the enrichment of many of the details. During this period, the third stage, the artist, completely involved in the work, tends to be uncritical, and the work proceeds rapidly. Last, a more objective and critical phase commences, the artist moves objects, changes the size of parts, modifies colors, and lightens and darkens according to his critical values.

The Art Elements.—The definition of composition as "the organizing

of the art elements for expressive purposes" needs elaboration. The art elements or "plastic" elements, as they are also called, are the basic elements with which the painter, sculptor, or designer works, since they represent the perceptible surface qualities of all the objects we see about us. When somebody who thinks in terms of art elements sees a head, he sees basic *form* (an egg-shaped mass), with a directional movement in space that constitutes its *line*. (If you were to draw a line that represented the axis of the head, which way would the lines run?) The surface of the form has *color*. It has also a variety of surface qualities (roughness, smoothness, etc.) that we call *texture*. And, last, there are intervals of distance between and surrounding the forms, which we call *space*. These five are the art elements: form, line, color, texture, and space. When an artist creates a work of art, he composes with some or all of these elements.

Art Principles.—Compose is a verb, and the word describes an act. As stated, the art elements of line, form, color, texture, and space are the basic materials that the artist composes. The act of composing consists of organizing these elements, and the process of organizing is regulated by an aesthetic logic, a sense of rightness, that is highly personal but seems related to certain generally accepted principles. Early twentieth-century writers on composition identified a complex of principles—balance, repetition, rhythm, transition, accent, variety, domination, and subordination. More recently the list has been simplified and condensed to three principles: *balance* (a sense of equilibrium and logical distribution), *continuity* (a rhythmic relationship uniting the various parts of a work of art), and *emphasis* (a reconciling of the differences that give the work variety and interest).

One can learn much about a painting by examining the way in which each of the art elements has been organized in accordance with these principles. For instance, the use of color in a canvas may be examined to determine:

1. Whether the color is balanced; that is, whether the colors in the various parts of the canvas have enough visual weight to sustain an equilibrium of interests throughout the canvas.

2. Whether the color is used rhythmically to carry the eye easily from one part of the painting to another and establish a color continuity.

3. Whether the color is used so that the important areas are accented and the unimportant ones less emphasized; and whether the quality of emphasis contributes interest and variety.

If one applies this same procedure to line, form, texture, and space, one realizes the complexity of the organization that characterizes a fairly

simple painting or sculpture. However, this very analytical approach to a work of art contributes more to the development of adult critical faculties than to creativity. The adolescent's chief interest in compositional theories and principles lies in their ability to help him discover weaknesses that might spoil an otherwise effective piece of expression.

Composition and Expression.—The principles that we have just discussed describe the formal relationships by which the elements of a work of art make up a related whole. Of more immediate use to the artist is a knowledge of the expressive potentialities of the art elements: that is, the way in which line, form, color, texture, and space can contribute to the communication of feeling. The following generalizations may prove useful in planning a composition or in evaluating the effectiveness of a work of art.

LINE. Dominantly vertical lines and masses create an atmosphere of dignity and grandeur.

Dominantly horizontal lines and masses create a sense of quiet and rest.

Dominantly diagonal lines and masses create action and movement.

Dominantly angular line movements create an agitated, harsh, and dynamic feeling.

Dominantly curved line movements contribute grace, ease of movement, fluidity, and lyric tone.

FORM. The illusion of solid form creates a sense of weight and reality.

Solidity of form intensifies the kinesthetic and empathetic appeal of the work.

The illusion of weight and volume contributes to feelings of gravity, grandeur, and sobriety.

An absence of weight (flatness) emphasizes the decorative aspects and patterns of a subject.

Lack of form helps the viewer dissociate himself from the subject, contributing to abstractness, airiness, and a light, fanciful mood.

COLOR. Color has three dimensions of character: *hue*, which refers to its color identity (its redness, orangeness, yellowness, greenness, blueness, or violetness); *value*, its darkness or lightness; and *intensity*, its relative purity (brilliance) or dullness. To illustrate these dimensions of color one might analyze and compare two familiar color concepts, navy blue and sky blue. Navy blue is *blue* in *hue, dark* in *value* (almost as dark as black, the darkest conceivable value), and *dull* in *intensity* (that is, one does not get a sensation of purity or brilliance of color). Sky blue is also *blue* in *hue,* but *light* in *value* (almost as light as white, the lightest conceivable value) and *medium* in *intensity* (that is, in sky

blue the purity of the color seems only diluted by the presence of light).

These various dimensions of color also affect the expressive character of color. Realistic colors convey a dominant concern on the part of the artist with objectivity and "fact"; nonrealistic colors suggest a concern with feelings, moods, and other subjective attitudes. Red, orange, and yellow are the most active, positive, and *hot* colors; blue, green, and violet tend to be recessive, negative, and cold. Intense (bright) colors are vigorous, naïve, and active. Subdued colors are refined, subtle, and passive. Dark colors and dull colors are somber, depressing, dramatic, and moody. Light and pale colors are sentimental, restful, feminine, and poetic. Color schemes characterized by great contrasts of hue and of light and dark create bold, emphatic, and forceful effects. Color schemes characterized by slight contrasts of hue and of dark and light create subtle, refined, and restrained effects.

TEXTURE. Rough textures provide surface animation and suggest vigor, masculinity, and a casual, informal character. Smooth surfaces suggest refinement, femininity, formality, and careful finish.

SPACE. When form is present in a work of art, space is automatically implied as existing between and around the forms. Deep space in a composition suggests great size and grandeur, and carries implications of man's smallness in contrast to the infinity of the universe.

Shallow space suggests the immediate, the intimate, the casual, and the familiar.

These concepts can provide a useful framework for analyzing both one's own work and that of others. Faced with a composition, one might ask a series of questions of the following type, based on the above generalizations. Do the main lines in the composition establish the proper mood of monumentality (verticality), quiet (horizontality), or action (diagonals)? Is the form too solid to create the fanciful, dreamy atmosphere that is desired? Is the color too literal for a fantasy? Is the texture of the finished work too smooth to suggest the casual, sketchy quality desired?

Other kinds of questions one might ask are as follows. Is the basic arrangement of the major elements of the composition ingenious and interesting? Do the contrasts created by color differences and dark-and-light differences focus attention on the various parts of the picture according to the degree of their importance? Are the main areas sufficiently varied in size and shape so that they create an interesting pattern? Has obviously central placement of important objects been avoided? Do important lines divide the picture into equal-sized parts? Is the paint applied so that the texture is varied, not monotonously

smooth or rough? Is the application of paint sufficiently direct so that the character of the medium (fluidity of water color, thickness of oil) is apparent? Are the brush strokes or crayon marks in evidence so that the observer can follow the artist's activity?

Style

Every work of art seems to have a quality of inner consistency: one feels that its forms, lines, colors, textures, and spaces are related by the very fact that they were done by one person; this quality gives them a unique cohesiveness that is called style. If you cut a figure from a magazine illustration and fit it into a picture by another artist, you find that even though the figure is the correct size and makes sense in the picture, it somehow remains conspicuously apart from the rest of the work; it has a different style. An important part of adolescence is the development of a self-identity, and artistically this means the development of a personal style (Figs. 51 and 52). In encouraging the development of a personal style it is important to stress honesty of expression as the desired goal rather than uniqueness or originality, since an undue striving for uniqueness too often results in a highly mannered way of working or in the imitation of the highly individualized styles of mature and sophisticated artists.

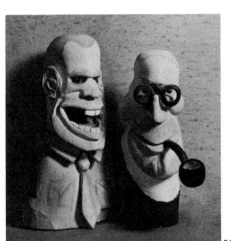

51

51. Carved and painted wood, about 6 inches high. Age 15 years.
52. Pencil drawing, 5½ x 8½. Age 15 years.
The two carved heads and the pencil drawing were done largely at home, but with assistance from the art teacher. This high school boy found a popular outlet for his unusual abilities through the sense of humor that determined the character of both his drawing and carving. Many adolescents never find popular and constructive outlets for their abilities.

52

Very often students do their best work outside the classroom, since out of school they are free to follow their own tastes and discover their own areas of competence and their own styles. This can either indicate stimulating teaching or be an indictment of the lack of it. Whether it be done in or outside the classroom, students should be encouraged to regard their work as a reflection of their own personality. In studying their own work, students might be encouraged to ask: If twenty other people did the same subject what would identify my painting as uniquely mine? How can I intensify this personal quality?

Three-Dimensional Expression

Most teachers and parents give too little thought to activities in three-dimensional media. Painting and drawing develop naturally out of the paper, pencil, and book world of our traditional schools. Consequently, we think more readily in terms of those activities than in terms of modeling, carving, and constructing (Fig. 53). This is a pity, for many temperaments derive great satisfaction from shaping materials into permanent sculptural form. Modeling is no more difficult than drawing or painting, but young people model less frequently because the processes are less familiar to most of us, and the materials less convenient to store and handle. Admittedly, carving, casting, welding, and soldering involve complicated procedures, fairly expensive tools, and extensive work space, but they are fascinating occupations and provide a valuable introduction to many industrial techniques. Moreover, they are not beyond the abilities of adolescents if genuine interest exists and if guidance and adequate facilities are available (Fig. 54).

The initial goal in undertaking three-dimensional activities should be

53

to gain an understanding of the nature and potentialities of the material being used. For instance, experimenting with clay reveals that extruded parts, or thin and extended parts, break off. Fine details readily lose their precision and clarity. Thus it follows that compactness of form and generalized large masses are the qualities best suited to clay. Indeed, a good way of introducing students to the whole field of three-dimensional activity is to have them explore the properties of many materials before starting work on any one of them; in this way the frequent tendency of young people to try to impose a preconceived idea on a resistant material may be avoided. Students should be encouraged to work on materials that they discover through their own explorations. Excursions planned as treasure hunts for materials can sometimes stimulate new ideas; for instance, a trip to the site of an old mansion or public building that is being demolished or the provocative shapes of stones and driftwood seen at the beach can suggest creative approaches to sculptured form.

While the nature of materials constitutes one approach to sculpture, another concerns itself with basic forms. Students can be stimulated to think successively in terms of (1) blocked-out shapes, (2) modeled shapes, (3) perforated (bored-through) shapes, (4) equipoised (suspended) shapes, and (5) kinetic (moving) shapes. And in *Vision in Motion* Maholy-Nagy suggests many other approaches to sculpture. "Sculpture can be approached from different viewpoints: tools, materials, form, volume, size, proportion, balance, positive-negative, setting, expression, light, etc. . . . the form is the result of many components: will, tools, reactions of the materials synthesized in the process of making. This in turn changes over into a quality of expression."

53. **Toothpick stabile, about 3 x 8. Junior high school student.**
54. **Silver and semiprecious stones, 1⅞ inches high. Age 17 years.**

The range of experience that can be provided by three-dimensional activities is frequently underestimated. The toothpick stabile, a simple essay in structure, expresses openness and lightness of form, while the metal figure is compact and weighty as befits silver. The silver figure reveals unusual technical skill, a sensitive feeling for sculptural form, and a high level of invention. Unfortunately the back of the figure, which has two semiprecious stones inlaid in it (thus making it a kind of sculpture-jewelry), cannot be seen in this photograph.

54

Mr. John Stenvall, a unusually inventive teacher, compiled the following list of three-dimensional projects that might stimulate individual creativity among secondary students:

Mobiles and stabiles—in varied materials such as wood, metal, plastic, cardboard, scree, wire, etc. These should be made for specific spots in the school or for the home.

Clay modeling in figure-sketching class—either portraiture, full figure, or caricature.

Abstract hand sculpture in wood, metal, or stone.

Collapsible chairs for summer use of wood or metal and canvas.

Automobile design in clay or plaster.

Clear plastic cast figures with enclosed wire forms.

Pottery: thrown, shaped, or cast—bowls, dishes, tea sets, pitchers, book ends, candlesticks, etc.

Puppets—leather, papier-mâché, wood, felt, wood pulp, etc.

Lighting fixtures of metal and glass.

Outdoor garden sculpture in cast cement or stone.

Group sculpture pieces of school activities.

Model of the student's ideal home.

Table centerpieces of paper or wire on various themes.

Abstract set pieces for dance programs.

Rubber figures for water carnival props.

Jewelry—cast, *repoussé*, formed, etc., of metal, bone, wood, gem stones, plastic, etc.

Projected airplane designs for the future, rocket ships, space platforms, etc.

Molded glass plates (fired in kiln in bisque forms).

Wooden toys for hospitalized children.

Unusual cake forms and decorations.

Ice sculptures for winter carnivals.

Snowmen for school yards.

Life-size (or larger) figures in wood and paper for summer carnivals.

Christmas tree decorations in metal, wood, plastic, etc.

Lamp bases, door knobs, book ends, etc. in magnasite.

Papier-mâché, metal, or wood decorative masks.

Decorative knives with bone, leather, wood, or metal handles.

Cast concrete bird baths.

Tin-can candelabra.

Plaster or metal mirror frames.

Carved plaster bas-reliefs or free-standing figures.

Bas-relief designs for commemorative coins.

Bas-relief mural for brick garden wall.

Forged andirons and fire grills in metal and screening.

Metal grilled doorway or gateway.

Metal or papier-mâché window display figurines.

Fruit or salad bowls in wood or metal.

Model units for exhibitions and displays.

Light modulators of paper, wood, or metal for use in making an abstract color movie.

Free-standing sculpture in foam glass.
Figures built up of plaster and fiber.
Lapidary work with native gem stones—in unusual shapes rather than the
typical cabochon shapes.
Bas-relief work in butter for state or county fairs.
Package design in folded or molded paper.
Carved or molded plastic chess pieces.
Flower arrangement, using native forms such as driftwood, boulders, etc.

The outline on pp. 114–15 indicates the tremendous range of design, construction, and appreciation activities open to adolescents both in the classroom and at home. Besides providing outlets for creative energies, these activities can suggest vocational and professional goals to the adolescent who is beginning to think about his career. In a short book like this it is not possible to discuss the many technical, aesthetic, and social factors involved in successful professional practice in these various fields; but the references at the end of this volume may contain helpful suggestions, and books on vocational opportunities are to be found in any good library.

Outside the Classroom

Nowadays, much of the painting, drawing, sculpture, modeling, and design done by adolescents takes place outside the classroom. This is mainly due to the narrow educational philosophy that determines the entrance requirements for most colleges and universities and obliges students to take academic "solids." Much of what is done by students "on their own" is fresh and original (Figs. 55 and 56). Because it is self-motivated, work done independently of class assignments develops habits of self-reliance and independence that are most important to mature creativity. The following section has been written to assist the many parents and students who are carrying on their art activities without the benefit of a teacher.

When drawing, painting, or modeling from nature without instruction, youngsters should be encouraged to paint simple rather than complex subjects (think of what a powerful painting Van Gogh made of an empty chair!), and when drawing or painting an actual object, to look at the model often and searchingly (Fig. 57) (it is not unusual to see a student work on a drawing for a half-hour, drawing, erasing, and redrawing, without ever glancing at the model from which he thinks he is working). Students who have received no direction or instruction commonly have a tendency to work too small, with consequent emphasis on a tight and detailed neatness. Too often their subjects are planned

55

55. Felt pen and ink, 8 x 10. Age 15 years.
56. Pencil, 3 x 6. Age 14 years.

Originality, perhaps the most valuable quality in artistic expression, appears most frequently when gifted young people follow their own impulses. Figure 55 was one of many dozen designs created in a few months by a high school student as a kind of glorified doodling. This exploring and inventive arabesque represents a sensitive playing with lines, overlapping movements, and simple textures. The gift of a felt pen, at the fortuitous moment when the designer of Figure 56 was bored with classroom assignments in charcoal and pencil, precipitated a series of bold, inventive designs.

57

57. Chalk, 20 x 24. Age 16 years.

Here freedom of execution facilitated searching observation. Since the dog would not hold a pose for more than a few minutes, the use of chalk and toned paper enabled the artist to work freely and make rapid notations of form. An assignment like this is also efficacious in correcting a tendency to draw with tight, hard outlines.

in pencil, with the result that the development of the work is inhibited by the pencil outline and dominated by the concept of outlining and then filling in between the outlines with color or dark and light. In such work the medium is usually used in a thin and characterless way. Modeling and sculpture will also usually be too small to permit the development of vigorous masses, and this contributes to a finicky, cramped effect. A third common evil encountered among those who work by themselves is the tendency to copy. Copying is probably the most pernicious habit that an adolescent can develop, since it undermines resourcefulness and stultifies the powers of analysis and observation. Copying is worth while only when it is done to find out how a certain effect has been obtained.

The antidotes to the above faults or weaknesses are obvious. For working too small the antidote is to increase the size of the work. Many beginning painters develop the habit of working too small from working with small brushes, often bought because they are the cheapest. The tendency to be dominated by pencil outlines can be overcome by executing the initial sketch in the medium that will be used for the completed painting or, if a preliminary pencil sketch must be used, by keeping the initial sketch loose and free. A delight in using the medium —enjoying the heavy richness of oil, the fluidity of water color, the rich plasticity of clay—is the key to an expressive use of the medium and in itself ensures against a negative, characterless handling. The antidote to copying is to develop the habit of working from observation or from imagination. This change in work habits is often difficult to achieve, since the person who has become accustomed to copying is frequently discouraged by the crudity of the results when he first paints directly from nature. Working from a book such as Nikolaides' *The Natural Way to Draw*, or with a good reference book on sculpture or life drawing, often provides a transition to a more independent approach.

Students who prefer abstract or highly stylized kinds of painting or sculpture are more independent of traditional skills and knowledge. They are less apt to miss the typical classroom situation. They find salvation by themselves and often gain more from following their own unconventional impulses and tastes than from direction. Such artistic personalities usually profit most from inspirational experiences—seeing exhibitions of paintings by artists they admire, reading books about their favorite masters, and visiting galleries and museums. Adolescents who are stimulated by new and experimental types of expression should see as many as possible of the large annual exhibitions that are organized to give the public a cross-sectional view of contemporary art. When this is not possible, well-illustrated publications showing contemporary trends in painting and sculpture can provide a fair substitute.

A difficult aspect of development for even the professional teacher to evaluate is the relation of techniques to effective expression. One cannot arbitrarily say that neatness, methodical procedures, and formal knowledge (such as theoretical perspective) should always remain subordinate to expressive aims, attractive as such a statement may sound, since many people derive their greatest satisfactions from these workmanlike qualities. Such people often become master craftsmen and create works that are beautiful because they are beautifully executed. This type of artistic personality feels completely lost and frustrated when asked to give up systematic procedures and controlled techniques, just as the impulsive artists who achieve their most effective expression when they are untrammeled can be completely defeated by involved and systematic procedures. A genuine belief in each person's ability to forge the methods best suited to his own needs is the best guide in determining which tendencies to encourage.

If a young artist enjoys methodical and precise procedures and seems to initiate them of his own volition, such procedures should be encouraged. If an impetuous kind of expression seems to come naturally, that in turn should be approved and directed. The logical choice of medium can contribute significantly to the development of work habits and techniques that are in accord with the adolescent's temperament. Personalities that prefer a direct and spontaneous kind of expression achieve the greatest satisfaction from working in oils, water color, chalk, pastel, charcoal, or gouache. They usually are not happy in the print processes, although linoleum-cutting allows for a moderately direct kind of expression. When working in three-dimensional media they prefer plasticine or clay to stonecutting or wood carving. Personalities that prefer the craftsmanlike approach usually are satisfied by oils (probably the medium that permits the greatest variation in handling), tempera, pen-and-ink, pencil, the print processes, carving in wood and stone, and working with metal, plastics, and other types of synthetics.

A common misconception is the assumption that in beginning to use a medium one should follow cautious and methodical procedures and that freedom and boldness of handling will come with familiarity. If a child who is starting on a new medium has a bent toward a free, uninhibited kind of expression, encourage him to experiment with the new medium in a bold and vigorous way. One learns to paint freely and boldly only by painting that way. Similarly, a controlled, craftsmanlike procedure also creates its particular capabilities. It trains one to develop great precision, to execute involved and highly formalized designs, and to include a tremendous amount of detail in a finished piece of work.

When growth seems to have been stultified by habits that are against

the learner's natural bent, a change can frequently be stimulated by introducing a new medium that will demand a different approach. This device does not involve a challenge to established methods of work and therefore often effects a change of approach without disturbing the young person's equilibrium. A friend of mine who was frustrated for years in her attempt to paint water colors in a free, impulsive fashion, which she greatly admired, finally found her medium when her parents gave her a set of wood-engraving tools. This girl was intelligent and systematic in her procedures, liked planning, and was a patient, cautious workman; her wood engraving profited from all of these qualities, which had only inhibited her free expression in water color.

To aid in selecting the medium best suited to the young artist's needs, the following list of media is given, with a brief statement of the working characteristics of each.

Painting Media

Oils.—Oils are probably the most versatile medium available for artistic activity; they can be handled either with boldness and freedom or with precision and care. The chief disadvantages are that the materials are rather expensive, the paints dry slowly, and since they are not soluble in water, the smears that inevitably get onto clothes and furniture are difficult to remove. Amateurs usually purchase a much more elaborate set of colors than is necessary. The aim in assembling a set of colors is to select a small group of basic colors from which one can produce a full range of hues, tones, and tints. The following set should suffice for most artists' needs:

yellow	light cadmium yellow
orange	cadmium orange
orangish red	light cadmium red or vermilion
purplish red	alizarin crimson
blue	ultramarine blue
blue-green	phthalocyanine blue
green	viridian
brown	burnt sienna
white	zinc white, lead white, or titanium white
black	ivory black

Water Color.—This medium is less versatile than oil, but involves less expense, dries rapidly, and can be used without any stickiness or smeariness. Until one has had considerable experience with water color,

it is difficult to control and tends to promote timidity of handling. Water color is best adapted to a free, sketchy, generalized treatment. In general, water colors are done on too small a scale (they should be at least 12 by 16 inches) and executed with a too small brush. A good all-purpose brush is a No. 10 or No. 12 round-tipped water-color brush. The list of colors suggested for oils is also suitable for water color.

Pastels, Colored Chalks, and Crayons.—There are a great many types of crayons, chalks, and pastels on the market, ranging from hard, waxy crayons to soft, smeary, chalklike pastels. All these media are easy to handle, since they resemble the familiar blackboard chalks, and they do not involve the use of a brush. They are best used freely and sketchily, but some of the harder grease or wax crayons can be used for precise and controlled techniques. Most of these media come in sets; the larger sets are best, since they include a greater range of colors. A good set should have some very dark colors, some bright, full-bodied yellows, oranges, reds, greens, blues, and violets, and a fair range of pale tints.

Tempera, Poster Paints, and Polymer Emulsion.—These are easy-to-use, rapid-drying paints that are soluble in water (like water color) and opaque (like oil). They are easier to control than water color and allow for considerable reworking. They can be used on paper or cardboard. Good-quality temperas are as permanent as oils. Since these paints dry rapidly, one cannot achieve the delicate blendings of color that can be produced with oils. They are best adapted to a bold method of painting in which the brush strokes are evident. The same basic colors are recommended as for oils. Poster paints are tempera paints packed in jars; they are used primarily by commercial artists. They are quite satisfactory except that many of the brilliant colors found in poster paints, such as magenta and turquoise blue, fade rapidly. The new acrylic polymer media use a synthetic plastic base. They have a more luminous surface than tempera, dry very rapidly, and are soluble in water.

Sketching Media

Pencil.—This familiar medium is convenient for sketching and making quick notes. A very soft drafting pencil or a carbon pencil is most satisfactory. Pencil is not ideally suited for finished works of art. It is difficult to build up a dark tone with pencil, and the narrow line produced by the ordinary pencil has little flexibility, expressiveness, or carrying power.

Charcoal.—Although it is messy, charcoal is excellent for bold, quickly executed effects. Charcoal produces rich masses of dark, and

since it can be erased or wiped out it is an excellent medium for making black-and-white studies. It is best when used for fairly large drawings. Compressed charcoal and black chalk produce blacker darks, but are harder to erase and messier. Charcoal pencils are not very satisfactory, since they combine the weaknesses of charcoal with those of pencil.

Conte Crayon and Grease Pencil.—The pigment here is carried in a grease base. Consequently, these media are not dusty and smeary, but they are difficult to erase. Grease pencils make a solid enough black so that drawings made with them can be reproduced by means of line cuts. (The line cut is the least expensive process commonly used in photo-engraving. Pencil and charcoal cannot be reproduced by line cut.)

Pen-and-Ink and Brush-and-Ink.—These are frequently used for cartooning since the ink line can be reproduced easily by means of a line cut. Pen-and-ink is a difficult medium, since ink runs easily and cannot be erased, and the pen line is inflexible and has little aesthetic quality. It is also difficult to build up a dark tone with pen lines. Brush-and-ink on rough paper produces a more flexible and expressive line, and also permits the modulations of solid blacks and whites by dry-brush techniques.

Print Processes

Making prints has a great appeal to people who like interesting processes. In addition, after an original "plate" is completed, a great number of prints can be made from it. Most of the print processes require considerable technical skill and some investment in equipment (Figs. 58 and 59).

58

Linoleum-Block Cutting and Printing.—This is one of the simplest print processes. It is best suited to bold and direct effects, but can be adapted to more careful and refined procedures. This medium provides a good introduction to the print processes, and it can be used for decorating textiles, printing holiday cards, and illustrating posters and books.

Wood-Block Cutting and Printing and Wood Engraving.—This is similar to linoleum-block cutting and printing, but since wood is a more intractable material, the cutting of the block takes more time and skill. Wood-block cutting permits of great precision and detail. Wood engraving is a very difficult and demanding process—beyond the abilities of most adolescents—but an unusually skillful craftsman would probably be challenged by it and consequently thrilled by accomplishment in the medium.

Monoprint.—This interesting and rarely practiced process demands little technical skill and produces interesting results. Monoprints are made by painting on a plate glass, or on a metal plate, with oil paint, printer's ink, or tempera paints. A piece of wet paper is then placed on the painted plate, and the design is transferred to the paper with the aid of a press. Monoprint is an excellent medium for introducing a young person to the print processes.

Serigraphy (Silk-Screen Printing).—For decorating purposes, making posters, and print making this is a very good medium. Serigraphy is particularly well adapted to making color prints. It is not too technical, but demands fair craftsmanship and neat work habits.

58. **Linoleum block, 2 x 3. Age 6 years.**
59. **Colored serigraph, 7½ x 9½. High school student.**

From six to sixteen to sixty the print processes provide media for self-expression that combine aesthetic values with challenging technical procedures. An element of drama always accompanies carrying a complex technical process to completion, for until the first print is made it is impossible to foresee the exact results. Even a design as simple as "Winter Is Trouble" gains in aesthetic interest by being cut in a block and printed. Serigraphy not only permits rich color, diverse textural effects, and large-sized prints, but also has many practical applications such as making posters, printing cards, and decorating textiles.

59

Etching.—Since the tones in an etching are made by massing lines, etching comes easily to a person who sketches well in pencil or pen-and-ink. Etching requires rather controlled and thoughtful procedures and involves considerable equipment, but is a very good activity for the serious student.

Lithography.—Lithography requires more equipment and space than is available to the average student. It can, however, be adapted to a wide range of work habits and is probably the most flexible of the print processes.

Three-Dimensional Media

Plasticine.—Plasticine is not a permanent material, but it is easy to work, and since it does not dry out, one can work on a project for an extended period of time. It is excellent for making freely modeled forms or for making studies. Work modeled in plasticine can be cast in more permanent form.

Clay Modeling.—Clay is easy to handle and has the advantage over plasticine that it hardens and can be fired into permanent form. On the other hand, it is difficult to keep in a working condition over a long period of time and is rather dirty.

Casting.—Casting modeled forms in plaster of Paris, metal, or synthetic stone is a complex, difficult, and fascinating process. It is a splendid activity for the person who is seriously interested in sculpture as an art and a craft.

Modeling with Synthetic Materials.—Some of the synthetic modeling materials that are now available can be shaped like clay or plasticine and will harden into ceramic or stonelike materials without firing. Magnesite is a commercial structural material that can be shaped or cast while wet and when dry has a handsome stonelike quality.

Carving Wood and Stone.—Carving is a much more arduous activity than modeling. Wood is easier to carve than stone, but even wood requires much time, patience, and considerable strength. Carving is a very satisfying activity for those who are capable of the sustained effort necessary for results.

Industrial Materials

Many sculptors are experimenting with modern industrial materials and processes in an attempt to revitalize sculpture by integrating it with contemporary industrial techniques. Wire, metal rods, sheet metal, plastics, wood, and other materials are shaped by lathes, drill presses, and

machine tools, and are welded, soldered, or bolted together to make ingenious, often mobile, abstractions. Experimentation with these modern materials and with machine techniques is intriguing to those who like shop practices and machine tools and who are ingenious and inventive. Such people are often innately sensitive to the aesthetic qualities of modern sculpture.

For additional information about artistic media, see the Recommended References, pp. 147–55.

Methods of Work

Most adult artists begin a project with a series of small sketches (Very tentative sketches of possible compositional arrangements, usually not more than 2 by 3 inches in size). It is easy to make a number of such sketches in a short period of time, and from these one can select the arrangement one prefers and proceed to work on a larger scale. Many adolescents profit from making simple preliminary sketches, but more elaborate plans are seldom rewarding. If elaborate planning procedures are employed, the impetuous adolescent is apt to find, like Leonardo da Vinci, that his interest has been expended in planning and there is no desire to execute the planned project. Also, elaborate plans are apt to be restrictive and not allow for the changes and modifications that occur in the development of any creative project. Certainly one should never feel that the final execution of an idea or design is merely copying a carefully worked-out plan.

A problem that confronts every artist is that of seeing his own work objectively. Most artists can see the work of another artist with much more clarity and objectivity than they can their own, since they are too involved in their own work to view it without bias. The following are a few devices that help to objectify one's own work and therefore enable one to be more analytical toward it:

Looking at the work in a mirror—the backward view being unfamiliar allows for a fresh evaluation.

Looking at the work in a reducing glass.

Putting the work away for at least a week without looking at it.

Putting the work in a frame.

Seeing the work in relation to other people's work. This is one of the great values that results from participating in public exhibitions.

Any person seriously interested in artistic activity is handicapped if he does not have a place in which work can be carried on without interruption from others. The work place should not be so elegant that the

worker is inhibited by the fear of making a mess. One of the best arrangements I have seen is a partitioned-off section of a double garage. This "studio" has become a meeting place for a group of high school students interested in art, and both good times and good work have resulted. Good light, both daylight and artificial, is needed; if possible, both should come from the same direction so that the artist may work on a project at any time without moving easels, models, and materials. A large, sturdy table (and, for oil painting, an easel) is necessary. And there should be storage space for materials, work in progress, and completed work.

Motivation

Much has been said in the last two chapters about the motivation and evaluation of art work on the junior and senior high school level, and most of the comments in Chapter V apply equally to teen-age children —with one significant difference. After the fourteenth and fifteenth year, young people become increasingly in tune with the adult world and therefore with its artistic expression. As a consequence, adolescents profit from and are strongly motivated by experiencing great works of art, particularly contemporary forms of expression. Attending exhibitions of painting, sculpture, the crafts, or any other field in which the student may be interested, visiting artists in their studios, seeing fine reproductions of works of art, and reading about the lives, techniques, and artistic theories of artists who are admired can provide highly valuable incentive and direction. The relationship between student and teacher is particularly important during this period of hero worship. Almost every artist can remember the impact of some adult whose personal interest during these formative years stimulated him to intense endeavor and consequent growth.

During these years a most important motivating factor, which operates both positively and negatively, is the influence of the "in" group at school, the tastes and interests of friends. Teen-age group contempt for intellectual and artistic activities has probably turned more American adolescents away from the arts than any other single influence. Fortunately this attitude is changing, and today an increasing number of high school and college students participate in and enjoy artistic experiences in their leisure time. Each year an increasing number of adults share these interests, both as amateur performers and as consumers. Attendance at museums and art galleries, books on the arts, popular magazine articles on artists and exhibitions, all are on the increase, and this augurs well for the intellectual atmosphere in which American adolescents of the future will be developing.

Outlets for Art

A discouraging problem that confronts the adolescent who paints, sculptures, cartoons, or carries on any other artistic activity is what to do with what he produces. The accumulation of paintings, drawings, or pieces of sculpture that are unwanted even when admired is one of the most frustrating circumstances of all amateur expression. Having the world's largest collection of one's own work can be very discouraging. Parents and teachers can ease this problem by stressing the importance of the activity rather than the importance of the product. Whenever possible, the adolescent should be helped to integrate his artistic interests and abilities with home life, with school, church, and other organizations, and with the community at large. Instead of buying Christmas cards, greeting cards, holiday and party favors, and personal gifts, adults can commission the adolescent to supply the family needs. There is a kind of commercial snobbery today that makes homemade gifts déclassé, and too often gifts are valued according to cost. Parents and teachers can do much to counteract this superficial snobbery by using children's drawings and craft objects as gifts. Nicely framed small sketches are also welcomed by bazaars, rummage sales, and other community money-raising events. Almost every social club, church group, or community organization is continually in need of posters, cartoons, flower arrangements, and favors. Many a high school student, if given the chance, can do better than his busy parents. Although such organizations generally require conventional solutions to the problem at hand, rather than original and unusual ones, they do provide an opportunity for young people to integrate their talents and abilities with the social milieu.

Young people should also be encouraged to enter their work in local exhibitions, county fairs, hobby shows, and community festivals. Participation allows the young artist to see his work in relation to the work of others and also gives him a chance to get the reactions of other people to his work. The adolescent who paints or draws will wisely standardize his pictures to a few sizes. A limited number of simple frames will then suffice for all situations, and the paintings can always fit in the frames at hand when the need for a framed picture arises.

Every community can provide opportunities for creative youngsters to exhibit regularly. The public libraries, public schools, church social rooms, and community recreation centers should be available for exhibits. In the city where I live, certain libraries have devoted their walls to children's exhibits for many years; the local art club has handled the scheduling and hanging of the exhibits. In the same city, an annual

community hobby show for adolescents has provided a fine opportunity for young people to exhibit examples of their taste and skill. The mere existence of an annual opportunity to exhibit work is a stimulus to activity throughout the year.

Certain museums hold an annual exhibition of children's work, organized in cooperation with the public-school system, and such exhibitions are well attended by adults and youngsters. A shop that carries artists' supplies always uses a wall to display the work of local artists, and young people have often taken advantage of this opportunity to show. Lack of opportunities for adolescents and other amateur artists to exhibit in a community merely means that interested adults have not worked together to sponsor and encourage such exhibits, since almost every community has agencies that will cooperate.

The productive adolescent may still find a burdensome and depressing quantity of work accumulating. When this occurs, the work can be grouped into categories of subject matter, media, and levels of development, and a selection of the best works in each category can be matted and stored in portfolios. Such a selection should be made only after sufficient time has passed so that one can see the work with some degree of objectivity. Whenever possible the selection should be made in conference with a sympathetic teacher, parent, or friend. The remaining work should be destroyed.

Adolescent artists should be encouraged to exchange work with other young people. In this way they can build up an interesting collection that will have both sentimental and educational value in later years.

Taking children through adolescence remains one of the crucial jobs of parents and teachers. Many of the concepts that served as guides to our elders in bringing us up no longer suffice. Patterns of living and ideas about personality and growth have changed. Both parents and children nowadays seem to be under more pressure than formerly. We parents, the children of the age of the airplane and the radio, are already outdated in the world of atomic power and television; technologically, we are outstripped; things have moved beyond us as they moved beyond our parents.

We are no longer certain that obedience is a virtue or drawing a necessity for an artist. We no longer believe that only specific colors are good together or that the Italian Renaissance represents the highest art development the world has known. We are not cynical, but uncertain. This is all for the best, since we may surely be absolved from showing young people what is good and true and beautiful if we ourselves do not know. Instead, we can do what is more rewarding: explore

these areas of thinking and feeling with our children and try to find the answers with them.

Many of the problems of adults in dealing with adolescents result from the attempts of tired age to cope with the overwhelming energy of youth. At times the need for patience, imagination, and sensitivity seems so overpowering that one looks for some alternative: a foolproof system for bringing up and educating children. There are no simple methods. But we can help by being as sympathetic to the expression of social, intellectual, and emotional growing pains as we are to the expression of physical ones. By remaining patient, sensitive, and imaginative in relation to each adolescent's creative potentialities we can do much to help young people find themselves. And helping young people find themselves is, in the final analysis, the fundamental responsibility of home, school, and community, of parent and teacher, since finding oneself constitutes growing up.

VIII CONCLUSIONS

WE have seen how the child, starting with a scribble, develops the ability to express himself through drawing, painting, sculpture, and many other artistic media. But sadly enough, despite all our educational facilities and ideals, many adults do not use this ability. I say "sadly" because deep within most people exists the desire to do things and make things, to "express themselves." One evidence of this desire is the creation all over America of sketch classes, adult craft classes, and art clubs.

Almost every city has an art club. Some of the older clubs were formed as art history clubs, but today most of them sponsor a vigorous activity program. The usual club is a going concern with from fifty to a hundred or more members, most of whom are amateur artists. A typical club sponsors a number of events—a lecture each month by an artist or art educator, occasional one-man or group exhibits, a program for exhibiting the work of artists of the community in the public libraries, an annual exhibition of the members' work, and occasional exchange exhibits with neighboring art clubs. There are also the usual teas, picnics, and money-raising events. Officers are elected, scholarships awarded, and good causes assisted.

These publicized doings of the art club are frequently peripheral to the studio classes, which constitute the most dynamic element of the program. The club in my own city has for years offered several very successful classes: a landscape-painting class in the afternoon, a drawing and painting class at night (frequently with models), a class in modern (abstract) painting, and a Saturday morning class for children. Sporadic classes in photography, craft activities, and flower arrangement have been organized by interested individuals or groups from time to time; these classes have not been so regular as the painting classes, partly because of a lack of work facilities. Altogether, about one hundred and fifty people are usually enrolled in the club's various classes.

This club—its membership is expanding—seems to answer a real need in the community. In addition to the club's classes, an adult education program in the public-school system offers a number of classes in art and crafts, and there are a few private classes as well.

If you have never visited any classes like these you will find a visit revealing. You will be disappointed if you expect a bohemian atmosphere, with tormented geniuses, beards, and picturesque personalities; even the models who pose in the life classes have a conventional, suburban look. The membership of the class represents a cross section of the community: housewives, clerks, lawyers, architectural draftsmen, stenographers, and public accountants, members of most professions and many trades, people from all economic levels of society. White-collar workers predominate, and craftsmen and mechanics seem to be found least often. The ages range from eighteen to eighty.

Many who attend the classes have taken art in the past in public school, some have gone to art school for a period of time, a few are in related professional fields, and others have had no previous training or experience. When you ask how they happen to have enrolled in these classes, you receive a variety of answers. Some have always been interested in art, others have always liked to draw, some wanted to study art but their parents discouraged them, and many studied art but gave up their studies to marry or to take a job or go to college. A fair number were not particularly interested in the arts before they began taking the classes, but having started, perhaps on the recommendation of a friend, have found unexpected satisfactions and have become enthusiastic art students.

All the members of the classes have one thing in common: they find that painting or drawing or taking photographs or making jewelry or ceramics is a marvelously absorbing activity that has become important to them. They all wish that they had more time to spend on their particular interest and that they had started earlier in life. The activity seems to answer a need to do things beyond making a living, caring for their families, visiting friends, and seeing movies and television.

Most of these people are not articulate about their inner yearnings and feel it would be silly to use high-sounding phrases, but what they do say is that they want to make things with their hands and to put down some of the beauty, color, and picturesqueness that they see about them. In other words, they feel a need to be absorbed in creative activity and they find such activity deeply rewarding.

The desire to "do things with one's hands," to "be creative," and to find a means for "self-expression" is particularly characteristic of our age. Perhaps this contemporary need to make things is the price we

pay for having been released from the continual energy-sapping labor of the past: the release of the housewife from baking bread and pumping water and washing clothes by hand, and the release of the working-man from a sixty- or seventy-two-hour work week. Or it may be that our hands, which over centuries of time have always been busy fashioning pots and flints, spinning yarn and weaving cloth, digging and cutting, have not as yet become accustomed to machine-made idleness and leisure. It may be that some social atavism is at work creating a desire to keep hands and minds happily occupied doing things, and that this drives so many hundreds of adults to classes, clubs, and hobby shops.

There may be another factor, too. Part of the role of education in a democracy is to develop the capacity for independent thought and action: to develop self-sufficiency, independence of viewpoint, and originality of expression.

All through our childhood years in school we are told to think for ourselves, to assert our priceless heritage of independence, not to be afraid of individuality and nonconformity; we are reminded that our ancestors were revolutionaries who came to this country to establish their independence. Then, as adults, when school is finished, we move into a culture in which conformity in tastes, ideas, and actions seems to be the order of the day. Our great industrial society continues to increase levels of productivity and consumption, but accompanying the machine-made abundance is a standardization of objects, tastes, and patterns of behavior. The person trained to cherish independence and individuality finds himself in a society in which these qualities seem to have little value. Many people solve the conflict through the arts, by digging deep within themselves to find and express the unique aspects of their personalities. When artistic activities are carried on with a sense of personal rightness as the main criterion, a level of independence is achieved that is possible in very few areas of modern life.

There is a third aspect of this contemporary desire for self-expression that should be mentioned, but hardly needs elaboration. In our day when the complexities of our social organization have created so much tension in both social groups and individuals, there is a great need for each person to find his particular oases of peace and tranquility. The absorption in the task at hand that comes when hand, eye, mind, and spirit are engaged in creative activity provides such oases for many a tense twentieth-century citizen. Any person who has attended an art class for adults has often heard his classmates comment with astonishment on the fact that they arrived in class exhausted and lethargic from the day's labors and left refreshed in body and spirit.

In his *Childhood and Society,* Eric Erikson makes an observation

that illuminates yet another aspect of creativity. "Every adult, whether he is a follower or a leader, a member of a mass or of an elite, was once a child. He was once small. A sense of smallness forms a substratum in his mind, ineradicably. His triumphs will be measured against this smallness, his defeats will substantiate it. The question as to who is bigger and who can do or not do this or that, and to whom—these questions fill the adult's inner life far beyond the necessities and the desirabilities which he understands and for which he plans." As American culture has become more urbanized and settled, many of the traditional ways of asserting one's "bigness" have disappeared. The frontier with its dramatic opportunities for coping with wilderness, wild animals, and unscrupulous men is gone. We live within circumscribed patterns, obedient children of the law, as it were; but the need to prove bigness still exists, and our society must find new ways for answering this need, which today is often expressed in antisocial patterns of violence, drunkenness, or ruthless ambition. The arts provide one means of achieving reassurance. When a person creates something powerful and expressive from a few smears of paint or dabs of clay, he feels reassured about his importance, power, and maturity.

The need to do creative things has deep roots in human nature and in our society, but many people never find the means of satisfying it. They have not established the habits of doing in youth and so lack both patterns of action and confidence in their abilities. Such people often sense, sadly, that their potentialities have remained undeveloped and that consequently an important part of their living experience has not been lived. Adults—parents, teachers, all adults—are in one way or another teachers of the young and can help them establish habits of creativity as a normal part of everyday life. Creative individuals make a creative society, prevent a static one, and the arts remain a major catalyzer of the social ferment that is needed to keep a culture from becoming static. In such a culture our children can realize the resources within themselves to the fulfillment of their own lives and the life of our national community.

RECOMMENDED REFERENCES

EXCELLENT complete bibliographies exist for practically every field of art. These, however, can be rather overwhelming to the nonspecialist, and the following short list has been compiled for those who require further guidance. One or two books have been selected in each of the areas discussed in the text so that adults can acquire general or technical information to assist them in working with nine-to-twelve-year-olds and especially with adolescents. Most of these books could also be read and enjoyed by adolescents who are seriously interested in the subject. For general background, the articles on art in the *Encyclopaedia Britannica* are both thorough and well-illustrated; they are mainly historical and technical in orientation. The Bibliography on pp. 157–58 deals with the theoretical aspects of art education.

Art Appreciation

Art Today, by Ray Faulkner, Edwin Ziegfeld, and Gerald Hill, rev. ed., Holt, Rinehart, and Winston, New York, 1963.

A very thorough, systematic, and interesting book dealing with many aspects of the fine and functional arts in society today. It provides an excellent introduction to the entire field of contemporary art.

Your Art Heritage, by Olive L. Riley, McGraw-Hill, New York, 1952.

An art history written for adolescents, but also excellent for adults who are venturing into the field for the first time. It discusses modern and historic art and comments on individual works in a sensitive and illuminating way.

Art; Search and Self-Discovery, by James A. Schinneller, International Textbook Company, Scranton, Pa., 1961.

A fresh approach to art appreciation, fresh in that appreciation is closely linked to self-expression. This book would be very useful to read in conjunction with high school or college classes in design, painting, or drawing.

Artists' Materials

The Artists' Handbook of Materials and Techniques, by Ralph Mayer, rev. ed., Viking Press, New York, 1957.

This book is a storehouse of valuable information, but it is often too complex for beginners. It is an excellent reference book for looking up details about materials, processes, and techniques, a work that the serious student of art would be glad to own.

Color

Most books on color are far too technical and involved for our purposes. However, the discussion of color in *Art Today* (see "Art Appreciation") is clear, straightforward, and helpful.

Composition

Art Structure, by Henry N. Rasmusen, McGraw-Hill, New York, 1950.

A college textbook that deals fairly simply with the problem of designing pictures and suggests a broad variety of approaches. The book has a sufficiently broad viewpoint to make it helpful to students interested in either abstract or representational painting.

Pictures, Painters and You, by Ray Bethers, Pitman, New York, 1948.

A stimulating approach to art appreciation, style, and composition. This is essentially a picture book, with illuminating and unpedantic comments on the pictures forming most of the text. It would be an excellent book for an adult to study with an adolescent.

Crafts

There is a tremendous quantity of reference material on crafts, and it varies greatly in quality. Many of the books are made up of cheap patterns and almost worthless suggestions about techniques. Some err the other way are are too technical for amateurs. Many publishing houses put out a series of books on arts and crafts, and one of the most extensive is the "How to Do It" series published by the Viking Press, 615 Madison Ave., New York. This series includes items on many aspects of art other than crafts and frequently hits a happy balance between the theoretical and the practical. Additions and deletions are made continuously, so the following list may not be definitive.

"How to Do It" Series

Angrave, Bruce. *Sculpture in Paper* (1957).
Bacon, C. W. *Scratchboard Drawing* (1951).
Bateman, James. *Oil Painting* (1957).
Becher, Lotte. *Handweaving: Designs and Instructions* (1955).
Bradshaw, Percy V. *I Wish I Could Draw* (1941).
Bradshaw, Percy V., and Hilder, Rowland. *I Wish I Could Paint* (1945).
Bradshaw, Percy V., and Hilder, Rowland. *Sketching and Painting Indoors* (1957).
Carr, Henry. *Portrait Painting* (New ed. 1959; first pub. 1953).
Coates, Helen. *Weaving for Amateurs* (2d ed. 1946).
Conran, Terence. *Printed Textile Design* (1958).
Durst, Alan. *Wood Carving* (Rev. ed. 1959).
Eckersley, Tom. *Poster Design* (1954).
Fei Cheng-wu. *Brush Drawing in the Chinese Manner* (1958).
Flint, Francis M. Russell. *Water Color Out of Doors* (1959).
Henderson, Keith. *Pastels* (1952).
Holden, Geoffrey. *The Craft of the Silversmith* (1955).
Hutchings, Margaret J. *Glove Toys* (1958).
Kirby, Mary. *Designing on the Loom* (1955).
Laker, Russell. *Anatomy of Lettering* (New ed. 1960; first pub. 1946).
Macnab, Iain. *Figure Drawing* (4th ed. 1959).
Marlow, Reginald. *Pottery Making and Decorating* (1957).
Marshall, Francis. *Drawing the Female Figure* (1957).
Marshall, Francis. *Fashion Drawing* (New ed. 1948).
Nichols, Bertram. *Painting in Oils* (New ed. 1959).
Norman, P. Edward. *Sculpture in Wood* (1954).
Talmadge, R. H. *Point-of-Sale Display* (1959).
Wray, Elizabeth, and Morris, F. R. *Dress Design* (1954).

For general information about a variety of crafts, the following books are useful:

Creative Hands, by Doris Cox and Barbara Warren, Wiley, New York, 2d ed., 1951.

An excellent book designed to introduce the novice to a variety of basic crafts. The presentation of each activity is simple and clear, the necessary tools are shown, and fine examples of craft objects are pictured in the illustrations. Some suggestions for decorating craft objects are also included.

Crafts Design, by Spencer Morley, Pauline Johnson, and Hazel Koenig, Wadsworth, Belmont, Calif., 1962.

A handsome, well-illustrated book that stresses both the design and the craft aspects of papercrafts, bookbinding, weaving, textile decoration, leather work, ceramics, mosaic, and enameling. Suitable for either teachers or students.

Creative Crafts for Everyone, by G. Alan Turner, Viking Press, New York, 1961.

A practical source book designed to introduce the reader to about twenty-five different design and craft activities. It contains good illustrations and specific directions, making it both visually and verbally informative.

Handicrafts and Hobbies for Recreation and Retirement, by Marguerite Ickis, Dodd, New York, 1960.

This book covers a wide variety of craft activities. Although the general make-up of the book and the examples shown in the illustrations are not attractive, a tremendous amount of information is presented with a minimum of technical terminology. Most of the materials and tools suggested are inexpensive.

More specialized crafts books worthy of note are:

Clay and Glazes for the Potter, by Daniel Rhodes, Greenberg, New York, 1957.

A very thorough technical book designed to "present in as clear and understandable form as possible the important facts about ceramic materials and their use in pottery."

Design and Creation of Jewelry, by Robert von Neumann, Chilton, Philadelphia and New York, 1961.

A thorough, well-organized, and well-illustrated book on the craft and design of jewelry-making. Both the text and the illustrations are extremely clear.

How to Build Modern Furniture, by Mario Dal Fabbro, 2d ed., Dodge, New York, 1957.

This book provides information on the care and use of both hand and power tools as well as comprehensive directions for all the chief procedures involved in constructing doors, drawers, legs, shelves, and the other parts of furniture. Upholstery, the installation of hardware, making metal furniture, and many other activities are discussed. All procedures are carefully diagrammed.

How to Work With Tools and Wood, edited by Fred Gross, rev. and enl. ed., Pocket Books, New York, 1955.

A series of very simple exercises for beginners in woodworking. The fundamentals of using wood and woodworking tools are explored.

The Manual Arts Press, Peoria, Illinois, has an extensive list of publications covering the manual arts (woodworking, metalworking, etc.). Anyone particularly interested in these activities should write for a catalogue. Other craft books worthy of mention are:

Mosaic Art Today, by Larry Argiro, International Textbook Company, Scranton, Pa., 1961.

Published to meet the current enthusiasm for mosaic crafts, this book suggests many uses for mosaic and describes various techniques and materials.

Nature Crafts, by Ellsworth Jaeger, Macmillan, New York, 1950.

This book suggests very simple "fun" activities in which nature materials are used in ingenious and charming ways. These activities would provide an easy introduction to crafts for a parent, teacher, or camp counselor.

Design

The literature in this field ranges from books on pictorial composition to those that are essentially craft manuals. The following books are neither unduly pictorial in emphasis nor limited by handicraft concepts:

Design, by Sybil Emerson, International Textbook Company, Scranton, Pa., 1953.

An unusually stimulating design textbook. It suggests a great variety of experiments with the art elements and with various materials that will develop an awareness of the art elements in crafts and in the industrial and commercial design fields. Activities designed to make students aware of the general problem of aesthetic organization are also presented. The book is well illustrated and should stimulate a person of an inventive nature to a variety of creative activities.

Vision in Motion, by L. Moholy-Nagy, Theobold, Chicago, 1947.

This is the most thorough and systematic presentation of the principles and practices of the Bauhaus school as developed in the School of Design in Chicago. It is neither a purely philosophic statement of ideas nor a manual

of exercises, but has elements of both in it. The discussion on modern design is very stimulating, though not easy to read.

Design Fundamentals, by Robert Gillam Scott, McGraw-Hill, New York, 1951.

A thoughtful, analytical approach to two- and three-dimensional design, stressing composition and the interrelationship of the art elements. Best suited to a mature person seriously interested in design theory.

Drawing

The reference material in this field is very extensive. Many books concern themselves with drawing a specific kind of subject (figure drawing, animal drawing, etc.), and others are manuals on pencil, charcoal, or pen techniques. Some of the best books in this area are collections of reproductions of fine drawing. In general, the books that are not too concerned with techniques provide the greatest direction and stimulus. Two generally satisfying books on drawing are:

The Natural Way to Draw, by Kimon Nicolaides, Houghton Mifflin, Boston, 1941.

This book is of both practical and theoretical value, suggesting not only procedures for beginners, but also many different approaches to drawing and kinds of drawing activities. The author's point of view is stimulating and encourages the development of a personal style rather than adherence to limiting ideas of what constitutes proper techniques.

Perspective Drawing, Freehand and Mechanical, by Joseph W. Hall, University of California Press, Berkeley and Los Angeles, 1960.

This book is recommended not merely as a text on perspective, but as a general reference on drawing, since it includes information on various media, on line and light-and-dark, and on various aesthetic problems. The book has a wealth of stimulating suggestions about drawing procedure, excellent illustrations, and a thorough discussion of perspective. The organization is somewhat confusing, since the first section on general drawing constantly refers to the second rather technical section on perspective.

Figure Drawing

Atlas of Human Anatomy for the Artist, by Stephen Rogers Peck, Oxford University Press, New York, 1951.

An excellent book on anatomy, with charts, diagrams, and photographs. It would be most helpful to any serious student of anatomy.

Figure Drawing Comes to Life, by Calvin Albert and Dorothy Seckler, Reinhold, New York, 1957.

A stimulating book that suggests many approaches to drawing the human figure. The variety of techniques and concepts presented provide a valuable introduction to the art of figure drawing.

Two of the standard older books on figure drawing have been republished as paperbacks. Since they cost little and have been proved useful by time, anyone interested in figure drawing might well own them.

Life Drawing, by George B. Bridgman, Sterling, New York, 1961.
The Human Figure, by John H. Vanderpool, Dover, New York, 1958.

Perspective Drawing

Most books on perspective are written for the architect: to enable him to project a sketch of a nonexistent building from a set of plans. This approach is of almost no help to the artist, whose interest in perspective is for purposes of sketching from nature.

Perspective Made Easy, by Ernest Norling, Macmillan, New York, 1946.

An unpretentious, unattractive, and inexpensive workbook. It does, however, provide the beginner with certain principles that will help him sketch objects in perspective and foreshortened form.

Practical Perspective Drawing, by Philip Lawson, McGraw-Hill, New York, 1943.

This book presents perspective very thoroughly in both its theoretical and its practical aspects. It is planned primarily for the serious pictorial artist, but it also contains most of the information needed by the architect. This would be a useful book to read after exploring the initial phases of perspective with Ernest Norling's *Perspective Made Easy.*

Painting

Most books on painting techniques exaggerate minor technical aspects of the painter's craft and thereby inhibit the beginner by making him too self-conscious about procedures. Actual experimentation for a few hours with the medium is usually all that is necessary for him to feel comfortable with piants and brushes. Books on painting are usually

more valuable to the student who has painted for some time and feels the need for further direction and new viewpoints. For such a person the "How to Do It" Series, p. 149, is suggested. The following very simple book on oil painting contains useful information and provides a methodology for the beginner who has no idea about procedure.

Oil Painting for the Beginner, by Frederick Taubes, Watson Guptill, New York, 1944.

Design Techniques, Design Publishing Company, Columbus, Ohio, 194-?

The title of this work is misleading, since the emphasis is not on design techniques but on popular painting, illustrating, and print techniques. Sub-titled "A Handbook of Forty Art Procedures," this inexpensive book is useful to beginners in that it introduces the nonprofessional reader to many different media used for two- and three-dimensional expression.

Picture Framing

Picture Framing, by Edward Landon, Tudor Publishing Company, New York, 1945.

An interesting field and very useful to an artist. This book has many fine suggestions about cutting mats and finishing frames.

Print Processes

There are many good books on individual print processes, but most of them are too involved for the beginner. There is an excellent section on the print processes in Mayer's *The Artists' Handbook of Materials and Techniques,* in which all the major processes are discussed very clearly. A noteworthy new book on print processes is:

Printmaking Today, by Jules Heller, Holt, Rinehart and Winston, New York, 1958.

An excellent book on the major print processes. It is well organized, the text has been kept down to a minimum, and the illustrations are effective.

Sculpture

Sculpture, Techniques in Clay, Wax, Slate, by Frank Eliscu, Chilton, Philadelphia and New York, 1959.

The author examines a typical modeling, casting, and carving process, respectively, to trace the sequence of steps in each process by which a piece of sculpture is made. The text is supported by some good photographs.

Zorach Explains Sculpture, by William Zorach, Tudor Publishing Company, New York, 1960.

An important American sculptor explains by means of words and pictures the art and craft of sculpture. Without being unduly technical this book still provides adequate direction.

BIBLIOGRAPHY

Alschuler, Rose H., and Hattwick, La Berta W. *Painting and Personality: A Study of Young Children.* Chicago: University of Chicago Press, 1947.

Andrews, Michael F. (ed.). *Creativity and Psychological Health.* Syracuse, N.Y.: Syracuse University Press, 1961.

Barkan, Manuel. *Through Art to Creativity.* New York: Allyn and Bacon, 1960.

Beck, Otto Walter. *Self-Development in Drawing.* New York: Putnam's, 1928.

Cane, Florence. *The Artist in Each of Us.* New York: Pantheon Books, 1951.

Cole, Natalie Robinson. *The Arts in the Classroom.* New York: Day, 1942.

D'Amico, Victor. *Creative Teaching in Art* (rev. ed.). Scranton, Pa.: International Textbook Company, 1954.

De Francesco, Italo L. *Art Education: Its Means and Ends.* New York: Harper, 1958.

Dewey, John. *Art As Experience.* New York: Putnam's, 1934.

Eng, Helga. *The Psychology of Children's Drawing from the First Stroke to the Coloured Drawing.* London: Routledge, 1931.

Erikson, Eric H. *Childhood and Society.* New York: Norton, 1950.

Gaitskell, Charles D. and Margaret R. *Art Education During Adolescence.* Toronto, Canada: Ryerson Press, 1954.

Getzels, Jacob W., and Jackson, Philip W. *Creativity and Intelligence.* London and New York: Wiley, 1962.

Ghiselin, Brewster (ed.). *The Creative Process.* Berkeley, Calif.: University of California Press, 1952.

Knudsen, Estelle Hagen, and Christiansen, Ethel Madill. *Children's Art Education.* Peoria, Ill.: Bennett, 1957.

Logan, Frederick M. *Growth of Art in American Schools.* New York: Harper, 1955.

Lowenfeld, Viktor. *Creative and Mental Growth: A Textbook on Art Education.* New York: Macmillan, 1952.
———. *The Nature of Creative Activity.* New York: Harcourt, Brace, 1939.
McDonald, Rosabell. *Art as Education.* New York: Holt, 1941.
McFee, June. *Preparation for Art.* Belmont, Calif.: Wadsworth, 1961.
Naumburg, Margaret. *Studies of the Free Art Expression of Behaviour Problem Children and Adolescents as a Means of Diagnosis and Therapy.* New York: Coolidge Foundation, 1947.
Oldham, Hilda. *Child Expression in Color and Form.* London: John Lane, The Bodley Head, 1940.
Ott, Richard. *The Art of Children* (with Preface by Herbert Read). New York: Pantheon Books, 1952.
Pearson, Ralph. *The New Art Education.* New York and London: Harper, 1941.
Progressive Education Association Commission on the Secondary School Curriculum. Committee on the Function of Art in General Education. *The Visual Arts in General Education.* New York: Appleton-Century, 1940.
Read, Herbert. *Education Through Art.* 2d ed. New York: Pantheon Books, 1949.
Schaeffer-Simmern, Henry. *The Unfolding of Artistic Activity: Its Basis, Processes and Implications.* Berkeley and Los Angeles: University of California Press, 1948.
Tomlinson, R. R. *Children as Artists.* London and New York: King Penguin Books, 1944.
Ziegfeld, Edwin (ed.). *Education and Art: A Symposium.* Paris: UNESCO, 1953.